ANCIENT CHINESE BRONZES

ANCIENT CHINESE BRONZES

MA CHENGYUAN

EDITOR: HSIO-YEN SHIH

HONG KONG OXFORD NEW YORK
OXFORD UNIVERSITY PRESS
1986

Oxford University Press

Oxford New York Toronto
Petaling Jaya Singapore Hong Kong Tokyo
Delhi Bombay Calcutta Madras Karachi
Nairobi Dar es Salaam Cape Town
Melbourne Auckland

and associated companies in
Beirut Berlin Ibadan Nicosia

This edition © Oxford University Press by arrangement with
Shanghai People's Publishing House 1986

First published under the title 中國古代青銅器
by Shanghai People's Publishing House 1982
This edition first published by Oxford University Press 1986

ISBN 0 19 583795 9

OXFORD is a trade mark of Oxford University Press

Printed in Hong Kong by Golden Cup Printing Co., Ltd.
Published by Oxford University Press, Warwick House, Hong Kong

Publisher's Note

The author, Ma Chengyuan, was born in Zhenghai, Zhejiang Province, in 1927 and graduated from the Department of History and Society in the Dasha University, Shanghai, in 1947. Since 1954 he has worked in the Shanghai Museum as head of the Acquisitions and Cataloguing Group and the Bronze Research Group and, from 1985, as Curator of the Museum. A member of the Shanghai Municipal Committee for the Purchasing and Identification of Cultural Relics, Ma Chengyuan led the exhibition, 'The Great Bronze Age of China', to the United States in 1980. He has, in addition, served on the Councils of the First and Second Sessions of the Chinese Archaeological Society and the Council of the China Paleography Research Institute. His publications include: as author, *Painted Pottery of the Yangshao Culture* (1957); as editor, *Bronzes in the Collection of the Shanghai Museum* (1964), and *Selections of Ancient Chinese Bronzes* (1975); as chief editor, *Selected Inscriptions on Shang and Zhou Bronzes* (1983); and, as author, *Ancient Chinese Bronzes* (1982).

Ancient Chinese Bronzes was translated into English by Tang Bowen. The number of examples in Part II of the book has been reduced by three, these being bronzes in collections outside of China. Also omitted were most of the illustrations of the inscriptions on the selected examples and their transcriptions into modern script, the three retained being deemed sufficient to demonstrate the development of bronze inscriptions in terms of content, length and style.

The editor, Hsio-Yen Shih, is Professor and Head of the Department of Fine Arts, the University of Hong Kong.

All the colour plates reproduced in this book were taken by Wang Junliang of the Shanghai Museum, with the exception of Plates 24, 29, 30, 41, 45, 54, 66 and 79 which were supplied by the Museum of Chinese History.

Contents

Chronology of Chinese Dynasties

Xia	*c.* 21st-16th century BC
Shang	*c.* 16th-11th century BC
Zhou	*c.* 11th century-221 BC
Western Zhou	*c.* 11th century-770 BC
King Wu	1066 BC
King Cheng	1063 BC
King Kang	1026 BC
King Zhao	1000 BC
King Mu	976 BC
King Gong	921 BC
King Yi	909 BC
King Xiao	884 BC
King Yee	869 BC
King Li	857 BC
(Gonghe)	841 BC
King Xuan	827 BC
King You	781 BC
Eastern Zhou	770-221 BC
Spring and Autumn Period	770-476 BC
Warring States Period	475-221 BC
Qin	221-207 BC
Han	206 BC-AD 220
Western Han	206 BC-AD 24
Eastern Han	25-220
Three Kingdoms	220-280
Wei	220-265
Shu	221-263
Wu	222-280
Jin	265-420
Western Jin	265-316
Eastern Jin	317-420

Southern and Northern Dynasties
 Southern Dynasties 420-589
 Song 420-479
 Qi 479-502
 Liang 502-557
 Chen 557-589
 Northern Dynasties 386-581
 Northern Wei 386-534
 Eastern Wei 534-550
 Western Wei 535-557
 Northern Qi 550-577
 Northern Zhou 557-581
Sui 581-618
Tang 618-907
Five Dynasties and Ten Kingdoms 907-979
Song 960-1279
 Northern Song 960-1127
 Southern Song 1127-1279
Liao 916-1125
Jin 1115-1234
Yuan 1271-1368
Ming 1368-1644
Qing 1644-1911

Part I A General Survey of Shang and Zhou Bronzes

Man learned to cast bronze objects very early in the long history of struggle for the production and development of material civilization. Records of the use of bronze exist for most ancient cultures. In China, copper objects have been discovered in sites of the Majiayao Culture from the Neolithic Period 5,000 years ago. About 2000 BC, China entered the first phase of its Bronze Age.[1]

Bronze is usually an alloy of copper and tin, or of copper, tin and lead. Less common is lead-bronze, an alloy of copper and lead. Only after learning to manufacture copper objects could man go one step further to master bronze alloy techniques.

In the course of making stone implements over a long period, ancient peoples must time and again have come into contact with lumps of pure copper in a natural state (that is, secondary copper of naturally high purity), and then gradually have come to recognize both its meltability and malleability. Later, as production continued to develop, they learned to obtain copper from malachite by smelting with charcoal as fuel. At first, ores were dug from mineral veins which were exposed on the surface of the earth. In order to obtain more ores, people had to follow mineral veins deep into the earth and to excavate ores from tens of metres below the surface.

The earliest cast objects of copper are small tools and

1. There is much discussion at present among Chinese archaeologists about the discovery of pieces of copper at more than one site of the Yangshao Culture, but no specific information has been formally published as yet. Majiayao represents one phase of the Yangshao Neolithic. A well-preserved copper knife has been found at a Majiayao Culture site in the Dongxiang Hui Autonomous County, Gansu Province. Details remain to be published. Both the Qijia Culture and the late period of the Longshan Culture of about 2000 BC had already entered the early phase of the Bronze Age.

ornaments. The merit of copper is that it is highly ductile, and can be either cold-worked or heat-treated. However, the degree of hardness of a copper tool is much lower than that of a stone tool, and its blade-edge is easily blunted. Only when an appropriate amount of tin is melted into copper does a fundamental change take place in the physical properties of the metal, increasing its hardness. A copper and lead alloy will also have increased hardness, but its chief effectiveness is in its resistance to wear, or its resilience. Knives cast of bronze are very sharp, and their usefulness far surpasses that of stone or copper knives. Bronze can retain its metallic lustre for a long time, and is highly resistant to corrosion. Some of the bronzes buried in the loess regions of northern China for several thousand years still preserved their brightness after excavation. Copper, on the other hand, easily develops a coat of black copper-oxide. Moreover, molten bronze is readily poured into moulds to be cast into tools or vessels of complicated form. Molten copper is less fluid, more viscous, and difficult to pour into moulds for complex vessels. As a result of continuous practice in production, ancient peoples gradually came to recognize the superiority of bronze.

Bronze must be smelted to its liquid form, and poured into moulds to be cast into different forms. Therefore, the casting of a bronze object requires the rational solution to a series of technical problems involving mining, smelting, mould-manufacture, alloy formulae, and the construction of crucibles and furnaces. These involved a long process of hard work, repeatedly moving from practice to understanding, and from understanding to practice. The change from using stone objects to the casting of bronze objects represents an achievement of profound significance in the revolutionary history of human technology.

The Chinese gained their first knowledge of bronze in the late Neolithic Period. It was not, however, until the period of the 'Slave Society' that bronze came to be commonly used and a standard force of production.[2] Bronze slag has been found in

2. Current Chinese historiography follows a modified Marxist periodization of societal change from the 'Primitive' to the 'Slave' or 'Slave-Owning' to the 'Feudal'.

the Longshan Culture of China's 'Primitive Society'. The Qijia
Culture has yielded lead-bronze containing 5 per cent lead.[3]
These finds show that the first stage of bronze casting in China
can be traced to a very remote time. As previously mentioned,
isolated pieces of copper have been discovered at sites of the
Majiayao Culture and even earlier phases of the Yangshao
Neolithic. However, many areas of the country had entered the
early Bronze Age by about 2000 BC.

According to historical documents, the Xia Dynasty already
knew how to cast bronzes.[4] In 1972 the foundations of a very
large palace were discovered at Erlitou in Yanshi, Henan
Province, a site that predates the early Shang Dynasty site at
Erligang in Zhengzhou. Bronze chisels, awls, knives, fish-hooks
and arrowheads were unearthed from the same stratum as the
palace foundations. As bronze arrowheads are expendable
weapons, they must have been made on a considerable scale
to meet actual needs in war. Subsequently, finely cast bronze
ge (dagger-axes) and *qi* (battle-axes) were excavated, and before
long a bronze *jue* (tripod goblet), as well as other vessels. The
most significant discovery was the *jue* whose analysis revealed
a typical tin-bronze content of 92 per cent copper and 7 per cent
tin. These bronze objects all came from the third stratum at
Erlitou.

It has been acknowledged that there are differences in the
characteristics of pottery from the first and second strata, and
those of the third and fourth strata.[5] Moreover, the third and

3. A Longshan site at Hougang, Anyang, Henan Province, excavated in
1972, has been dated by Carbon 14 to 1960 BC (± 90). A Qijia site at
Dahezhuang, Yongjing County, Gansu Province, excavated in 1971, has
been dated by Carbon 14 to 1725 BC (± 95). See 'A Brief Report on
Excavations at Hougang, Anyang, in Spring 1972', *Kaogu* 1972:5; and
'Report on Radiocarbon Datings (1)', *Kaogu* 1972:1.
4. *Zuo zhuan*, 'Xuan gong, 13th Year': 'The rule of the Xia in former times
was virtuous. Things were obtained from afar. There was a tribute of nine
pieces of bronze, which were cast into *ding* and other objects.' *Mo zi*, 'Geng
zhu': 'The King of Xia ... cast *ding* in Kuanwu.' The *Yuejue shu*, 'Record
of Swords': 'At the time of Yu, bronze was used for making weapons.' These
are all later accounts of the Xia Dynasty's casting of bronze. Chinese
historical writings are unusual in their continuity. These later accounts
cannot be regarded as valueless guesswork only.
5. See 'A Brief Report on the Trial Excavation at Erlitou in Yanshi, Henan,

fourth strata belong to a time before the Erligang Period of the Shang at Zhengzhou. Some scholars maintain that the lower two strata belong to the early Shang culture, the palace remains being those of Shang Tang's capital when he founded the dynasty. Others think that all four cultural strata at Erlitou belong to the Xia Dynasty, and that the Shang capital has been proved to be Zhengzhou. This controversy relates to the beginning of China's Bronze Age.[6]

Initially, at least, we must acknowledge that the third and fourth periods at Erlitou are earlier than the Erligang Period of the Shang at Zhengzhou. The cultural remains are markedly different despite some similarities between the Erligang remains and certain aspects of periods three and four at Erlitou. At present there are still no means to prove definitively that they belong to the early Shang culture. Carbon 14 dating shows that the fourth stratum is from about 3,600 years ago, or to be placed about the 17th and 16th centuries BC. The third stratum must clearly be a good deal earlier. If this dating has some reliability as a reference, then considering the phenomena in the cultural strata, we can posit that these remains belong to pre-Shang or pre-Shang dynastic times and are the remains of a bronze culture under the Xia Dynasty. However, excavation of Erlitou-type sites is still inadequate, and much work remains to be done. So far we can at least conclude that, before the 17th century BC, a bronze-casting industry with special Chinese characteristics already existed in its initial stage on the Central Plain of north-central China, far earlier than that of the Erligang Period.

The Erlitou finds are, however, only a beginning. The bronze objects found in the third stratum had already attained a relatively high standard in piece-mould casting. Such results

1959', *Kaogu* 1961:2; 'A Brief Report on the Excavation of the Early Shang Palace Foundations at Erlitou in Yanshi, Henan', *Kaogu* 1974:4; 'A Brief Report on the Excavation of the Third and Eighth Zones of the Erlitou Site in Yanshi, Henan', *Kaogu* 1975:5; and 'Bronze and Jade Objects Recently Discovered at Erlitou, Yanshi', *Kaogu* 1976:4.
6. See Zhou Heng, 'Some Questions Concerning the Xia Culture', *Wenwu* 1979:3; and Yin Weizhang, 'A Discussion on the Erlitou Culture', *Kaogu* 1978:1.

could not have been achieved without several centuries of experience in the accumulation of production techniques. We have, therefore, good cause to expect that remains of even earlier bronze casting will be discovered.

BRONZE CASTING

There was an enormous demand for bronze objects in Shang and Zhou times. Among the bronzes still preserved, more than 10,000 with inscriptions are known, and those without inscriptions must be far more numerous. As for bronze weapons and tools expended in warfare and production, their numbers are even more difficult to estimate. From this we can see that bronze casting flourished in ancient China.

To cast bronze, it is first necessary to solve the problems of copper mining and refining. As there was such a huge demand for copper, mining and refining must have been carried out on a considerable scale. At the ancient mining and refining site at Tonglushan in Daye, Hubei Province, discovered in 1972, the timbers and supports unearthed from one hill crest alone occupied more than 3,500 cubic metres; the slag-heaps are estimated to be about 40,000 tonnes.[7]

This mining site is known to have been in operation from the Spring and Autumn Period through the Han Dynasty. When pottery sherds of the Western Zhou Period were later discovered at the site, they indicated possibly the earliest time for the mine's exploitation. Its early galleries are on the upper level, and later ones below, reaching more than 50 metres below the surface. Archaeological excavation has revealed that the Tonglushan mine includes vertical shafts, inclined shafts, inclined galleries and horizontal galleries connected in its construction. Copper ores were extracted layer by layer from the lowest level upwards. Miners first sank an inclined shaft

7. See 'A Brief Report on the Excavation of an Ancient Mine of the Spring and Autumn and Warring States Periods at Tonglushan, Hubei', *Wenwu* 1975:2.

from the surface of the ore seam to its bottom where a horizontal shaft was then opened, finally to return upwards. An initial sorting of ores was made at the bottom of the shaft, discarded rock and poor ores being used to fill voids left by earlier extractions. This process was repeated until the uppermost part of the seam was reached. It was a very advanced method of ore mining for the time, the same still being used today in non-mechanized mines.

The solution to the problem of ventilation was understandably a relatively primitive one but was, nonetheless, ingenious. Miners used the natural flow of air formed by differences in atmospheric pressure at varying levels of shaft-openings, and blocked abandoned galleries to control and direct the air-flow along galleries where excavation was under way. Shafts also had a simple system of drainage, with such devices as wood troughs to channel water into a tank from which wood buckets could be hauled up a vertical shaft to the surface. Illumination was provided by burning bamboo slips, of which many small, burnt pieces were found stuck in gallery walls. The first sortings of ore were also hauled to the surface up vertical shafts. A Spring and Autumn Period shaft-opening measured about 80 centimetres square, while a Han Dynasty example was slightly larger, about 110-130 centimetres square. The digging tools found in shafts included wooden shovels and hammers and large bronze axes from the early period, and mostly iron implements from the Han Dynasty.

Apart from the great amounts of slag, remains of many furnaces and more than ten disc-shaped copper ingots were found at Tonglushan. However, the absence of pottery moulds indicates that it was only a mining and refining site.

Tonglushan is only one of a number of ancient copper mines discovered in the Daye area. As this ancient mine remained in operation for many centuries, its scale, underground installations and methods of excavation may be seen as representative of mining some 2,500 years ago.

As archaeological work on mining and metallurgy progresses in China, we should be able to gain a more thorough understanding of the arduous labour and wisdom of the slave-miners in ancient times.

Bronze is an alloy requiring tin or lead as well as copper. Placer tin can sometimes be found along river-beds near tin deposits. Relatively large quantities of tin are required for bronze, however, and so tin mines had ultimately to be opened. Mining for tin also yielded lead, which made possible the casting of lead-bronze or lead and tin bronze.

Analysis shows that early Shang bronzes can be divided into two types of alloy. One type is a copper-tin alloy, sometimes with a trace of lead; the second is an alloy of copper and lead, or of copper, tin and lead, with the lead in greater proportion than the tin. By the late Shang, the first type of bronze alloy was predominant. The hardness of bronze increases with the addition of tin, but an excessive quantity of tin will cause bronze to become brittle. The artisan-slaves of ancient times had a clear understanding of changes in the physical properties of bronze depending upon its tin content. The ancients believed that both copper and tin were soft metals, and that the combination of these would form a hard alloy. This is a dialectical under-standing. The *Artificers' Record*, a book of engineering of the state of Qi in north-eastern China from the 5th century BC, records six types of bronzes with varying tin content which it calls the Six Recipes.[8] This book is a compendium and record of the long experience in casting of Qi slave-artisans, and the world's oldest written account of bronze alloy constituents.

8. The 'Six Recipes' given in the *Kao gong ji*

	Percentage of copper	Percentage of tin
For bells and cooking vessels:		
6 parts copper, 1 part tin	85.71	14.29
For axes and adzes:		
5 parts copper, 1 part tin	83.33	16.67
For battle-axes and halberds:		
4 parts copper, 1 part tin	80.00	20.00
For large knives:		
3 parts copper, 1 part tin	75.00	25.00
For arrowheads:		
5 parts copper, 2 parts tin	71.43	28.57
For mirrors and igniting mirrors:		
1 part copper, ½ part tin	66.66	33.33

The Six Recipes were not, however, the only standard. Laboratory analysis demonstrates that experience in production had led to refinement of these recipes. For example, bronze weapons of the 5th century BC generally contain a certain amount of lead. If their tin content was relatively high, they would have been easily broken, but the addition of lead increased their resilience while slightly diminishing their hardness. This was particularly effective for bronze swords with long blades, and such narrow but sharp-edged types as the *ge* (dagger-axe) and *ji* (halberd).

The state of Yue was famous for its casting of swords. Among the swords of the king of Yue is a type with inlaid spine, which displays a superb casting technique. The spine was first cast, then fitted into the blade by a second casting. Analysis shows that the blade-edge has a higher proportion of tin which makes it very sharp but rather brittle; the central spine area has a lower proportion of tin, making it softer but more resilient, or it contains more lead. The combination of the two, a hard cutting edge with a more flexible spine, improved the quality of the sword.

Another advantage in adding lead to the alloy is that it increases the fluidity of the molten metal, enabling closer contact with mould surfaces and thereby improving the quality of the casting. Those Warring States Period bronzes with very delicate yet clearly defined decorative patterns were made possible, as analysis has revealed, by a higher lead content than that of other types.

There are many other important aspects to analysis of bronze alloys, including tin-plating techniques, the casting of alloys with high tin content, the technique of adding decorative stains, and that of enhancing the surface hardness of mirrors.

8. (continued) The proportions given on p. 7 are not those of bronzes after casting. In the smelting process, tin oxidizes easily, thereby reducing its proportion in the alloy. The mirrors referred to were flat surfaced in the earliest period, and convex by the Han Dynasty. Igniting mirrors were concave in order to focus the sun's rays. Measurement of some ancient igniting mirrors in the collection of the Shanghai Museum reveals that their concave surfaces all have parabolic curvature.

From the above it can be seen that the founders of ancient times had a rich knowledge of the properties of different bronze alloys, which remains a precious heritage to the present day.

In the Shang and Zhou periods mainly pottery piece-moulds were used for casting bronzes. These are different from later moulds in that clay or pottery pieces were divided around the form to be cast. A great number of pottery mould parts have been found in ancient foundry sites. Over 50,000 pottery mould pieces were unearthed at the large foundry in the remains of Xintian, the capital of the state of Jin, in present-day Houma City, Shanxi Province, and these were but a small part of those buried at the site.[9]

The earth used for making pottery mould parts was clean and fine-grained clay that had been carefully selected. This was because impure clay could not produce fine details of decorative patterns for casting and would cause other blemishes. However, the clay itself could not withstand high heat, its lack of solidity being susceptible to cracking. It was, therefore, necessary to mix in very fine sand as temper in order to improve the clay's heat resistance and mechanical strength, so that moulds would not crack or collapse when molten bronze was poured into them. Whether from the Yin ruins at Anyang of the Shang Dynasty, from Luoyang of the Western Zhou Period, or from the Houma remains of the Jin state of the Spring and Autumn Period, pottery moulds all have a certain amount of fine sand mixed within the clay. Also, when molten bronze is poured into the mould, a small amount of gas will be generated. If this gas has no outlet, it will produce air bubbles on the casting, even ruining it completely in serious cases. This is why air ducts had to be formed in the moulds, and particularly in their outer layer, to improve ventilation. The inner layer of the mould was relatively thin, but its outer layer was much thicker and with more sand temper. The way to increase porosity of the clay was to mix in finely chopped straw, or other organic matter such as rice husks. When the clay moulds were fired, such organic

9. 'Quantities of Pottery Moulds Found in the Eastern Zhou Remains at Houma, Shanxi', *Wenwu* 1960:8-9.

matter burnt off, leaving hollow spaces. We often find many such tiny openings in Shang and Zhou pottery moulds.

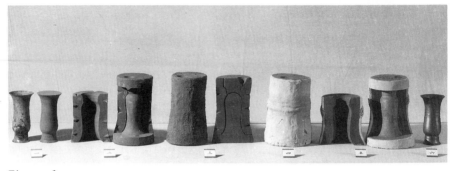

Figure 1

Based on research on excavated materials (Figure 1), the Shang casting process was follows:

1. First, an exact solid model of the bronze object to be cast was made. The principal decorative motifs, if any, were then carved on it.
2. A stand was made of clay, upon which the model was placed upside down, after which the outer mould pieces were formed by pressing clay section by section, following the model's distinctive parts. For example, the outer mould pieces for the body of a *ding* (tripod food container) had to be made in at least six separate sections which were later joined to form three pieces. If the *ding* was to have relief ornament on its surface, a large piece of outer mould would not be removable from the model, while smaller sections could be removed and then joined while still wet. We can sometimes see as many as six seams on the body of a *ding*, where mould pieces were joined, although three seams are more usual. When two smaller sections were joined to form a larger mould piece, their alignment was sometimes not perfect, as is revealed in traces left after casting. Mould pieces also had to be joined by triangular mortises and tenons.
3. The outer mould pieces released from the model were then half dried in cool shade before the touching up and carving of fine details in the decoration, these requiring meticulous workmanship. From the complicated designs on bronzes, and

their precise yet vigorous lines, we can see that such work must have been the responsibility of the most highly skilled and experienced artisan-slaves.

4. A surface layer of the exact thickness of the wall of the bronze object to be cast was shaved away from the model while its clay was still wet. Then, the model was divided into an upper and lower part (possibly some models were made in two separate parts). If the model were that of a *hu* (jar), its upper part would be the inner mould for the body while its lower part would be that for the foot-ring. Some bronzes have inscriptions for which a separate mould piece was inserted to the bottom, side or foot-ring of the model. If the inscription was to appear on a vessel's exterior, its mould would have been inserted to an outer mould piece.

5. When the finishing touches were complete, the model and outer mould pieces were allowed to dry in the shade. When completely dry, they were then fired in a kiln. Analysis shows that the firing temperature was about 600°C, turning the clay into a soft pottery. Too high a temperature would have caused the clay to shrink considerably, and the mould pieces to become distorted. After firing, the clay moulds became pottery moulds. An opening was left in the mould assemblage for receiving the molten bronze, and air as well as slag outlets were made in the moulds for large bronze vessels.

6. The assemblage of pottery mould pieces was strengthened with a coating of clay, and then preheated before the molten bronze was poured off, to ensure its swift flow and to prevent premature hardening or blockage. Vessels were cast upside down. Once the bronze had cooled, its outer mould pieces were smashed and its inner model removed. It was then filed and polished with whetstones. Some bronzes are so well polished that charcoal or some such abrasive must have been used for additional finishing of their surfaces. At the conclusion of this process, a sparkling new bronze vessel had come into being.

The pottery mould assemblage for a large bronze object was placed directly on the ground. Fragments of such an assemblage for a vessel resembling a square *ding* (four-legged food container) of more than one metre in length have been discovered in the

Yin ruins at Anyang. Four holes for the erection of posts in the ground around it indicate that it had been placed within a shed.

The casting of a large bronze vessel was highly complicated work requiring close co-ordination. For example, even the preheating of the huge mould assemblage was no simple undertaking for such a piece as the late Shang Dynasty Si Mu Wu *ding* (Plate 24), which weighs 875 kilogrammes. As for its pouring, no single furnace could have melted so much bronze, and so several furnaces must have operated simultaneously to provide the molten alloy which was poured in a continuous flow into the channel leading to the mould's opening. If tin were added to the alloy at too early a stage, its rapid oxidization would affect the alloy's proportions of copper and tin, as well as cause an unevenness in the bronze alloy in different furnaces, and so it had to be added just before the opening of each furnace. Much experience was required for the correct timing of such a sequence. Only highly skilled slave-artisans could have controlled each of the many stages in the complex process of bronze production.

The many complicated parts of bronze vessels, such as three-dimensional decoration, the movable yet attached handle, and the chain linking a vessel's lid to its body, were all made in two castings, or by the method of separate casting. Animal forms in the round and parts of complicated form were first cast separately, and then inserted to the piece-mould of the main body. A movable part which was to occupy a small space, such as the handle for a *hu* or *you* (covered jars), required extreme care in leaving openings for its placement so that it would not come into contact with the molten bronze during the second casting. This method is simple to describe but quite difficult to execute, some movable parts being separated from the main body by only two or three millimetres. It was not easy to ensure that the thin layer of separation made of pottery would not be destroyed by the hot molten bronze. If damage occurred in this area, the entire vessel would become a reject. The merit of this double casting method is that it can produce bronzes of extremely complicated structure.

Shang and Zhou slaves developed both piece-mould casting and the double casting method within the conditions and

limitations of their time. As a result, the ancient bronzes of China display not only distinctive national characteristics in style, but also a perfected technology. They have no parallels in the ancient world.

In the late Western Zhou Period, the slave system declined, hindering development of production. Bronze casting went through a period of stagnation, and many crude works were produced. By the late Spring and Autumn Period, a great social change began to take place: feudal landlords and serfs gradually replaced the slave system. Patterns of production changed accordingly, to such an extent that new developments took place in the social economy. Bronze casting, a major part of handicraft production, also benefited by further improvement.

It was during the late Spring and Autumn Period that, based on the piece-mould casting technique, dies for impressing moulds began to appear, creating firmly standardized patterns. Decoration required only a single, complete set of dies to reproduce the same motifs on many mould pieces. Casters could impress many groups of decorative motifs on thin pieces of clay, and then join these together according to any specified design. This did not require the time demanded for making each element of an elaborate pattern individually. If the mould clay were very fine, pure and dense, even hairline details could be reproduced with the same precision and clarity as that offered by modern plaster moulds. Such a precise casting technique is most impressive. Development of this technique was impelled, in part, by increased market demand. By this technique, high-quality moulds could be produced at speed, and continuously, without the repetitive finishing and touching-up of the model and piece-moulds for each vessel. For example, the model of a *zhong* (bell) had only to be made as a half which could be replicated, the two halves then simply joined to form the whole. The 36 studs protruding from the bell had separate standardized moulds which were inserted to the bell's body mould. Other decoration on the bell could be added in a similar way. The assembling of moulds at this time was quite similar to that of machine parts today. However, the great improvement in efficiency of this method also had its drawbacks. As the decoration was impressed by dies and not carved by hand, it

could be delicate and precise, but was deficient in artistry. Some designs lacked variety and impart a feeling of monotony.

In addition, the methods of double and multiple casting were popularized at the same time. Such methods were used, previously, only for a vessel's subsidiary parts which were difficult to position, or for such parts as handles. Now, however, there was a fundamental advance. For example, the handles and feet of a *ding* (tripod food container) had earlier been cast at the same time as the main body, but now they were cast in advance according to specifications, and then inserted to the outer mould after the vessel's body moulds had been assembled. This method saved a great deal of time and labour, was more efficient, and so was widely adopted.

A brief outline of China's ancient method of bronze casting with piece-moulds is given above. The piece-mould casting technique was, without doubt, the principal method used for more than a millennium during Shang and Zhou times. There were, nevertheless, exceptions such as tools of types like axes, adzes and small knives, which used stone moulds. Such moulds, made of red sandstone, were found in the Shang remains at Wucheng, Qingjiang County, Jiangxi Province.[10] Like pottery moulds, moulds made of this type of sandstone are somewhat absorbent, but they are not easily damaged and can therefore be used repeatedly. The use of sandstone moulds was never extended to the casting of large vessels as they were difficult to carve for producing delicate decoration. Moreover, the ideal sandstone was available only in certain regions.

The lost-wax, or *cire-perdu*, method of bronze casting was common in ancient civilizations, but emerged in China rather late. It may also be called the model-melting method. A model of the object to be cast was made of wax, then coated on all surfaces with layers of processed clay until an appropriate thickness was reached, these becoming the clay mould. After the clay mould had been fired to a semi-pottery stage, the wax model would have melted and flowed out of the mould. Molten bronze was then poured into the channel left open for it, and

10. 'A Brief Report on Excavations of Shang Remains at Wucheng, Qingjiang, Jiangxi', *Wenwu* 1975:7.

once cooled and the mould removed, the casting was complete. Some of the bronzes recently unearthed from the tomb of the Marquis of Zeng in Sui County, Hubei Province, have highly complicated decoration in which the openwork, entwined dragons and snakes could not have been cast by the piece-mould method.[11] Studies have shown that they were cast by the lost-wax method. These bronzes probably belong to the early Warring States Period, and are the earliest examples of lost-wax casting so far discovered in China. However, wide adoption of this method must have come much later. Examination of actual objects shows that it was not until the Sui and Tang Dynasties that all bronze casting was by the lost-wax method.

BRONZE TOOLS AND WEAPONS

The discovery of an early Shang Dynasty bronze foundry site outside Nanguan in Zhengzhou was an important event. A large number of pottery moulds for casting tools, found in great concentration there, indicates that tool-making was already not a rare and isolated phenomenon in the Erligang Period which ended about the 14th century BC.[12] There seems to have been a certain degree of division of labour at this bronze foundry, since abandoned moulds for making tools were placed together in one area, suggesting that, when moulds were removed after casting, they were divided by kind with each following its own casting process. Among these moulds, those for casting hoes were most concentrated in placement. This was a truly significant discovery.

In the past, most bronze specialists believed that bronze was so precious a metal that it was used mainly for casting ritual vessels. Moreover, it was said that slaves would have vented their anger on bronze tools and destroyed them. This

11. *The Tomb of Yi, the Marquis of Zeng in Sui County* (Beijing, Wenwu Press, 1980).
12. 'Excavations of Shang Remains at Zhengzhou', *Kaogu xuebao* 1957:1; and *Erligang at Zhengzhou, Kaoguxue Zhuankan* (Beijing, Science Press, 1959).

misconception obviously resulted from the discovery of large numbers of bronze ritual vessels in ancient tombs. In addition, it was believed that bronze was never used for casting farm tools. The bronze foundry site outside Nanguan yielded substantial evidence that bronze tools were cast in large numbers at foundries as early as the Erligang Period of the Shang Dynasty. Apart from the prominence of pottery moulds for casting hoes, actual bronze hoes and axes cast from such moulds have also been unearthed at the site.

Bronze tools from the same period have also been found in early Shang tombs at Panlongcheng in Huangpi County, Hubei Province. These are handicraft and farm tools, including several shovels, which are already quite mature in shape.[13] In Wucheng, Qingjiang County, Jiangxi Province, bronze tools were discovered side by side with stone moulds for casting them.[14] These bronze tools are similar in form to those found on the Central Plain. Such discoveries tell us that bronze tools were already in use in that vast area between the Yellow and Yangtze rivers in the early Shang. They also show that, as soon as bronze-casting techniques were mastered, they were at once used in productive work.

A bronze *lei* (covered jar) with animal mask decoration, belonging to the middle period of the Yin ruins of the Shang Dynasty, was discovered in 1954 in Ningxiang, Hunan Province.[15] Inside it were 224 blunt-edged small axes, all of the same size and unused. Such axes are also known as *jin*. As no other objects were found near it, we may surmise that the *lei* was cached for some reason. What deserves our attention is that, if these small axes were buried there as treasure, they must have functioned as coinage whose value was determined by their weight. In any case, the 224 small axes of the same size and shape give us some concrete evidence that tools were cast in large quantities in the Shang Dynasty.

13. 'Shang Dynasty Erligang Period Bronzes from Panlongcheng', *Wenwu* 1976:2.
14. See note 10.
15. 'Shang Dynasty Bronzes and Remains Found at Huangcai, Ningxiang, Hunan', *Kaogu* 1963:12.

Bronze farm tools of the Shang and Zhou Dynasties include the *si* (plough-share), *lei* (fork), *chan* (shovel), *cha* (spade) and *zhu* (hoe), *lian* (sickle) and *nou* (light hoe) for loosening soil, weeding, ditch-digging and harvesting. Among the bronze handicraft tools were the *fu* (axe), *jin* (small axe), *ben* (adze) and *zho* (chisel). Axes and adzes were used both for farming and handicrafts. In addition, there were many specialized handicraft tools of unusual form.

Far fewer bronze farm tools have been unearthed than bronze handicraft tools, as they served such different functions. Bronze handicraft tools were more directly associated with the slave-owners' way of life. A carriage, for example, usually carried a set of tools for making emergency repairs or for other purposes. Body slaves who were close to the slave-owners also carried tools with them. Those handicraft tools which were closely associated with the daily lives of the slave-owners would have been buried with them when they died, and so are more apt to be found in excavations. Bronze farm tools were less likely to be inhumed with slave-owners, because they had no direct links to their daily life, and so are rarely found in excavations.

Such, however, is not always the case. Not long ago, seven bronze shovels were discovered in Tomb No. 5 at the Yin ruins in which a Shang king's concubine was buried.[16] Even earlier, an early Western Zhou tomb at Poshankou in Yizheng County, Jiangsu Province, also yielded a set of bronze farm tools.[17]

One characteristic of bronze objects is that, once they were broken or worn out, they could be melted down again to make new objects and were not, therefore, carelessly abandoned. Some of the bronze spades discovered from Shang and Zhou times have been worn to almost half their original size. They would have found their way back to the furnace after a little further use. Without doubt, the majority of worn objects must have been returned to the furnace and so it is purely by chance that some farm tools have survived.

16. 'Excavation of Tomb No. 5 at the Yin Ruins of Anyang', *Kaogu xuebao* 1977:2.
17. 'A Record of Bronzes Unearthed at Poshankou, Yizheng', *Wenwu* 1960:4.

Even from the small number of bronze farm tools so far discovered, we can see that they are quite mature in shape, and clearly share features which place them in a continuous tradition from period to period. Bronze farm tools of the 'Slave Society' period have been unearthed in each of China's principal regions, and some also bear regional characteristics. For example, some of the bronze farm tools from the Yangtze River valley are clearly different in shape from those unearthed in the Yellow River valley. Generally speaking, each region had its own complete set of different types of farm tools. All this shows that bronze farm tools played an effective and progressive role in production during the Shang and Zhou Dynasties, as agriculture could not remain at the technical level of the Stone Age.

It is true that bronze was then a valuable metal, and high-quality bronze would certainly not have been used for casting tools. Guan Zhong, of the early Spring and Autumn Period, said: 'Fine metal is cast into swords and halberds to be tested on dogs and horses; bad metal is cast into hoes and axes for working the soil.'[18] In the past, people believed that 'bad metal' referred to iron, which is obviously not in accord with archaeological evidence. If such 'bad metal' for making farm tools had been iron, revolutionary and fundamental changes would have taken place in the agricultural production of the state of Qi. Moreover, once iron was used, it would soon have been utilized everywhere, but no such traces have been found in excavation of early Spring and Autumn Period sites. So far, all the iron tools that have been found belong to the late Spring and Autumn Period. Iron was not generally used in large quantities until the mid Warring States Period.[19] Therefore, 'bad metal' must have been bronze of inferior quality.

18. *Guo yu*, 'Qi yu', in which Guan Zhong also suggested to Duke Huan of the state of Qi the promulgation of the following criminal laws: 'Serious offenses should be redeemed by rhinoceros-skin armour and halberds, light offenses by leather shields and halberds, and petty offenses by metal. A bunch of arrowheads is required for settling a lawsuit. Fine metal is to be cast into swords and halberds, and bad metal is for casting farm tools. In this way, the state of Qi will have sufficient military equipment.'
19. Li Zhong, 'An Investigation of the Development of Iron Technology in China's Early Feudal Society', *Kaogu xuebao* 1975:2.

Bronze tools were used in Guan Zhong's time on a fairly large scale. This can be proved definitively by the fact that large spade-shaped coins were in circulation in the mid Spring and Autumn Period, and small spade-shaped coins were in circulation later in the period. These metal coins, which were cast in the shape of farm tools and circulated in large quantities, could not have been copied from the shapes of stone or bone implements, but only from bronze examples. As bronze farm tools inspired coinage, whose value was determined by weight, their long period of general usage requires no further proof.

Engels said: 'Copper and tin, and their alloy bronze, were by far the most important metals. Bronze provided serviceable tools and weapons, but bronze tools could not replace stone tools; only iron tools could do that, and the method of obtaining iron was not yet understood.'[20] When we say that bronze could not replace stone tools, we do not mean that bronze tools did not play an important role in agricultural production. A large number of bronze plough-shares, shovels and hoes have been discovered in recent years among the tools buried in the tombs of the Dian royal family in Jinning and Jiangchuan Counties, Yunnan Province.[21] Although bronze was a valuable metal in the region ruled by the Dian royal family, it is clear that this did not prevent its being cast into farm tools. The Dian bronze farm tools were by no means burial objects cast especially for that purpose, but functional tools of very good quality. Their discovery contributes significantly to our understanding of Shang and Zhou bronze farm tools. Of course, stone tools were not entirely replaced by bronze farm tools. However, the degree of development of bronze farm tools is reflected in the highly developed agriculture of Shang and Zhou times, in the large numbers of pottery moulds for casting bronze farm tools excavated at the foundry sites, in the bronze farm tools that are continually unearthed in various places, and in the existence

20. Frederick Engels, *The Origin of the Family, Private Property and the State* (Beijing, Foreign Languages Press, 1978), p. 194.
21. *Report on Excavations of the Ancient Necropolis at Shizhaishan, Jinning, Yunnan* (Beijing, Wenwu Press, 1959); and 'A Report on Excavations of Ancient Tombs at Lijiashan, Jiangchuan, Yunnan', *Kaogu xuebao* 1975:2.

of a large quantity of coins made in the shape of bronze farm tools. We must not, therefore, arbitrarily conclude that farm tools of Shang and Zhou times remained at the level of the Stone Age.

Bronze was used even more extensively for handicraft tools. As highly efficient tools of the time, they were indispensable in construction, in cart-making, in ivory, bone and wood carving and lacquer craft, in the textile industry, in leather tanning and in boat building. Tools are material indicators of the development of the forces of production. Without a large number of sharp-edged bronze handicraft tools, productivity and the quality of products could not have been improved as they were, and many new branches of handicrafts would not have come into existence. Such new handicraft products and the consummate skills required in their manufacture are integral parts of China's glorious ancient civilization.

Marx said: 'It is not the articles made, but how they are made, and by what instruments, that enable us to distinguish different economic epochs ... Among the instruments of labours, those of a mechanical nature ... offer many more decided characteristics of a given epoch of production than those which ... serve only to hold the materials for labour.'[22] Bronze farm and handicraft tools of the Shang and Zhou Dynasties serve as indicators of the state of the economy. In this sense, the age of slavery in China's Shang and Zhou times can also be called the Bronze Age.

Bronze was also used extensively for casting weapons, another important feature of the Bronze Age. To strengthen the state apparatus, the slave-owning aristocrats had to equip a large army which was indispensable for maintaining class rule. Slave-owning aristocrats kept their slaves in submission with this army, and launched racial wars of plunder, turning captives into slaves. Such military exploits were recorded in inscriptions on bronze vessels.

Both the Shang and Zhou Dynasties maintained huge armies. According to historical records, in the battle of Muye launched

22. Karl Marx, *Capital* (Moscow, Foreign Languages Publishing House, 1954), Vol. I, p. 180.

by King Wu of Zhou against the Shang, King Zhou of Shang resisted with an army of 700,000, which subsequently turned against him. This may not be an accurate figure, as some records say 170,000 men were mobilized, but in any case the battle of Muye was fought between two large armies in which most of the men had to be armed. King Zhou's army of defence was hastily organized when the enemy was already at the city wall. This shows that King Zhou must have had a large quantity of bronze weapons stored and in reserve, and that their production could only have been on a large scale.

Later, the Western Zhou court also maintained a large army to hold the conquered Shang clan in submission, and to break the resistance of other clans and tribes. For a long time, large armies were stationed at the Western Zhou capitals, Zongzhou (Feng and Hao) and Chengzhou (Luoyi), to protect the royal family. There is a type of *ge* (dagger-axe) from the Western Zhou Period with the characters for Chengzhou inscribed on it. This was a special weapon used by the Eight Divisions of Chengzhou. Muye was garrisoned by the Eight Divisions of Yin. In addition, various feudal states had their own armies of considerable size. For example, the Zhou king empowered the Marquis of Qi 'to punish the five marquises and nine counts',[23] which shows that military powers existed over such an extensive area that the Marquis of Qi had a powerfully equipped army. Bronze inscriptions also record such assignment of military powers to various feudal rulers by the Zhou kings. Armies had to be armed. The casting of bronze weapons had to be developed to a considerable degree to meet their needs.

The bronze weapons system of Shang and Zhou times was developed for chariot warfare, the principal form of warfare at that time. In chariot warfare each chariot was a basic fighting unit. There were soldiers on the chariot, and foot-soldiers assigned to it. The main weapons in chariot warfare were long-handled and short-handled dagger-axes for hooking, slashing and hitting, and spears for stabbing (spears were used together with shields for both attack and defence), as well as bows and arrows. Except for the bow, all weapons were made of bronze. Warriors

23. *Shi ji*, 'Qi tai gong si jia'.

of the time were also armed with a pointed, curved broad knife, which was a unique slashing weapon. The bronze *yue* (long-handled axe) was used for executions, but its smaller form was also used by soldiers in battle. The bronze *yue* of the Shang Dynasty is flat and squarish in shape, its broad edge being either straight or curved. The bronze *yue* of the Western Zhou Period is more varied in shape. As an executioner's tool, the bronze *yue* was used for a long time, even until the arrival of the Iron Age. The bronze sword first appeared in China in the Shang Dynasty. It was rather short at first, with a tongue-shaped, double-edged blade, and a handle at one end. Some examples have a skull cast on them, probably as a sign of courage in cutting off the enemy's head. Generally, the bronze sword was not widely used in the Shang Dynasty, and more appeared in the early Zhou, but it did not become extremely popular until the late Spring and Autumn and the Warring States Periods. We can see a clear line of development of the bronze sword from the Shang Dynasty to the Warring States Period. Past opinion that the bronze sword was imported from the West does not conform with the facts. Bronze arrowheads were also in frequent use during the Shang and Zhou Dynasties, and were expended in large numbers.

Each of the different bronze weapons had its own process of emergence, development and change, which gave Shang and Zhou bronze weapons their distinctive characteristics. Some basic forms of these bronze weapons spread far and wide in Asia, their influence reaching Siberia in the north and the Indo-Chinese Peninsula in the south.[24]

RITUAL BRONZES OF SHANG AND ZHOU SLAVE-OWNING ARISTOCRATS

In the 'Slave Society', the bronze-casting industry was controlled by the court and the aristocracy. The government appointed special officials to supervise the production of bronze articles. In addition to making tools and weapons, the foundries turned out large quantities of bronze ritual vessels. This is an important feature in the history of bronze casting in China.

Ritual vessels were used to realize the 'rule by rites'. The so-called 'rule by rites' was a euphemism used by the slave-owning aristocrats for their system of rule, and particularly for their ranking system. Ritual vessels were used at ceremonies, chiefly when sacrifices were offered and feasts held. The phrase 'rule by rites' was an abstract concept. It was a norm governing the internal relations of the ruling class expressed through many ceremonies and a system of etiquette. The same applied to the use of ritual vessels.

In the 'Slave Society' of China, the offering of sacrifices was an event of extreme importance. Sacrifices were offered for many purposes, and the offering of sacrifices of a religious nature was an important part of the rites. Religious practices in Shang and Zhou times were to a large extent acts of sorcery, but they also had strong political content.

All the slave-owning aristocrats believed in the mandate of Heaven. Just before he was defeated, King Zhou of the Shang was still imperturbably saying: 'Was I not born with the mandate of Heaven?'[25] After King Wu of the Zhou conquered

24. A culture known as the Karasuk existed in eastern Siberia, on the upper reaches of the Yenisei and Ob Rivers, between 1200 and 700 BC. According to A.L. Mongait, 'the population in the Minusinsk Basin increased greatly. This increase resulted evidently not only from natural population growth, but also from the migration of some tribes from the northern part of China. This can be proved both by anthropological data (during the Karasuk Period, there were traces of the Mongolian race among its inhabitants) and by archaeological data (the bronze objects discovered here are similar to those of northern China). Karasuk bronze objects clearly had their origins in the bronze weapons of China's Central Plain.' See A.L. Mongait, *Archaeology of the U.S.S.R.* (Moscow, 1955), p. 141.

Locally cast dagger-axes have been found in the ancient culture of Vietnam, corresponding to China's Western Zhou Period. The shape of this type of dagger-axe clearly bears characteristics of those from north China in the Shang and Zhou Dynasties, but the decoration is of local style. See Bernard Karlgren, 'The Date of the Early Dong-so'n Culture', *Bulletin of the Museum of Far Eastern Antiquities, Stockholm*, No. 14 (1942), Pl. 20.2 from Hanoi, and the Vietnamese journal *Archaeology*, No. 14 (1974), pp. 13, 21 and 22, for spears and arrowheads similar to those found in the middle reaches of the Yangtze River, and corresponding in date to China's late Warring States Period or perhaps still later.

25. *Shi ji*, 'Yin ben ji'.

the Shang, he declared that his father, King Wen, 'had received the mandate of Heaven' and that he himself 'was succeeding Wen in creating the state'.[26] This meant that he was also empowered by Heaven to rule. All the slave-owning aristocrats believed in the Ruler on High and the mandate of Heaven. Based on their own pattern of rule, they imagined a non-existent heavenly realm with many gods. As in the world of man, where there was a supreme ruler and his subordinate ministers and subjects, so there were in the heavenly realm a Ruler on High and subordinate gods, who dominated the world of man. The ruler declared himself to be the Son of Heaven, a lofty position which gave him the highest spiritual authority. In an era when politics and religion were combined into one, the more respect paid to spiritual authority, the more firmly the ruler's authority was consolidated. Spiritual authority was, therefore, deified political power, or a political power clothed in spiritual garb. The offering of sacrifices to gods and spirits was thus an important event in the social life of aristocrats.

Associated with the paying of homage to gods and spirits was the paying of homage to ancestors. The offering of sacrifices to ancestors was virtually an obsession with Shang nobles. Excavation of the royal tombs at the Yin Ruins in Anyang, Henan Province, revealed that the Shang kings did not scruple to kill large numbers of slaves as sacrifices to their ancestors. As many as 2,000 skeletons of men killed as sacrifices were found in the 1975 excavations at Anyang. The tomb of Fu Hao, a royal concubine of a Shang king, yielded almost 200 ritual vessels in complete sets.[27] A considerable number of the extant bronze vessels of the Shang and Zhou Dynasties are ritual vessels.

Many of the ordinary bronze ritual vessels were used for offering homage to parents and grandparents, as inscriptions on them often indicate. Bronze vessels of the Shang Dynasty have relatively simple inscriptions. For example, a bronze *you* (jar) has the three characters 'Gu Fu Ji' cast on it. Gu is the name

26. Inscription on the great Yu *ding* (Plate 40).
27. 'Another Important Achievement in the Archaeological Excavations at the Yin Ruins', *Kaogu* 1977:3.

of the clan to which the owner of the *you* belonged, while Fu Ji means Father Ji, Ji being his serial number in the ancestral temple. In the Shang Dynasty and the early Zhou, the ten Heavenly Stems (*jia, yi, bing, ding,* etc.,) were used as serial numbers in the ancestral temple. The three characters on the bronze *you*, therefore, mean that the sacrificial vessel was made for the deceased Father Ji of the Gu clan. Again, a bronze *yan* (steamer) bears the inscription: 'Ge zuo Mu Wu bao zun yi', which means 'A precious ritual vessel made by Ge for his deceased mother Wu'. *Zun yi* is the generic name for ritual vessels. The famous Si Mu Wu square *ding* (Plate 24) is an important vessel made by the Shang King Wen Ding for offering sacrifices to his mother Wu.

Bronze sacrificial vessels played an even stronger role in the Western Zhou Period. Within a very short period after the fall of the Shang, there suddenly appeared a large number of bronze vessels cast with long inscriptions from which we know that most were ritual vessels for the offering of sacrifices to ancestors. The Zhou had no such vessels before their overthrow of the Shang, and so we can see that the casting of long inscriptions was not the traditional practice of the Zhou people. The sudden appearance of a large number of such vessels was most likely due to political reasons. We know that the Zhou prospered only during the last decades of the Shang Dynasty. They themselves did not have a rich cultural heritage and in many aspects they learned from the Shang. A large number of oracle bones were discovered a few years ago at the site of a Zhou palace in Qishan, Zhouyuan County, Shaanxi Province.[28] A small number of these were carved with inscriptions whose contents place them in the period of the Zhou King Wen. The Zhou obviously learned to use oracle bones from the Shang. They not only learned the Shang way of doing things, but also strengthened themselves in new directions. King Wu established his dominance of the country after defeating the Shang.

28. 'A Brief Report on the Excavation of a Western Zhou Building Site at Fengchu Village, Qishan, Shaanxi Province' and 'Early Zhou Oracle Bone Script Discovered at Fengchu Village, Qishan, Shaanxi Province', *Wenwu* 1979:10.

Although he said he had 'received the mandate of Heaven', his victory was founded on a weak base as he had not fought many hard battles to win it. This was the reason why, in addition to learning the old methods of rule from the Shang, the Zhou also adopted new measures. Thus, it was said that 'the Zhou followed the rites of the Shang so that they could learn what would be harmful and what beneficial'.[29] Whether rites were harmful or beneficial, all such rites were for the purpose of strengthening Zhou rule.

The casting of long inscriptions on a large number of bronze vessels was a 'beneficial' rite for the Zhou because they could use these to publicize the virtues and the mandate of Heaven of their kings Wen and Wu, and to eulogize their military victories. Such are the most prominent contents of early Zhou bronze inscriptions, a phenomenon showing that the Zhou manipulated public opinion on a large scale. The significance of casting such inscriptions on bronzes was two-fold.

First, before their overthrow of the Shang, those who had rendered outstanding service to the Zhou were minor aristocrats and members of the Zhou royal clan. Immediately following King Wu's military victory, these people were enfeoffed and given higher titles of nobility to become powerful aristocrats in control of princely states and large areas of land which they had never previously administered. Inscriptions on bronze vessels record their appointments by the Zhou King, and their services to the royal house. These were the equivalent of credentials confirming their positions and posts, and functioned as talismans of their authority. In the past, Shang Dynasty slave-owning aristocrats of powerful families did not require such credentials as their positions had been created by history. But, for the new nobles of the Zhou Dynasty, such credentials were necessary.

Second, the inscriptions were linked to sacrifices to ancestors, which were products of the patriarchal clan system and its characteristics. The patriarchal clan system observed a very strict hereditary relationship. As the sons and grandsons of aristocrats who had rendered meritorious service at the founding

29. *Lun yu*, Book II, 'Wei zheng'.

of the dynastic rule, these descendants had to live in the reflected glory of their fathers and forefathers, and so they had to recount the achievements of their ancestors. They also had to report to their ancestors whatever glory they themselves had won so as to establish their own positions within their respective clans. The patriarchal clan system was a means by which the Zhou consolidated their inner ruling circles and strengthened their dynastic rule. Many of the bronze inscriptions emphasize 'recalling of the past'. As a result, bronze vessels of the Western Zhou commonly have long inscriptions.

The He *zun* (jar), cast in the 5th year of the reign of King Cheng of the Western Zhou, has an inscription of 122 characters (Plate 37). The inscription records King Cheng's proclamation, which relates the exploits of King Wu and his son King Cheng in vanquishing the Shang and the building of the Zhou capital, Chengzhou, as well as the meritorious service of He's father, Gong, in assisting the royal house, for which the king rewarded He with cowries. Therefore He had this bronze *zun* cast in memory of his father Gong.

The great Yu *ding* (tripod food container), cast in the 23rd year of King Kang of the Western Zhou, has an inscription of 291 characters (Plate 40). This begins with King Kang's narration of King Wen's virtues and his mandate of Heaven, and King Wu's succeeding to King Wen's cause, resulting in the destruction of the Shang. Glowing words are used to extol King Wu's achievements in the defeat of the Shang and the establishment of the Zhou rule. The inscription also mentions the reasons for the Yin rulers' defeat and the lessons to be learned from it. King Kang refers to Yu's entrustment with important duties, his appointment to high office and gifts of wine, official robes, horses and carriages, and over 1,700 slaves. Yu, therefore, had this *ding* cast in memory of his ancestor, the Lord Nan. The bounteous reward shows that Lord Nan must have been an important minister who had rendered invaluable service to the royal house.

The great Ke *ding* of the time of King Xiao of the Western Zhou is inscribed with 290 characters (Plate 51). In this long inscription, Ke extols his ancestor Shi Hua Fu's moral excellence and his service to King Gong of the Zhou Dynasty.

On account of Shi Hua Fu's service, Ke was given a high official position to become a court minister who transmitted the king's orders and reported to the king the conditions of his subjects. King Xiao gave him large tracts of land and many slaves. In praise of the king's virtues, Ke had the *ding* cast to be used in memorial ceremonies for his ancestor Shi Hua Fu. The content of this inscription shows clearly that the Zhou court placed trust and favour in its ministers, and bestowed political and economic benefits on them. This practice was directly linked to sacrifices to a person's ancestors. This is an important characteristic of ritual vessels of the Western Zhou.

The honouring of ancestors was not, however, the ultimate aim. We can see from the inscriptions that, after explaining the purpose of casting the ritual vessels in honour of their ancestors, the nobles immediately prayed to their ancestors for 'blessing', 'eternal happiness' and protection. By having these vessels cast and by participating in ceremonial activities, the nobles wished to preserve their privileges so that they might live for generations on the toil of others. This is the most important characteristic of bronze ritual vessels.

In addition, bronze ritual vessels were a necessary means to maintain the ruling order of the slave-owning class. In the 'Slave Society' of ancient China, and particularly during the Western Zhou Period, there was a particular format for the distribution of power, land and slaves, which is known as the system of enfeoffment. King Wu and King Cheng of the Zhou Dynasty divided part of their political power, land and slaves among their uncles and brothers, turning them into feudal lords. Within their own territories, such feudal lords enjoyed hereditary privileges, while paying tribute to the Zhou court at regular intervals. The feudal lords again divided part of their land and slaves among their officials. These officials owned smaller tracts of land known as estates. Such properties were also called *lijia*, or 'establishment of the family'. *Shi*, or scholars, were the lowest in rank within the ruling class. Some of them were free men who had attached themselves to slave-owning aristocrats. Apart from distributing power and wealth, the large-scale enfeoffment of nobles in the early Zhou Dynasty was mainly to meet

political needs. For example, the fiefs of Qi, Lu and Wei were founded in the areas where there had been the most damaging rebellions staged by the Shang nobility and their allies. The areas, controlled by the many feudal lords who were not members of the royal house, also acted as buffers for the king of Zhou. Without adopting the system of large-scale enfeoffment, the Zhou court could not have ruled efficiently over a country of such vast territories. Although the country under the system of enfeoffment was ruled at two levels, that of the central government and that of the fiefs, its hierarchy was actually even more complicated. Only when this hierarchal system was secure could rule be effectively maintained. Each slave-owner of a different rank had power and wealth corresponding to his position. This resulted in a relatively stable system of rule.

Bronze ritual vessels played a role in maintaining and manifesting this feudal ranking system. Slave-owners of different ranks use ritual vessels corresponding to their positions, and could not exceed specified limits in numbers; otherwise, they would be in violation of propriety. Difference in title and rank determined difference in the number and scale of ritual vessels. This characteristic was particularly pronounced in the Western Zhou Period. Ritual vessels were 'vessels embodying the rites'.

The *ding* (tripod food container) was a principal vessel among ritual objects. Although we still do not have a sufficiently systematic knowledge of the use of the *ding* in Shang times, it is clear that there was a difference in the number of *ding* used by slave-owners of different ranks. In the course of excavations at the Yin ruins, the well-preserved tomb of Fu Hao of the royal house yielded more than 30 *ding*.[30] Among them were two large square *ding*, one large round *ding*, two sets of round *ding* of the same size with six in each set, and six pairs of twelve square and round *ding* with flat legs. Several other examples were unearthed individually. Some Shang tombs in the same area had less than seven *ding* buried with the dead. There was

30. See note 16.

a great difference in the number of *ding* buried in the tombs of members of the royal house and of ordinary slave-owning nobles.

The use of bronze *ding* as insignia of rank in the Western Zhou Period originated from the system of 'lining up the *ding*'. The so-called lining up of the *ding* refers to the arrangement in a single row, according to size, of an odd number of *ding* containing meat and other foodstuffs: the higher the rank of the noble, the greater the number of *ding* and the greater the variety of food that he could enjoy. According to records, the king used nine *ding*, feudal lords seven, high officials five, and scholars of lower rank three.[31]

Ministers at the Zhou court used a similar number of ritual vessels. Ke, a ranking noble at the time of King Xiao in the Western Zhou Dynasty, had a set of seven *ding* arranged according to size. Ke was an important minister close to King Xiao, and had been granted large tracts of land. He was therefore able to use the same number of ritual vessels as a feudal lord. Archaeological excavations have also proved the existence of this system of 'lining up the *ding*'. A set of five *ding* arranged in a row was discovered in the tomb of Count Yu's concubine at Rujia Village near Baoji in Shaanxi Province. Excavation of the tombs of the state of Guo at Shangcunling near Sanmen Gorge in Henan Province has revealed that, according to the rank of the dead, seven, five or three *ding* were buried in a tomb.[32] The state of Guo was eliminated in the early Spring and Autumn Period. Its system of burying a row of *ding* with the dead to reflect differences in rank within the ruling class was still that of the Western Zhou.

To put it more simply, the number of ritual vessels reflected degrees of ostentation and extravagance. For the king, the nine *ding* contained mutton, pork, fish, dried meat, intestines and

31. *Chun qiu*, 'Gongyang zhuan, Huan gong, second year', note by He Xiu on the line: 'The great *ding* of Gao was taken from Song.'
32. 'A Brief Report on Excavations of Western Zhou Tombs at Rujiazhuang, Baoji, Shaanxi Province', *Wenwu* 1976:4; *The Cemetery of the State of Guo at Shangcunling, Archaeological Excavations at the Yellow River Reservoir, Report No. 3* (Beijing, Science Press, 1959).

tripe, skin, fresh fish and cured meat. The feudal lords had seven
ding, without the last two foods. For a high official, the first
ding contained mutton and the other four pork, fish, cured meat,
intestines and tripe. A scholar's three *ding* contained pork, fish
and cured meat. The system of 'lining up the *ding*' indicated
the different ranks within the ruling class.

The bronze *gui* (ring-footed, bowl-shaped vessel) is also a food
container. One difference between the *ding* and the *gui* is that
the *gui* was used in even numbers. According to records, the
king used eight *gui*, feudal lords six, high officials four, and
scholars two. Many existing *gui* vessels were also found in sets
of even numbers. Among the bronze vessels found in Western
Zhou storage pits at Zhangjiapo in Xi'an, Shaanxi Province, were
five sets of *gui* vessels.[33] Three of these were of even number,
each comprising four vessels. One set had only three, with one
gui missing. The fifth set had seven vessels belonging to Shi
Shi, a high official. These seven vessels were actually from two
sets, with one missing. Tombs of the late Western Zhou and
early Spring and Autumn Periods at Shangcunling near Sanmen
Gorge in Henan Province had six, four or two *gui* vessels buried
in them. This confirms what is recorded in historical
documents.

Details of the use of bronze vessels to indicate the high and
the low, the superior and the inferior, were, however, not rigid
but relative to circumstances. When the slavery system came
into conflict with the development of production forces, the
power of the royal house declined, the internal contradictions
of the slave-owning class erupted and political order was thrown
into chaos. This disorder was sensitively reflected in the use
of bronze ritual vessels. A set of bronze *ding* cast between the
Western Zhou and the Spring and Autumn Period, inscribed
with the name of the Marquis of Zeng, was unearthed in
Jingshan, Hubei Province, in July 1966.[34] There are nine *ding*,
graded in size, in this set. Nine was the number of *ding* supposed
to be used by the king. According to historical records, people

33. *Report of Excavations in West Feng* (Beijing, Wenwu Press, 1962).
34. 'Bronzes from the State of Zheng Discovered at Jingshan, Hubei',
Wenwu 1972:2.

of the states of Shen and Zeng colluded with the Quanrong tribe to kill King You of the Zhou Dynasty at the foot of Mount Li. The Marquis of Zeng was the ruler of the state mentioned in those historical records. As he was such a powerful feudal lord, he did not have to keep it a secret that he had usurped the king's prerogative to use nine *ding* vessels. Discovery of these nine *ding* provides us with a vivid example of the confusion in the order of rule among nobles at that time. There was the same kind of confusion in the use of *gui*. It is not surprising that feudal lords usurped the king's right to certain numbers of ritual vessels in the Spring and Autumn Period. A set of eight *gui* was unearthed from the tomb of the Marquis of Cai in Shou County, Anhui Province. The inscription on the huge *gui* of Sun Pei, the Marquis of Ju, records that eight *gui* vessels were made for the offering of sacrifices.[35] Some feudal lords even completely disregarded the conventions and had ten *gui* in a set, surpassing the number used by the king.

Bronze musical instruments, which were closely associated with the ritual vessels, also reflect the ranking system of the nobles. The Shang had only the *nao* (a hand-held bell to be struck with a wooden mallet), but not the *zhong* (hanging bell); and the *nao* were of small size and usually in a set of three. But, in the tomb of Fu Hao at the Yin ruins, a set of five *nao* was uncovered. In the minds of the nobles, the relationship between ritual and music was so close that 'rites could not be performed without music'. By this was meant that the physical manifestation of ritual must be given a gentle and elegant touch to embellish the rule of the nobles. Musical instruments were therefore developed to meet such needs. Bronze *zhong* first appeared around the transition from the early to the mid Western Zhou Dynasty. The *zhong* unearthed from a tomb of the mid Western Zhou at Pudu Village, Xi'an, Shaanxi Province, had only three to the set.[36] By the time of the Ke and Liang Qi *zhong* of the mid and late Western Zhou, the numbers and

35. *Relics Unearthed from the Tomb of the Marquis of Cai at Shou County* (Beijing, Science Press, 1954).
36. 'Excavation of the Western Zhou Tombs at Pudu Village, Chang'an', *Kaogu xuebao* 1957:1.

sizes of the bells had begun to vary greatly, estimated to range between 11 and 13 in a set.[37] In the original system for use of *zhong*, the king had four sets, a feudal lord three, a high official two, and a scholar one. There was, therefore, a great difference in numbers of such bells between the ranks. By the Spring and Autumn Period, as much confusion had appeared in the use of bronze bells as in the use of bronze ritual vessels. A bronze *zhong* belonging to Lu Qi, a high official of the state of Jin in the late Spring and Autumn Period, was unearthed in Wanrong, Shanxi Province.[38] The inscription on the *zhong* says that he made 128 large *zhong* and 64 chiming stones. The 128 bells must have been in four sets to match the 64 chiming stones. This is another example of a high official's usurping the king's prerogative. By using the expression 'usurping the king's prerogative', we would appear to accept the legitimacy of the Zhou king's rule. In fact, changes in the ruling order were inevitable phenomena at the time when the 'Slave Society' was declining and in transition to the 'Feudal Society'.

The core of the rites was to maintain the rule of the slave-owners and to uphold their system of authority. The bronze ritual vessels embodied their ranking system and ruling order. In this sense, the most important bronze ritual vessels became symbols of power for the slave-owning class.

Immediately after the founding of the Western Zhou Dynasty, when King Cheng had suppressed the rebellions staged by the remaining forces of the Shang slave-owners and their allies in the east to achieve political stability, he is said to have removed to Luoyi nine *ding* vessels of the Shang, these being symbols of legitimacy and transmitted reportedly from the time of the legendary King Yu. This event is known in history as 'installing the *ding* at Jiaru' (Jiaru was the royal city in the Zhou capital Luoyi). These nine *ding* became, then, state heirlooms of the

37. Guo Moro, *Liang Zhou jin wen ci daxi tulu kaoshi* (Beijing Science Press, 1957), pl. 213; 'Two Western Zhou Bronzes Recovered from a Scrap Heap', *Wenwu* 1959:5; *Bronzes in the Collection of the Shanghai Museum* (Shanghai People's Fine Arts Press, 1964), pl. 60.
38. Guo Moro, *Liang Zhou jin wen ci daxi tulu kaoshi*, pl. 269; *Bronzes in the Collection of the Shanghai Museum*, pl. 80.

Zhou royal house and symbols of its supreme power. There is a well-known historical tale of 'asking questions about the ding'.[39] In 604 BC, during his expedition against the Rong tribe of Luhun, Prince Zhuang of the state of Chu deliberately deployed his forces in the vicinity of Luoyi and held parades of inspection to show off his strength. King Ding of the Zhou Dynasty sent his grandson Man to convey his greetings. The Chu prince took this opportunity to ask the king's grandson about the sizes and weights of the nine ding. This insulting act angered Man. He told the Chu prince bluntly that, although the Zhou royal house had declined, Heaven had not changed its mandate. It was most improper to ask questions about the sizes and weights of the ding. It can be seen from this story that the nine ding were precious vessels symbolizing the power of a dynastic regime.

Such precious vessels were bronze vessels to be kept permanently in the ancestral temple and they were particularly valued. All the great slave-owning nobles had their own ancestral temples and precious vessels. The failure of the ruler of a feudal state to protect his precious vessels signalled the end of his political power. 'To have one's ancestral temple destroyed and precious vessels removed' was synonymous with 'having one's country subjugated and family destroyed'.[40] If one were not able to preserve oneself, paying homage to one's ancestors would certainly be out of the question. When we say that the precious bronze vessels were symbols of the power of slave-owning nobles, we are, of course, speaking in the narrow sense. As only one of the characteristics of bronze vessels, this function of the precious vessels should not be exaggerated.

The slave-owning nobles of both the Shang and the Western Zhou attached great importance to paying homage to their ancestors. The Zhou expressed greater fervour in this on their bronze vessels. They were inexhaustible in expressing the so-called virtues of their ancestors in inscriptions on the bronzes. Their purpose in making the bronzes was also to praise their ancestors. This practice of the Zhou nobles was linked

39. *Zuo zhuan*, 'Xuangong, third year'.
40. *Meng zi*, 'Liang Hui wang, Part 2'.

to protection of their families' positions. Their ancestors had founded the state and elevated their families, one generation succeeding another to enjoy special privileges as slave-owning clans.[41] The existence of such families itself ensured the exalted positions of their members. Their purpose in paying homage to ancestors and extolling their virtues was to preserve the glory of their families so that they could enjoy their privileges generation after generation. Of the 167 bronze inscriptions included in Guo Moro's book, *A Study and Explanation of Zhou Dynasty Bronze Inscriptions with Illustrations and Reproductions*, 85 (or more than half) belong to bronzes made for paying homage to ancestors.[42] From this we can see one of the main purposes of the Western Zhou slave-owning nobles in casting bronze ritual vessels.

Moreover, another important characteristic of ritual vessels of the slave-owning class is shown in the inscriptions. The casting of bronzes with inscriptions was essentially an embodiment of the rites. We know that most Shang bronzes have only very simple inscriptions (Figure 2). A few longer inscriptions appeared in the late Shang, but none exceeds 100 characters. Lengthy inscriptions appeared in the early Western Zhou (Figure 3), recording ceremonies at which nobles received instructions and appointments from the Zhou king.

During the Western Zhou, many ministers and officials had hereditary positions, relying on their ancestors' reflected glory to obtain privileges. Inscriptions on Western Zhou bronzes often record that the king of Zhou ordered a slave-owning noble to inherit the official position of his grandfather or father, and granted him a reward corresponding to his official position. The slave-owning nobles recorded the Zhou king's bestowal of favours in inscriptions on bronze vessels (Figures 3 and 4) as credentials for enjoying special privileges and as an honour to their families. These hereditary official positions were not automatically transmitted. Inheritors had to be reappointed by the king although this was only a matter of form, a routine

41. *Shi tong*, 'Si jia'.
42. Guo Moro, *Liang Zhou jin wen ci daxi tulu kaoshi* (Beijing, Science Press, 1957).

Figure 2 Inscription of two characters on the He Da square *ding*, late period of the Yin ruins, Shang dynasty (Plate 25)

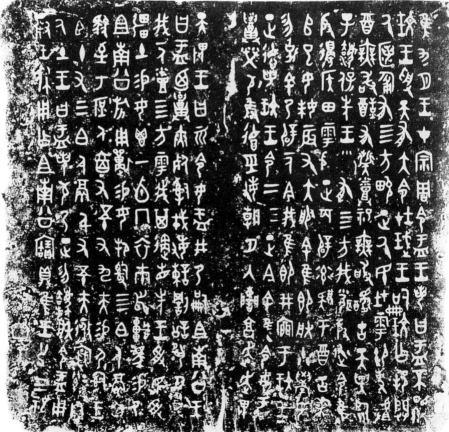

Figure 3 Inscription of 291 characters on the great Yu *ding*, reign of King Kang of the Western Zhou Dynasty (Plate 40)

Figure 4 Inscription of 70 characters on the Grand Master Ju *gui*,
period of King Yi of the Western Zhou Dynasty (Plate 49)

procedure to be followed. Many of the inscriptions included in this book record such events.

The inscriptions reflect many aspects of the rites, including enfeoffment of a feudal lord, audience at court, participation in the various activities of the court such as sacrificial ceremonies, banquets and hunting, as well as military expeditions, citations for meritorious service in a victorious war, honours won by a hereditary official, sacrifices offered by a clan, marriages, exchanges of property, lawsuits, and so on. These bronze vessels, with which slave-owning nobles paraded their glories, and which they intended to pass on to thousands of generations of their posterity, shed light on every aspect of social life at the time.

Besides those particularly precious bronze vessels placed in ancestral temples, other bronze sacrificial vessels were also used in everyday life. For example, the inscription on the Count of Guai *gui* says that the vessel was made for offering sacrifices at the ancestral temple, and for feasting friends and relatives by marriage.[43] This vessel was made for several purposes. The inscription on the Ke *xu* (covered rectangular container) also says that the vessel was cast for entertaining the noble clans of Shi and Yin, as well as relatives by marriage, and for offering sacrifices to ancestors.[44] We can see that, even in the use of bronzes in everyday life, certain political implications were clearly present. For example, there were many bronze dowry articles among the objects unearthed from the feudal states of the Spring and Autumn Period. When feudal lords and high officials of the time wanted to safeguard each other's political position and interests, or when a small state sought the protection of a large one, marriage was often used as a link to strengthen connections or to form political factions and alliances.

The above are a few concrete examples to demonstrate some

43. Wu Dacheng, *Kezhai jigu lu*, 11:12; Guo Moro, *Liang Zhou jin wen ci daxi tulu kaoshi*, pl. 137; *Bronzes in the Collection of the Shanghai Museum*, pl. 54.
44. Wu Dacheng, *Kezhai jigu lu*, 15:18; Guo Moro, *Liang Zhou jin wen ci daxi tulu kaoshi*, pl. 112.

of the uses of bronze vessels. So extensive were these uses that Shang and Zhou slave-owners spared no effort in exploiting the slaves who cast bronze vessels.

THE FORMS AND DECORATION OF SHANG AND ZHOU BRONZES

Bronze objects of the Shang and Zhou Dynasties were created in distinctive styles. Food vessels such as *ding, li, yan, gui, fu* and *xu;* wine vessels such as *jue, gu, jia, zun, hu, you* and *lei;* water vessels such as *pan, yi* and *jian;* and musical instruments such as *zhong, nao* and *zheng* — all are modelled in forms peculiar to China, clearly displaying indigenous styles. They can be clearly distinguished from bronzes of other nations of the ancient world. A glance at the organic relationships of the typical forms of Shang and Zhou bronzes at each stage of their development reveals a consistent heritage, yet each period has its own characteristics. The most pronounced of these characteristics is that the Shang Dynasty had a very rich variety of wine vessels while the Western Zhou Dynasty paid more attention to the development of food utensils.

The habit of wine drinking among ancient slave-owning nobles can be traced to very early times. A great many pottery wine vessels have been unearthed from the site of the Erlitou Culture in Yanshi, Henan Province.[45] Bronze wine vessels began to appear during the same period. Complete sets of wine vessels, forming an important component of ritual vessels, had already come into existence by the 14th century BC. Bronze wine vessels of the late Shang Dynasty were unrivalled anywhere in the ancient world in both variety and quantity.

Tomb excavations have revealed that the simplest Shang wine vessels were the *jue*, the *gu* and the *jia*, which formed a set. The *jue* is a tripod goblet with an open spout. The *gu* is a vase-shaped wine container, and the *jia* a tripod wine server. From these basic vessels were developed the *he*, the *zun*, the *you*, the *hu* and the *lei*, which are large and medium-sized drinking

45. See note 5.

vessels or wine containers. There are also more luxurious wine containers such as the square *yi*, the horn-shaped *gong* and the animal-shaped *zun*. The existence of so many and varied bronze wine vessels shows that large quantities of grain were used for making the wine to fill the vessels. This, in turn, shows that the Shang had a well developed agriculture. Slave-owning nobles were able to extort from their slaves more and more grain for making different types of fermented alcoholic drinks in large quantities. Furthermore, the many different types of wine containers also confirm what has been recorded in historical documents and bronze inscriptions: that the Shang slave-owning nobles, both high and low, were indeed deeply immersed in wine.

The Zhou people did not adopt this habit of the Shang. Beginning from the early Zhou, the number of wine vessels greatly decreased in number. Even before they gained political power, the Zhou were not in the habit of drinking heavily. When King Wu launched his campaign against the Shang, he listed the crimes of King Zhou, of which indulging in drink was one. Taking a lesson from the fall of the Shang, the Zhou Dynasty strictly forbade unbridled drinking. After winning victory, King Wu dealt with indulgence in wine as a political issue. In the 'Decree Against Wine' included in the *Book of Documents*,[46] we can see that, before he sent Kang Shu to keep watch on the subjugated Shang people, he issued an order to the effect that if the Zhou people indulged in drinking at a gathering, they would be punished by death. This was the political background for the great decrease in bronze wine vessels in the early Zhou, and the eventual complete disappearance of many such vessels.

With this decrease in bronze wine vessels was a proportionate increase in the number of food vessels. The *ding*, the *li*, the *yan*, the *gui*, the *xu* and the *fu* were the main food vessels of the Western Zhou. Zhou people ate from various *ding*; that is, meat or other food was cooked in a *huo* before being placed in individual *ding*. The *huo*, also known as the *huo ding*, was a cauldron used for cooking. The various *ding* were large food containers used by nobles of different ranks. If *ding* with

46. *Shu jing*, 'Zhou shu, Jiu gao'.

beautiful decoration had been used for cooking, the heat of the fire would undoubtedly have separated the tin in the bronze and destroyed the handsome appearance of the vessel. In the Western Zhou, particularly during its middle and late periods, the bronze *li* (hollow tripod container) was more extensively used than during any previous period. The *li* generally has a smaller capacity than the *ding* and, according to inscriptions on *li*, most of the *li* were used in everyday life. The *gui* (ring-footed bowl-shaped container) was used for holding cooked rice or other grains. Like the *ding*, it was one of the principal types of bronze vessel in the Western Zhou. Later, there appeared the *xu* and *fu* which, according to inscriptions on them, were also for containing cooked rice. The bronze *dou* and *pu*, which were containers for meat sauces, also became popular.

The Zhou people made fewer wine vessels, but did not ban alcoholic drinks altogether. Wine was to be consumed in moderate amounts. The principal wine vessels of the middle and late Western Zhou were the *hu* and the *he*. A set of bronze ritual vessels was usually equipped with a pair of square or round *hu*. The *he* was a vessel for mixing the wine, mainly with water, to dilute it. Very few bronze drinking vessels of the late Western Zhou have been found. The shape of the *jue* had changed to a small cup with a handle and a foot-ring. The *gu* had become shorter and resembled a cup with one or two handles. Such bronze drinking vessels have only rarely been discovered, probably because by then most were made of wood or pottery. In short, there is a very clear contrast between the bronze wine vessels of the Zhou and those of the Shang. Throughout the Zhou Dynasty, bronze wine vessels were never cast on the same scale as in the Shang Dynasty.

In accord with the forms of the bronze vessels, the decoration on Shang and Zhou bronzes is rich in indigenous motifs and styles. The unique content and style of the decoration, as well as the highly unusual ways in which motifs were applied, fully demonstrate that the art of Shang and Zhou bronzes emerged and developed on Chinese soil.

Most of the decorations on Shang and Zhou bronzes are animal designs; only a few are geometric designs. Among the different animal designs, the most characteristic are animal

masks which were popular in the Shang and early Western
Zhou. These are frontal views of exaggerated or imaginary
animal heads with large staring eyes, large gaping mouths, fangs
or serrated teeth, a pair of erect ears or large horns on the head,
and a pair of sharp claws. Some of these images only show the
animal head. Others have the animal head flanked symmetrically
by snake-like bodies, or by different types of dragons or
phoenixes, but with the head remaining the principal part of
the design.

This kind of ornament on bronze vessels was, in the past,
called the *taotie* motif. According to an ancient legend, Tao Tie
was an unworthy son of the god Jin Yun. A gluttonous man-
eater, he stuffed so many human beings into his mouth that
he could not swallow them. As a result he became a monster
with only a head and no body, thereby harming himself.
According to Confucian scholars of old, the purpose in putting
the *taotie* design on Zhou Dynasty *ding* was to warn people that
eating too much would be harmful. This interpretation by
Confucian scholars was obviously a didactic interpretation of
retribution through cause and effect. However, as a result of this
interpretation, some Song Dynasty scholars began to call the
animal head designs on bronzes the *taotie* design, a term still
used today. But, it is rather difficult to place all the animal
masks under the category of the *taotie* design, because some
of them have not only a head, but also a body. Of course, there
are images similar to the *taotie* design on bronze vessels. For
example, a Shang square *ding* (four-legged food container) of
He Da, unearthed in Ningxiang, Hunan Province, has four
enormous human face designs on its four sides (Plate 25).[47]
The faces have a serious expression and there are two
degenerated claws on each side of each face. Are these *taotie*
designs? This is very difficult to determine. People are now
accustomed to calling *taotie* designs animal mask designs,
because most of the so-called *taotie* designs are frontal views
of the heads of animals such as the ox, sheep, tiger or bear, or
of imaginary beasts such as dragons and *kui* dragons. Except

47. 'The Square *Ding* with Human Faces of the Shang Dynasty', *Wenwu*
1960:10.

for some special examples, most of the animal masks are similar, although there are great differences in the horns on their heads. Some of the horns are even very strange, such as those of an elephant which are crooked, or those of a dragon which are spiral, or those which are themselves the images of tiny dragons or snakes.

The dragon and the phoenix, and their variations, are also common motifs, with the former being more numerous. Dragons were the subject-matter of many intricate, ancient mythologies. The legendary dragon is, in fact, the deified snake, or a combination of the snake and features of other animals. The oldest legend about a dragon is closely connected with water and the Xia King Yu's harnessing of flood waters. Qu Yuan wrote in his poem 'The Riddles':

> What chart did the dragon draw
> To lead rivers to the sea?

Later, in an exegesis to these lines, Wang Yi wrote: 'When Yu worked on flood control, a holy dragon drew lines on the ground to guide the water to flow where it should flow. As a result, the flood water was placed under control.'[48] There are other legends connecting the Xia King Yu with dragons, and Yu is described as a flood-control hero who was half-human and half-god. The dragon in these legends was an image created by the ancients who wished to control flood waters. The control of water constituted a great problem in ancient agriculture. People were then at the mercy of the forces of nature. They had to resort to an imaginary heavenly creature, the dragon, to help them control flood waters. Later, the dragon was worshipped as the god of water and regarded as a symbol of water. When dealing with the art of painting pictures on clothes, the *Artificers' Record* says: 'Convey the idea of water with the dragon.'[49] Legends about dragons had very profound influence not only in the Xia and Shang Dynasties, but also in later times, continuing for a long time without loss of popularity. Owing to the needs of rulers throughout the dynasties, and to the

48. *Chu ci*, 'Tian wen'.
49. *Kao gong ji*, 'Hua gui zhi shi'.

embellishments added by Confucians and Daoists, legends
about dragons became more and more absurd until they lost
all the social significance that had given birth to them, and
became purely devices for hoodwinking the people.

The phoenix, too, is a legendary creature. On bronze vessels
it is depicted as a bird of prey with beautiful feathers. The Shang
tribe regarded the *xuan* bird as their forefather. It is said that
'Heaven sent the *xuan* bird to earth and brought into being the
Shang'.[50] The *xuan* bird is none other than the phoenix, the
totem of the Shang tribe. The phoenix was reportedly also the
totem of the ancient state of Yanzi in present-day Shandong
Province, where official posts were named after birds. In more
recent times, people believed that the phoenix was the god of
wind. It goes without saying that wind has important bearing
on crops, so that worship of the phoenix and its variations was
equivalent to worship of that natural force. The dragon and the
phoenix, the symbols of water and wind, were images of these
forces of nature in bronze decoration.

On bronze vessels there is also the image of fire in a whorl
design on a raised circular surface. The pattern of the motif is
similar to that for the character 𤇾 (*zhong*) in bronze inscrip-
tions. Both obviously stand for the same thing. The character
means flame, and in bronze inscriptions its ideogram has the
shape of a glowing fire. Again the *Artificers' Record* says of
painting pictures on clothes: 'Convey the idea of fire with rings'.
This means that fire should be formed by a circular drawing,
and the character is in the shape of a ring, so that it is
undoubtedly the drawing for fire. In ancient Chinese legends,
the god of fire is Zhu Rong. The character *zhong* is the combined
sound of *zhu* and *rong*. Therefore, the whorl designs on bronze
vessels reflect the homage paid to the great natural force of fire
in the Shang and Zhou Dynasties.

The three images mentioned above by no means account for
all the elements in the contents of bronze decorations. There
are many strange creatures. For example, there are birds with
horns on their heads, birds with animal bodies, animals with
bird bodies, and creatures with human faces and dragon, snake

50. *Shi jing*, 'Shang song, Xuan niao'.

or bird bodies. The meanings of these figures are very difficult to determine. But, according to what has been recorded in historical documents, most of them stand for the gods of heaven and earth, mountains and rivers, in ancient mythology. Many of them are described in the book, *Classic of Mountains and Rivers*.[51] As Karl Marx said: 'All mythology subdues and dominates and fashions the forces of nature in the imagination and through the imagination; it disappears, therefore, with real mastery over them'.[52] This incisive scientific inference may serve as an important guide to our understanding and analysis of the social significance of decoration on Shang and Zhou bronze artefacts. Images in the decoration were initially not an extraordinary aesthetic concept, but were conceived out of reverence for the forces of nature and a naïve wish to control them.

All mythology of the remote past is set against a background of the struggle for production, reflecting man's understanding of the forces of nature and his struggles against them. When society became divided into classes, legends were inevitably stamped with the brand of a class. The slave-owning nobles of the Shang and Zhou Dynasties offered sacrifices to heaven and earth, and curried favour with numerous gods. Like the king who was above everybody else in the human world, the heavenly emperor was the supreme authority over the numerous gods. The nobles created a heavenly kingdom on the pattern of their own rule. The forces of nature became strange creatures in the minds of the people, and were regarded by the slave-owning nobles as protectors of their rule and their class interests. To benefit themselves, or at least to avoid disasters, the nobles continually offered sacrifices to the gods on a large scale. By doing so they wished to cajole the gods, please them and receive protection from them. Politics, religion and the arts were combined into one in Shang and Zhou times. The images of strange creatures on bronze vessels also helped to rule through spiritual authority, and to spread the belief in fate.

51. *Shan hai jing.*
52. Karl Marx, *Preface and Introduction to 'A Contribution to the Critique of Political Economy'* (Beijing, Foreign Languages Press, 1976), p.44.

The social significance of some of the decoration on the
bronzes is described in ancient Chinese documents through
mythological tales. It is said that King Yu of the Xia Dynasty
had cast nine *ding* vessels decorated with the images of all kinds
of good and evil spirits. It was believed that anyone who beheld
these images would be safeguarded against misfortune, or devils
and demons, even when crossing great rivers or going deep into
the mountains. This means that the slave-owners believed that
the decoration on bronze vessels could protect them against
injury and evil. Although the story of the casting of the nine
ding did not necessarily originate in the Xia Dynasty, the
interpretation that the decoration on bronze ritual artefacts
played an apotropaic role certainly has its significance. Shang
and Zhou bronze vessels with such strange zoomorphic
decoration and style must have performed a similar function.
The principal motif of a large dragon-and-tiger *zun* (wine
container) unearthed in Funan, Anhui Province, is a fierce tiger
with a large open mouth devouring a creature that is half-human
and half-monster (Plate 29). The same motif is vividly presented
in two other extant vessels, bronze *you* (wine containers), both
of which are in the shape of a squatting tiger with a half-human
monster in its widely gaping mouth.[53] Some chariot fixtures
of the Western Zhou and the Spring and Autumn Period, and
a bronze *hu* with bird and beast decorations unearthed in
Hunyuan, Shanxi Province, also have the same motif.[54] This
image is obviously not that of an ordinary man-eating tiger, but
the representation of an ancient legend which was popular for
more than 1,000 years during the Shang and Zhou Dynasties.
The story, recorded in the *Classic of Mountains and Rivers*, is
about a god on the Dushuo Mountain who fed 'evil spirits'
to tigers.[55] This widely known apotropaic tale also has con-
nections with the bronze decoration of Shang and Zhou times.
The slave-masters of the Shang Dynasty were most super-
stitious, continually trying to predict what injurious thing they

53. Specimens in the Sumitomo collection, Kyoto, Japan, and the Musée
Cernuschi, Paris, France.
54. See Plate 60.
55. *Shan hai jing.*

would encounter. The ferocious and strange beasts on bronze vessels were considered to have mysterious apotropaic powers. This may sound ridiculously childish and absurd today, but it provided the slave-masters of that time with a sense of security. There are more such strange decorations on Shang bronzes than on those of the Western Zhou. This is totally in accord with the Shang slave-owning nobles' zealous belief in gods and spirits, and their constant practice of divination.

The animal masks on bronze artefacts of the Shang and early Zhou are all executed in exaggerated and mysterious styles. Even domesticated animals, such as oxen and sheep, are given ferocious visages. They all have large staring eyes and angry, gaping mouths. In their motionless postures they seem to be so charged with tension that they may burst into a savage roar at any moment. Amidst the fire and smoke of a sacrificial ceremony, such images on the bronzes would have helped to create a solemn, hushed and mysterious atmosphere.

BRONZE OBJECTS OF THE EARLY 'FEUDAL SOCIETY'

The slave-owning system disintegrated in the late Spring and Autumn Period. New patterns of production formed by the land-lord class and the peasants replaced the old patterns of produc-tion. The nine-square system whereby one large square of land was divided into nine small squares, the eight outer ones being allocated to slaves who had to cultivate the central one for the slave-owner, was first abolished in the north-eastern state of Lu in 594 BC. A taxation system applicable to all cultivated land was introduced, recognizing the legal ownership of land by landlords. This change soon took place in all the other states. The old system of the slave-owning nobles declined steadily until it ceased to exist. The changes brought about by the newly emerged landlord class were suited to the development of production of that time.

Things could not continue in the same old way. Changes also took place in the bronze ritual vessels. By the late Spring and Autumn Period, bronzes had gradually lost their characteristics

as ritual vessels for the slave-owning class, and become utensils for everyday use by the newly arisen landlord class.

The late Spring and Autumn Period had, for the most part, the same types of bronzes as before, but there were great changes in their forms, many of the old ones being discontinued and many new ones being produced. This can be seen clearly in the quantity of long preserved as well as newly unearthed bronze artefacts of the transition period between the Spring and Autumn and the Warring States Periods. For example, the square *hu* (wine container) already existed in the late Western Zhou and early Spring and Autumn Period. But, by comparing the Count Ji *hu*[56] of the early Spring and Autumn Period with the square *hu* with lotus and crane (Plate 59) of the late Spring and Autumn Period unearthed at Xinzheng, Henan Province, we can see that there is a great difference between the two. The former is modelled in a simple and solid style, while the latter is exquisitely worked with intricate craftsmanship. There was an even greater change in the vessel type *ding* (tripod food container). Most of the *ding* of the Shang or Western Zhou have upright handles on the rim and no lid, and their form is rather simple. The *ding* with a lid and handles on the sides became the popular form in the late Spring and Autumn Period. The forms of these *ding* also varied according to different regions, each area having its own special features. Innovations in the forms of bronze vessels had by then become a social trend. People preferred vessels in new forms to those of old forms which had been handed down for hundreds of years under the slave-owning system. At the same time, as trade developed, bronze objects appeared on the market as commodities. This also helped to promote the diversification of their forms and styles. The situation was the same with other handicraft products such as gold and silverware, jade objects and lacquerware. Old habits did not, however, disappear overnight. Objects in both old and new styles sometimes existed side by side. Some bronze articles excavated from tombs of the early Spring and Autumn Period still followed the Western Zhou style.

The situation was quite different by the late Spring and Autumn Period. A set of nine *ding* and another set of seven *ding*

56. Guo Moro, *Liang Zhou jin wen ci daxi tulu kaoshi*, pl. 182.

were unearthed in Shou County, Anhui Province, from the tomb of the Marquis of Cai who lived in the late Spring and Autumn Period.[57] The same tomb also yielded eight *li*, eight *gui*, four *fu*, two *hu*, and three *zun*. The two sets of *ding* are both in entirely new styles (Plate 58). The four *fu* have broad rims, which is an even newer stylistic element. The *zun fou* and *guan fou* discovered in the same tomb are also in a completely new style. Only the *zun* vessels are close to the old form, but even they are decorated with new designs of the time. In addition to the bronze ritual vessels and jade articles buried in this tomb, a slave was inhumed as a sacrifice. This burial basically followed the old system of burying the living with the dead practised by the nobles, but it shows a certain change as well.

Not only were there changes in the forms of the old types of bronzes, but many new types also appeared in growing numbers. Bronze vessels, such as the *dui*, the *fou*, the flat *hu*, the *jian*, the *bei* and the *zhi*, were all novel products popular at that time. Owing to the great variety in their design, we have yet to determine the exact names of some. If we say that the development of bronze articles in the late Spring and Autumn Period was shown mainly in changes in the forms of the vessels, the development in the Warring States Period was manifested in the creation of a greater number of new types. This course of development can be clearly discerned in the bronze objects unearthed from tombs of the transitional period between the Spring and Autumn and Warring States Periods.

Another prominent feature of bronze articles in the early 'Feudal Society' was an increase in the number of useful items for everyday life, including bronze mirrors, belt-hooks, lamps, a large number of seals and a still larger number of coins, and so on. Some of these were already not for the exclusive use of the court and nobles, but appeared in the lives of commoners in society.

In the period of the 'Slave Society', people had to use still water to see their reflections but this was very inconvenient because they had to look downwards. Although bronze mirrors existed at that time, they were not in general use. By the time of the

57. See note 35.

Warring States, particularly after its middle period, the casting of finely crafted bronze mirrors for common use had increased. This marked the beginning of the development of bronze mirrors which was to continue for about 2,000 years. As for bronze belt-hooks used on garments, some were luxuriously inlaid with gold and silver, while others were made in simple, practical styles to be used extensively in everyday life. Bronze lamps, too, were cast in the Warring States Period. Cleverly designed lamps in the shape of a human figure have been discovered in Shandong, Hebei, Henan and other places.

As the feudal economy developed, a large number of bronze coins entered circulation. Although in the Shang and Zhou 'Slave Society' tools were used as coinage, their value being determined by weight, the need for them was limited because exchange was conducted on a small scale in the slave-owning economy. The scale of exchange was enlarged as production developed when feudal patterns of production held sway. The flourishing economy of the Warring States Period gave rise to an unprecedented development of bronze coins. There were knife coins in the state of Qi, square-footed and pointed coins in the states of Han, Zhao and Wei, round coins in the state of Qin, 'demon face' coins in the state of Chu, and others. Thus began the rich history of ancient Chinese bronze coinage. From that time on, more bronze was used for minting coins than for casting vessels.

The casting of bronze seals also deserves our attention. During the slave-owning period, enfeoffed lords ruled over only limited areas, and there were relatively few laws and regulations to be proclaimed. Both the assigning of duties to government organizations of different levels and the methods of administration were also relatively simple, with the result that official centres did not have a well-developed system of documentation or communication. At the same time, the families of slave-owning nobles enjoyed hereditary privileges and, therefore, had little use for personal seals. By the time of the 'Feudal Society', the central government existed together with feudal states. As the government had an expanded territory to rule, laws and decrees had increased in number. To strengthen their rule, various government organizations had increased their powers and

functions. The role of state machinery had been augmented. To adapt to this new situation, official centres at various levels gradually began to use seals to differentiate their duties so as to exercise their power more efficiently. For this reason, official seals gradually became popular in the Warring States Period. From another point of view, when the rights of slave-owners to hereditary positions and salaries were abolished, the status of private families was raised. Commoners who were not attached to the hereditary houses of slave-owning nobles began to have opportunities to display their personal talents. Many accomplished people during the Warring States Period were of humble origin. As a result, personal seals which represented an individual's activities and reputation began to be widely used. The casting of official and personal seals developed at a rapid rate.

Bronze was also used for making measures of length, volume and weight. Such measures did not exist in the Shang and Zhou Dynasties, or at least we have not yet found examples from those times. Famous bronze measures of volume from the Warring States Period are Chen's three measures of the state of Qi, namely the Zi He Zi *fu* (Plate 66), the Chen Chun *fu* and the Zuo Guan *he*. The well-known square *sheng* of Shang Yang was the standard measure of volume for one *sheng*, proclaimed when Shang Yang instituted his reforms in 344 BC (Plate 74). The square *yue* and the You Li *sheng* were also measures of volume from the Warring States Period.[58] Some bronze vessels may have been used also as measures of volume during the Warring States Period, since these have calibrations for different capacities carved on them. The emergence of bronze measures at this time was directly related to the calculation of land rents and taxes. They were tools of exploitation for the emerging landlord class. In China the measure for weight was the balance-scale. Weights used on the balance-scale in the state of Chu were made in the shape of rings. Measures made of bronze were more accurate and enduring then those made of other materials, and they had a much higher value as standards.

58. 'Ancient Measures', *Wenwu* 1964:7; National Bureau of Weights and Measures, *Illustrated Selection of Ancient Chinese Weights and Measures* (Beijing, Wenwu Publishing House, 1981), nos 97, 87 and 90.

Inscriptions on bronzes also underwent pronounced change. The old practice of extolling the rites and moral concepts of the slave-masters through such inscriptions gradually disappeared. Long inscriptions, such as those which appeared commonly on bronzes of the late Western Zhou, became rare. Most of the bronze inscriptions from the Spring and Autumn Period are simpler in content, showing that the practice of inscribing everyday articles and recording marriages with inscribed wedding gifts became widespread. By the Warring States Period, customs of inscribing bronze vessels had changed fundamentally. Of course, a small number of vessels followed the old custom of the slave-masters and had long inscriptions cast on them. Examples are to be found on the *ding*, *hu* and other vessels unearthed from the Warring States Period tombs of the kings of Zongshan in Pingshan County, Hebei Province.[59] Each of these vessels has a long inscription running to several hundred characters, but these are rare exceptions. Most Warring States bronze vessels were not cast for recording events as had been the main motive for casting vessels in the past. As a rule their inscriptions record only the date on which a vessel was cast, the department that supervised the casting and its supervisor's name. Bronze inscriptions that originally had reflected the characteristics of ritual vessels had by now undergone a fundamental change.

We can see that bronze ritual vessels of the slave masters of the Spring and Autumn Period had gone through first a gradual change and then an accelerated change before their special characteristics disappeared completely. This process coincided with the process of social change at that time; we may say that it reflects one aspect of such social change. By the time of the Warring States, bronze objects were no longer purely ritual vessels acting as status symbols of the slave-masters, but had become utensils for daily use by the landlord class. With the old restrictions removed, there appeared a vogue for casting new types of vessels and other articles. The bronze technology of the slave-owning period declined steadily while that of the early

59. 'A Brief Report on Excavations of Warring States Period Tombs of the State of Zhongshan in Pingshan County, Hebei', *Wenwu* 1979:1.

feudal period developed under new conditions to meet the new needs of society.

In the Warring States Period, bronze was also used for tallies. The famous Tally of Qi, Lord of E, was unearthed in Shou County, Anhui Province (Plate 73). It was issued to Qi by the king of Chu as a certificate for transportation and sale of goods along fixed water and land routes without the payment of taxes. Various kinds of bronze tallies have been found almost everywhere in China. As for production of bronze weapons and carriage parts, the Warring States Period far surpassed the past in the scale and quality of its production.

As handicraft products for everyday use, bronze articles of the Warring States Period are characterized by their sumptuous decoration, contrasting with the crude and austere style of the early Spring and Autumn Period. Some of their exquisite designs resemble the patterning of silk brocade. The search for fine and intricate designs became the vogue. Elements of the designs on bronzes of the early and mid Warring States Period are sometimes so minute that they can scarcely be deciphered with the naked eye. Such fine details may appear over-fastidious, but they serve to show that bronze-casting techniques had reached an almost unbelievable degree of precision and perfection at that time. The objects are of such even thickness, regularity in structure and fine, clear decorative design as had never been seen before. During the Warring States Period bronze technology made remarkable and uniform progress, marked by an increase in productivity and an improvement in quality.

Designs on Warring States bronzes have far fewer religious and mysterious elements. The angrily staring animal masks of Shang and Zhou times have disappeared, being replaced by many kinds of agile animals with a certain degree of motion, and by sumptuous geometric abstraction. There were still mythological motifs, but these had become less esoteric. Bronze decoration in the early and mid Warring States Period saw the greatest transformation: all kinds of animal motifs became geometric or semi-geometric in design. By semi-geometric design is meant that traces of animal imagery are still discernible within the geometric figures. This transformation is a reflection in

decorative design of changes in ideology during the Warring States Period. As the mysterious designs that embodied the old ideas of the slave-owning system were abandoned, those original designs had to be reformed. By applying elaborate decoration, the traditional dragon and snake motifs were miniaturized and executed with incomparable precision. This method of decoration led inevitably to new variations in geometric figures. Abstraction and distortion are inevitable phases in the evolution of design. For example, abstraction and distortion had also appeared in bronze designs of the early Shang period, and again in the mid and late Western Zhou. The distortion in Warring States bronze decoration developed towards geometric patterns. In actuality, there are no patterns which can develop without distortion.

Pictorial representations reflecting the social activities of landlords and nobles, such as feasts, archery and hunting, also appear on bronzes of the late Spring and Autumn and the Warring States Periods. Those of the late Spring and Autumn Period are simpler in content than those of the Warring States. These decorations, which describe the social activities of the upper class instead of supernatural beings, are an important innovation and a severance from the old traditions of the Shang and Zhou. They broke the bounds of belief in fate and began to be linked to real life. Some pictures describe scenes of battle, including laying siege to a city, hand-to-hand fighting and combats by chariot and on water. These reflect the fierce struggle between powerful states of the time, and enable us to witness in rough outline some vivid scenes of battle in the Warring States Period.

Many Warring States bronzes with geometric decoration are inlaid with precious stones, gold and silver. Most of them are decorated with geometric distortions of animal motifs. Their craftsmanship is superb. These magnificent pieces of bronze were, of course, the most superior objects for use in the luxurious lives of the new land-owning nobles. However, Warring States bronzes were made mainly for practical purposes. As it was impractical to decorate large numbers of articles for everyday use with delicate designs, bronze articles of simpler design began to appear in large quantities. Most of the bronzes cast in the late

Warring States Period are of these simpler and more practical types.

After subjugating the six other independent regimes that divided the country, the First Emperor of Qin unified the whole of China in 221 BC, and established a centralized feudal empire. His merit lies in having produced a positive and profound influence on the history of China. Of course, he also had his negative side. His extravagance and unprecedentedly luxurious court life wasted a huge amount of the blood and sweat of the peasants. The several thousand large pottery warriors and horses buried near his tomb are a case in point.[60] One can imagine the funds needed for financing such a huge project. The unification of the economy and culture in the Qin empire is reflected in the casting of bronzes. Regional characteristics that had existed during the Warring States Period gradually disappeared, and the forms and sizes of bronzes moved steadily towards uniformity.

Bronzes of the Western and Eastern Han Dynasties became even simpler. The main products were ordinary, useful articles for everyday life, which were quite widely distributed. Only a small number of luxurious articles were produced for the highest class of land-owning nobles. The extraordinarily magnificent bronzes with gold and silver inlay, or with gilding, unearthed from the Han tombs in Mancheng, Hebei Province, are examples of such articles.[61]

Bronze art of the Western and Eastern Han Dynasties was based increasingly on real life in its forms and designs. Images shaped in bronze are representational, and yet full of imagination. The Changxin Palace lamp of the Western Han is made in the image of a child-like palace maid holding a lamp in her hands (Plate 78). The bronze galloping horse of the Eastern Han Dynasty is sculpted in simple lines (Plate 81), its lightning speed conveyed by the placement of one of its hooves on the back of a flying bird.

China has been a country with many ethnic groups since

60. *Wenwu* 1975:11.
61. 'A Brief Report on the Excavation of Han Tombs at Mancheng', *Kaogu* 1972:1.

ancient times. The bronze art of minority peoples had distinctive ethnic characteristics, while absorbing and assimilating cultural elements of first the Huaxia and later the Han peoples. It has always been an important component of Chinese bronze art as a whole. When the extensive areas of the Yellow River valley had already entered the Iron Age, some frontier areas inhabited by minority peoples were at their own stage of development when bronze art flourished. This is demonstrated by bronze cowrie containers decorated with groups of cast images reflecting local social customs, and other highly decorative bronze articles and weapons unearthed from the tombs of the Dian royal family in Yunnan Province.[62] These bronzes provide concrete data for the study of the social system of the Dian people during the Western Han Dynasty. The Ba tribe in Sichuan and the Baiyue tribes in south-east China also produced their own very outstanding bronze art. The bronze art of the Xiongnu and Xianbei bears the characteristics of these steppe tribes.

From the brief account given above, we can see that the origin and development of ancient Chinese bronzes, which flourished over a long period, reflect to a certain degree the progress of history and culture, and offer a partial picture of the society of their times. From the technical and artistic points of view, these bronzes fully embody the great creative genius of the slaves, who were the real creators of the material civilization of ancient Chinese society. Such is our conclusion.

62. See note 21.

Part II Selected Examples of Ancient Chinese Bronzes

BRONZE TOOLS

Si

The *si* (plough-share) is a farm tool with a curved handle used for turning soil. Its bronze head is fitted on to a thick piece of wood, and attached to the shoulder of the wood is a curved handle which bends slightly forwards. It is operated by holding the handle with the hand and pushing the bronze head into the soil with the foot. The *si* is, therefore, a hand-operated plough. Its bronze head has a straight blade with sharp cutting edges. According to available data, the *si* head of the Shang Dynasty is longer than that of the Western Zhou, and has a deeper socket for the handle. During the late Spring and Autumn Period there was a smaller *si* head, which was not used for turning soil but for cultivating small garden plots. In some cases, to save material, the edge of the socket opening was pierced above and below, to leave a horizontal bar in the middle.

Si (Plate 1a)
Shang Dynasty
Reportedly unearthed in Hui County, Henan Province
Length 27.6 cm; width of blade 11.5 cm
Shanghai Museum

Flat based, the blade is sharpened on three sides at its tip. The socket at the base has two sloping walls and a flat rectangular opening.

Plate 1b

Plate 1a

Si (Plate 1b)
Western Zhou
Length 11.7 cm; width of edge 14.5 cm
Shanghai Museum

This is a heavier and shorter type of *si* head. The blade also has three cutting edges. The two sides of the blade spread out like wings. There are two sloping walls in the socket.

Lei

The lei (fork) is a farm tool indispensable for digging holes or ditches. It has two prongs and was developed from the primitive wooden *lei* made with a forked tree branch. Only a small number of bronze *lei* heads have been found and their wooden handles have long perished. This example is also shaped like a forked tree branch with flat prongs, and there is a square socket for the handle.

Lei (Plate 2)
Western Zhou
Length 16.8 cm; distance between the
prongs 6.8 cm
Shanghai Museum

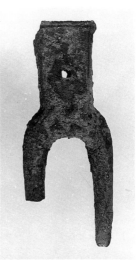

Plate 2

Jue

The *jue* (hoe) is a farm tool for digging and weeding. It has a
long, broad blade with a bevelled or double-bevelled cutting
edge. There is a socket for a right-angled bent handle. It was
used as is the modern hoe. There was only the character 钁 ,
meaning a big hoe, in ancient times, but not the character 鐝 ,
which appeared later. The two characters have the same initial
consonant and are pronounced in very much the same way. The
jue has often been mistaken for an axe, which has a narrower
body.

Jue (Plate 3a)
Shang Dynasty
Length 15.1 cm; width of cutting edge
7.8 cm
Shanghai Museum

A broken *jue* unearthed from a Shang site in
Zhengzhou, Henan Province, is the same
shape as this one.

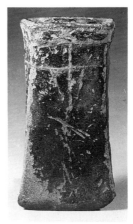

Plate 3a

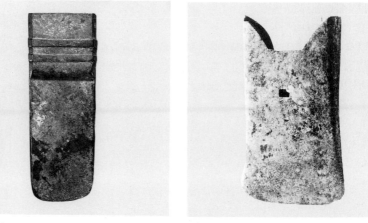

Plate 3b Plate 3c

Jue (Plate 3b)
Shang Dynasty
Reportedly unearthed in Hui County, Henan Province
Length 17.8 cm; width of cutting edge 6.3 cm
Shanghai Museum

Jue (Plate 3c)
Western Zhou
Length 17.2 cm; width of cutting edge 9.8 cm
Unearthed from a tomb at Zhengposhankou, Suyi County,
Jiangsu Province
Nanjing Museum

This *jue* has a shallower socket than most.

Ben

The bronze *ben* (adze) was used in agriculture for clearing land.
The difference between the *ben* and the *fu* (axe) is that the
former has a single-bevelled cutting edge while the latter has
a double-bevelled one. The *ben* has a slightly curved back, and
a rectangular or oval socket. The bronze *ben* was developed from
the stone *ben* of the Neolithic Period. It was used not only in
agriculture but also as a principal tool in carpentry. Before
the plane was invented, wood surfaces were shaved smooth with
a *ben*.

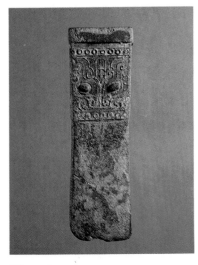

Plate 4a

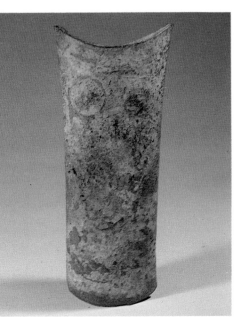

Plate 4b

Ben (Plate 4a)
Shang Dynasty
Length 14.9 cm
Shanghai Museum

This *ben* with an animal mask decoration appears to be a handicraft tool.

Ben (Plate 4b)
Western Zhou
Length 22.6 cm; width of cutting edge 7.8 cm
Shanghai Museum

This *ben*, with a curved back and rounded body, has a curved cutting edge. It was obviously not used as an adze. If fitted with a curved handle, it would be like a modern pickaxe.

Cha

The *cha* (spade) is a farm tool for digging ditches or building dikes. A sentence, 'The raised *cha* like clouds ... ', in the *History of the Han Dynasty* describes a multitude of peasants raising

their *cha* to dig a ditch.[63] The bronze *cha* head has a square blade or a square blade with rounded corners. With three sides of the blade sharpened, it was used for making a groove in the ground. A thick piece of wood, rectangular and shouldered, could be fitted into its socket, and a handle joined to the shoulder. The *cha* blade is inserted into the soil by stepping on the shoulder. A *cha* with a deep socket and broad cutting edge was discovered for the first time in a tomb of the early Shang Dynasty at Panlongcheng, Huangpi County, Hubei Province.[64] Most bronze *cha* of the Western Zhou and the Spring and Autumn Period have shallow sockets.

Cha (Plate 5a)
Shang Dynasty
Unearthed at Panlongcheng, Huangpi
County, Hubei Province
Length 16.6 cm
Hubei Provincial Museum

Plate 5a

Cha (Plate 5b)
Western Zhou
Length 10.3 cm; width of blade
9.7 cm
Shanghai Museum

Plate 5b

The shape of the blade is similar to that of the Shang *cha*, only much shorter. Moreover, the socket is indented at the opening on both sides, which would have saved bronze without affecting

63. *Han shu*, 'Gou xue zhi'.
64. See note 13.

the sturdiness of the tool. This is a clever improvement. A *cha* of the same type has been unearthed from the remains of a Western Zhou wooden structure in Qichun, Hubei Province.[65]

Chan

The *chan* (shovel) is a farm tool used in Shang and Zhou times for lifting earth and removing surface growth. It was formed by casting a socket on a square or rectangular blade. The socket, with a square or oval opening, was fitted with a short handle. The bronze *chan* was a far more efficient tool than the bone *chan* used in the Neolithic Period. Bronze *chan* of the Shang and Zhou Dynasties so far discovered can be divided into two basic types: one has square shoulders, a broad blade and a socket with an oval opening; the other has sloping shoulders, a narrow blade and a socket with a rectangular opening. The latter type was used until the Warring States Period. Even some of the iron *chan* of the Western Han Dynasty were made in this form. In the Western Zhou Dynasty, the *chan* was called the *qian* (the character for coinage). The line 'Get ready your *qian* and *fu*' in the 'Ode to the Zhou' in *The Book of Songs* means 'Get your *chan* and *fu* ready'.[66] *Chan* of the same size and weight could be used as a medium of exchange in transactions under the social conditions of the time. Later, coins were minted in the shape of the *chan* and the word *qian* became the general name for coinage. *Chan* thus became the special name for this type of farm tool. Most existing bronze *chan* belong to the Western Zhou Period.

Chan (Plate 6a)
Shang Dynasty
Unearthed at Dasikong Village, Anyang, Henan Province
Length 22.4 cm; width of blade 8.5 cm
The Institute of Archaeology, Chinese Academy of Social Sciences

65. 'A Western Zhou Wood Architectural Structure at Maojiazui, Qichun, Hubei', *Kaogu* 1962:1.
66. *Shi jing*, 'Zhou song, Chen gong'.

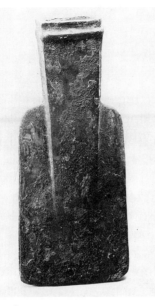

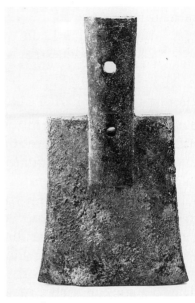

Plate 6a Plate 6b

Chan (Plate 6b)
Shang Dynasty
Reportedly unearthed in Hui County, Henan Province
Length 21.6 cm; width of blade 12.6 cm
Shanghai Museum

A bronze *chan* of this type has also been uncovered in the Yin ruins, Anyang, Henan Province

Chan (Plate 6c)
Western Zhou
Length 13.4 cm; width of blade 9 cm
Shanghai Museum

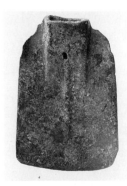

Plate 6c

This type of bronze *chan* with a narrow blade and sloping shoulders was most popular in the Western Zhou Dynasty. Examples have been found in every area.

Fu

The bronze *fu* (axe) is a chopping tool widely used in agriculture and handicraft production. There were two types of *fu:* one with a straight cutting edge, the other with a curved cutting edge. Smaller *fu* and the *fu* with a curved cutting edge were used only in handicraft production. The wood-chopping *fu* was also called *jin* 斤. The fact that the character 斧 (*fu*) has the radical 斤 (*jin*) shows that they were the same kind of tool.

Fu (Plate 7a)
Shang Dynasty
Length 12.3 cm; width of blade 3.3 cm
The Institute of Archaeology, Chinese
Academy of Social Sciences

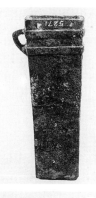

Plate 7a

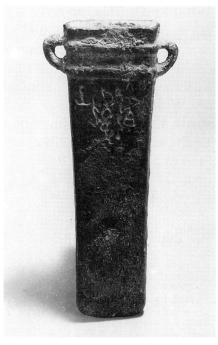

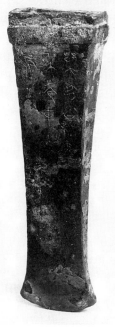

Plate 7b Plate 7c

Fu (Plate 7b)
Western Zhou
Length 24.2 cm; width of blade 5.7 cm
Shanghai Museum

There is an inscription at the rear end of the blade.

Fu (Plate 7c)
Spring and Autumn Period
Length 16.5 cm; width of blade 4.5 cm
Shanghai Museum

The inscription reads, 'Da Shu of Lü had a *fu* made with new metal for making chariots.' Lü was the fief of a count, an aristocrat of the state of Jin. New metal meant newly refined bronze and not melted bronze scrap.

Lian

The *lian* (sickle) is a farm tool used in harvesting. There are two types of *lian:* one without a handle, and the other to be fitted with a handle. The former is flat and with a curved back pierced with holes through which the *lian* could be looped to the hand with rope. It was used for cutting grain. The latter is similar to the sickle of today. The bronze *lian* of the Western Zhou unearthed at Yizheng, Jiangsu Province, is shaped somewhat like a clam shell.[67] Other Western Zhou bronze *lian* of similar shape also exist. The narrow, rectangular bronze *lian* with saw teeth was widely used in the Eastern Zhou Dynasty along the middle and lower reaches of the Yangtze River.

Lian (Plate 8a)
Western Zhou
Unearthed at Poshankou, Yizheng, Jiangsu Province
Length 14.2 cm
Nanjing Museum

The three holes are for tying the *lian* to a handle.

67. See note 17.

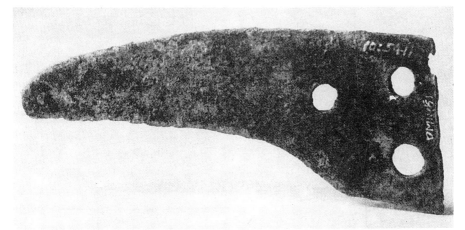

Plate 8a

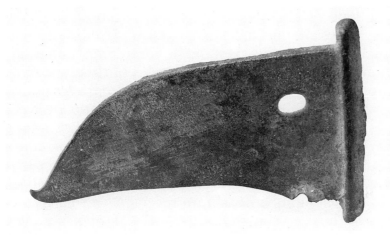

Plate 8b

Lian (Plate 8b)
Western Zhou
Length 11.7 cm
Shanghai Museum

This *lian* with *nei* and *lan* looks like a *ge* (dagger-axe). The *nei*
is the socket for the handle. The *lan* are the two tooth-like
protrusions above and below the socket for tying the *lian* to
the handle with leather straps. The socket on this specimen
is partly damaged.

Lian (Plate 8c)
Spring and Autumn
Period
Length 10.4 cm;
width 4.7 cm
Shanghai Museum

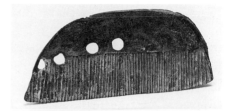

Plate 8c

This *lian* can be held tightly in the palm of the hand with the fingers in the loops of rope tied through its holes.

Nou

The *nou* (light hoe) is a weeding tool. A note to *The Book of Songs* says: 'The *nou* head is six *cun* long while the handle is one *chi* long.'[68] These measurements may not be quite correct, but all types of *nou* are short-handled weeding tools. *Nou* originally meant a big clam shell. Some bronze *nou* do have a flat and rather broad blade. Examples of this type of *nou* so far discovered are triangular with two wings of saw-toothed cutting edges which can be ground very sharp. Between the wings, and connected to them by horizontal bars, is a small socket for the handle. Holding the handle, its operator could push the *nou* forward horizontally to cut down weeds in the field. Another type of *nou* is shaped like a V. It has no socket, but a handle could be fitted into the V. With this type of *nou* there was thus a saving in the quantity of bronze used without loss of efficiency.

Nou (Plate 9a)
Spring and Autumn
Period
Length 10.3 cm
Shanghai Museum

One of the wings
is broken.

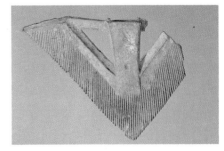

Plate 9a

68. *Shi jing*, 'Zhou song, Chen gong'.

Nou (Plate 9b)
Spring and Autumn
Period
Length 9 cm;
width 17.3 cm
Shanghai Museum

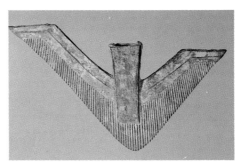

Plate 9b

BRONZE WEAPONS

Ge

The *ge* (dagger-axe) is the most frequently seen ancient weapon used for hooking and slashing. It was cast in bronze in the shape of an ox tongue with sharp cutting edges. There are two short protrusions at its rear for fitting it on to a handle with fastenings of animal sinew or leather straps. The *ge* of the Shang Dynasty has a broader blade. It became narrower at the end of the Shang and the beginning of the Zhou. There also appeared a type of *ge* with a *hu*. *Hu* originally meant the flap of muscle drooping from the neck of an ox. This later type of *ge* has its cutting edge extended downwards which looks like the *hu* of an ox. With the *hu*, the *ge* head could be more firmly tied to the handle. This improved *ge* has been proved to be more efficient.

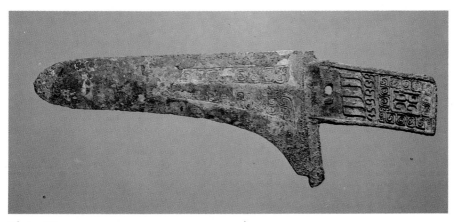

Plate 10a

Ge with design of cloud and thunder (Plate 10a)
Late Shang Dynasty
Length 24.9 cm
Shanghai Museum

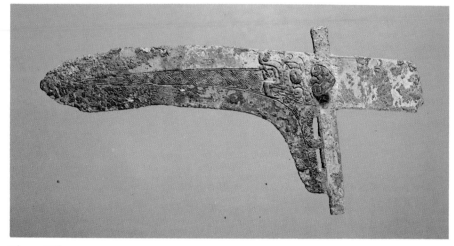

Plate 10b

Ge with dragon design (Plate 10b)
Early Western Zhou
Length 23.8 cm
Shanghai Museum

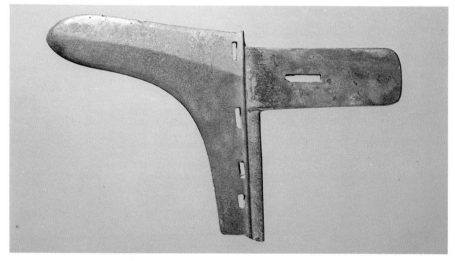

Plate 10c

Ge (Plate 10c)
Early Spring and Autumn Period
Length 18.1 cm
Shanghai Museum

This *ge* was from Jinyang, the old capital of the state of Jin, located south of present-day Taiyuan in Shanxi Province.

Mao

The *mao* (spear) is a weapon with a long shaft for thrusting. It was used in combination with the *dun* (shield) for both attack and defence. Excavated *dun* are all made of wood or leather, and were mostly rotten when unearthed. A few examples, unearthed in Hubei and Hunan where burial conditions were more favourable, are quite well preserved. Most of the spearheads of Shang and Western Zhou times are large in size, with wide bulging sides or in the shape of a leaf. Those of the late Spring and Autumn and Warring States Periods are in a variety of forms, but their sides all gradually became narrower to facilitate piercing.

Xu Ya *mao* (Plate 11a)
Late Shang Dynasty
Length 23.1 cm
Shanghai Museum

The sides bulge, and an indented area is cast in the centre of the spine.

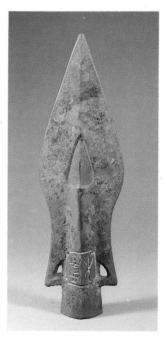

Plate 11a

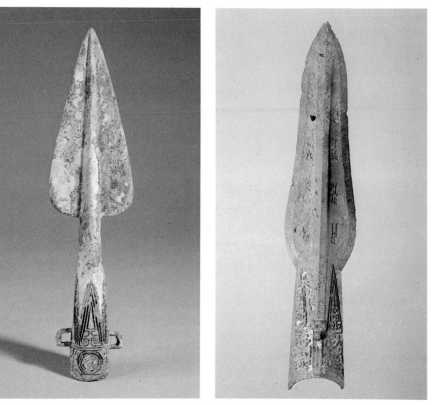

Plate 11b Plate 11c

Mao with flame design (Plate 11b)
Late Shang Dynasty
Length 24.3 cm
Shanghai Museum

The sides of this *mao* of improved design are shaped like a leaf.
The flame design is also known as the heavenly flame design.

The Zhezhi Wuyi *mao* (Plate 11c)
Early Warring States Period
Length 27.1 cm
Shanghai Museum

This *mao* belonged to Zhezhi Wuyi, the Yue king Yuyi, who,
as recorded in the histories, was the son of the famous Yue king
Goujian.

Ji

The *ji* (halberd) is a combination of the *ge* (dagger-axe) and the *mao* (spear). With a *mao* mounted on top of a *ge*, the *ji* was used both for hacking and thrusting. The *mao*-like part of the *ji* is called the *ci*. The *ge* and the *ci* were cast together as one piece in the Western Zhou Period, but separately in the late Spring and Autumn Period. With its rear end lengthened and sharpened, the *ji* became a weapon with three cutting edges. Most of the *ji* we see today did not have their *ci* when they were unearthed, but their sharpened rear ends show that they are *ji* with their *ci* missing. The *ji* was a widely used weapon during the Spring and Autumn and the Warring States Periods.

Marquis's *ji* (Plate 12a)
Late Western Zhou
Unearthed in Xin Village,
Zun County, Henan Province
Length 18.9 cm
Shanghai Museum

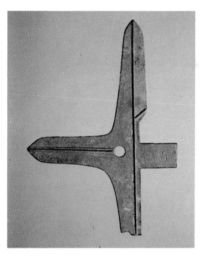

Plate 12a

This *ji* belonged to a marquis. As Xin Village was a necropolis of the state of Wei in the Western Zhou Dynasty, we know that this *ji* belonging to a marquis was a weapon of the state of Wei.

The *ji* of Yinqi, Marquis of Chen (Plate 12b)
Mid Warring States Period
Length 26.2 cm
Shanghai Museum

This *ji* belonged to Yinqi, the Marquis of Chen, who was later King Wei of the state of Qi as mentioned in histories. He reigned from 356 to 320 BC.

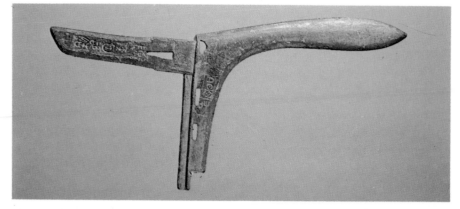

Plate 12b

The Shang Yang *ji* (Plate 12c)
Mid Warring States Period
Length 13.4 cm
Shanghai Museum

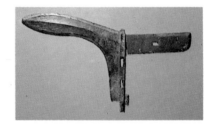

Plate 12c

This *ji* belonged to Shang Yang. Its inscription reads 'Made by Da Liang'. Da Liang was Shang Yang's official title. The shape of this *ji* shows that there was no difference between the *ji* of the state of Qin during Shang Yang's time and that of the six other states.

Yue

The *yue* (battle-axe) was a weapon in wide use during the Shang Dynasty. It has also been frequently discovered in tombs of the early Zhou Dynasty. The *yue* was used exclusively for execution; in other words, it was an executioner's tool. There is a character 戉 in bronze inscriptions, the pictograph describing a *yue* cutting off a man's head. This character also referred to a form of punishment. It is recorded in histories that, in King Wu's expedition against the Shang, a battle was fought at Muye. After his defeat, King Zhou of the Shang committed suicide by self-immolation, but King Wu still cut off the dead king's head with a *yue*. There are two types of *yue*: one large

or very large, and the other small. A number of small *yue* have been found by the bodies of the king's bodyguards in the royal tombs of the Yin ruins at Anyang, Henan Province. The large *yue* were all discovered in larger tombs, such as Fu Hao's tomb at Xiaotun in Anyang, Henan Province, the early Shang tombs at Panlongcheng, Hubei Province, and the Shang tomb in Yidu, Shandong Province.[69] Therefore, the large *yue* was also a symbol indicating the noble rank of the tomb's occupant. When King Wu was crowned, he was assisted by the Duke of Zhou holding a large *yue*, and the Duke of Zhao holding a small *yue*. This shows that, to some extent, the *yue* was also a symbol of power.

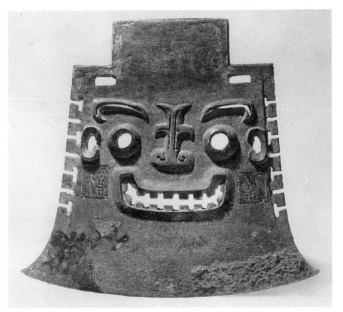

Plate 13a

Xu Ya *yue* (Plate 13a)
Late Shang Dynasty
Unearthed in 1966 at Sufutun, Yidu County, Shandong Province
Length 32.5 cm
Shandong Provincial Museum

69. See notes 13 and 16 and 'Slave Burial No. 1 at Sufudan, Yidu, Shandong', *Wenwu* 1972:8.

Both sides are decorated with the same half-beast, half-human mask, with large staring eyes, widely spaced teeth and wide-open mouth. Most extant large bronze Shang *yue* are decorated with masks like these. The eyes and mouth of this type of mask are not different from ordinary beast masks, but its whole configuration is more humanoid. It is worth noting that this particular type of mask always appears on a *yue*. As the *yue* was a tool of execution, this mask may be the image of the God of Punishment. According to the *Classic of Mountains and Rivers*, the God of Punishment was Ru Shou, who had a human face and tiger's claws holding a *yue*.[70] He is, therefore, described as a half-human, half-beast monster. The ferocious features of the God of Punishment accord with the decoration on the *yue*. The image of the God of Punishment on the *yue* shows that when Shang slave-masters killed, they had to seek the help of spirits and monsters.

Yue with two holes and a socket
(Plate 13b)
Early Western Zhou
Length 17.7 cm
Shanghai Museum

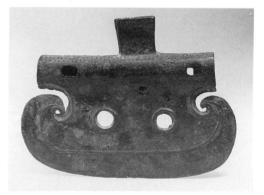

Plate 13b

The tubular socket was for the attachment of a handle. This weapon is also known as *sui*. The character *sui* in bronze inscriptions is written 戉 , which is a variant of the character *yue*.

Dao

This *dao* (knife) is a weapon of war and not a knife used in the kitchen. One type of *dao* had a long, broad blade, with the

70. *Shan hai jing.*

pointed end bent backwards like a hook, and could be fitted with a long handle. This type was cast during the Shang Dynasty. By the time of the Western Zhou Dynasty, the blade had become longer and narrower, and its end reduced to a rounded cutting edge. Broad-bladed large knives of the Western Zhou have also been discovered. Another type also has a long, broad blade, but its pointed end bends only slightly backwards, and its handle would have been shorter. This latter type accompanied armoured warriors who were sacrificed to guard their dead masters in Shang tombs. Bronze inscriptions have a character showing this weapon type used by executioners. A third type has a triangular blade with double cutting edges. Its handle is slightly curved and, at the end of the handle, is a pierced bell. Most knives of this type were discovered in northern Hebei, Shanxi and Shaanxi Provinces, which shows that it is a weapon with regional characteristics. It is a small weapon and must have been used in fighting at close range.

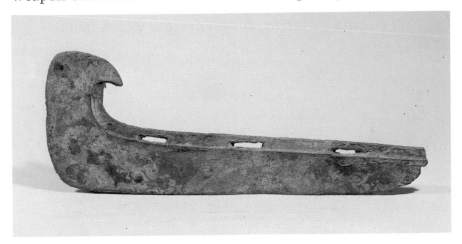

Plate 14a

Dao with curved point (Plate 14a)
Late Shang Dynasty
Length 33.8 cm
Shanghai Museum

There are three holes on the back of this *dao* for tying a handle to it. This type of *dao* has been unearthed from the Yin ruins at Anyang, Henan Province.

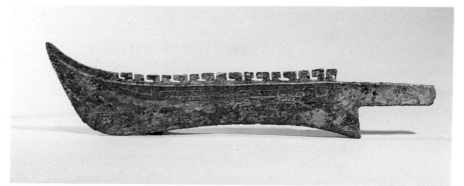

Plate 14b

Dao with design of cloud and thunder (Plate 14b)
Late Shang Dynasty
Length 34.7 cm
Shanghai Museum

This *dao* has a curved point and originally a straight cutting edge which became concave with long use. Excavations have unearthed this type of *dao* with curved wooden handles.

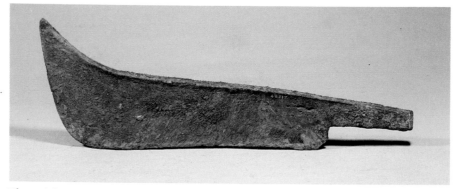

Plate 14c

Dao with checked pattern on its back (Plate 14c)
Late Shang Dynasty
Length 32.1 cm
Shanghai Museum

This *dao* with a slightly curved cutting edge shows little wear, and is very close to its original shape as cast.

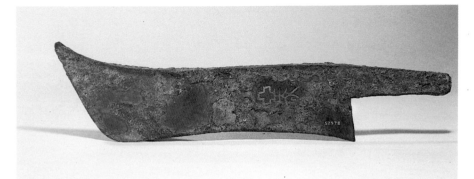

Plate 14d

Ya Yi *dao* (Plate 14d)
Late Shang Dynasty
Length 30.5 cm
Shanghai Museum

This *dao* belonged to the Ya Yi clan, an important clan in the
Shang Dynasty. The name frequently appears on bronze articles
of the mid Shang and early Zhou Periods.

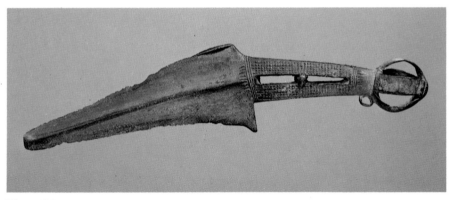

Plate 14e

Dao with double-edged blade and bell at the end of the
hilt (Plate 14e)
Late Shang Dynasty
Length 26.1 cm
Shanghai Museum

This *dao* has a long triangular blade, with a central spine. Its
handle is cast as an extension of the blade.

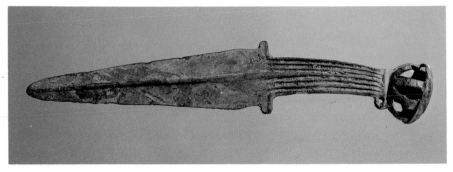

Plate 14f

Dao with double-edged blade and bell at the end of the hilt (Plate 14f)
Late Shang Dynasty
Length 26.2 cm
Shanghai Museum

This *dao* has a long triangular blade and a flat handle decorated with vertical lines. There are two protrusions where the blade joins the hilt.

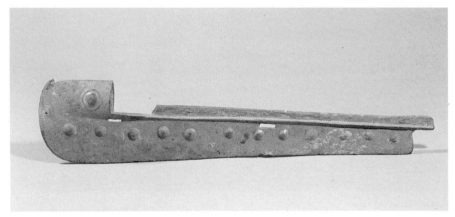

Plate 14g

Dao with nipple stud decoration (Plate 14g)
Early Western Zhou Dynasty
Length 34.7 cm; length of socket 1.7 cm; width of socket 3 cm
Shanghai Museum

This *dao* has a narrower blade with two holes in its back. The end of the blade is cast with a socket for holding the handle.

Jian

The *jian* (sword) first appeared as a weapon in the Shang
Dynasty. Bronze *jian* have been unearthed from the Yin ruins
at Anyang, Henan Province. Examples of the late Shang and
Western Zhou are short, and their blades are rectangular and
slightly narrower at the ends. The cutting edges of a *jian* are
called *e*. The blade is thicker along its spine, and its base could
be fitted with a hilt. The bronze *jian* of the early Western Zhou
Dynasty discovered at Luilihe, in Fangshan near Beijing, has
an exquisite openwork sheath decorated with a hydra pattern.
This shows that this type of *jian* was carried by few people and
not a weapon in common use. A bronze *jian* of the early Spring
and Autumn Period unearthed at Zhongzhou Road in Luoyang,
Henan Province, has a longer blade, but is still a type of short
sword.[71] By the late Spring and Autumn Period, the *jian* had
become a new type of weapon with which even the lowest-
ranking army officers were armed. To make it more effective
for stabbing purposes, the blade was greatly lengthened. The
bronze *jian* was very popular in the late Spring and Autumn,
and in the Warring States Periods. The states of Wu and Yue
were famous for their superior bronze *jian*. The *jian* of Gou Jian,
king of the state of Yue, unearthed in 1965 in Jiangling, Hubei
Province, represents the highest level of bronze casting attained
at that time. Because of the weapon's popularity, bronze swords
discovered in north, north-east and south-west China all bear
regional characteristics in their styling.

Jian with human head decoration (Plate 15a)
Late Shang Dynasty
Length 25.3 cm
Shanghai Museum

The rear end of the *jian* has been hollowed on both sides for
fitting a hilt. The human head decoration stands for a severed
head, a symbol of the *jian* user's bravery. The two rings at the
base of the blade are for the attachment of tassels. This type
of bronze *jian* also existed in the early Zhou Dynasty.

71. *Luoyang's Zhongzhou Road* (Beijing Science Press, 1959).

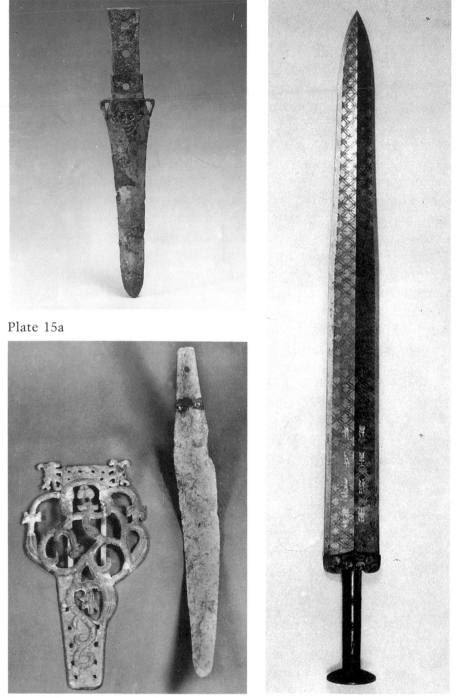

Plate 15a

Plate 15b

Plate 15c

Jian with flat blade (Plate 15b)
Early Western Zhou Dynasty
Unearthed at Liulihe, Fangshan, Beijing
Length 27 cm
Beijing Cultural Relics Bureau

There is a sheath for this *jian*.

The *jian* of Gou Jian, King of the state of Yue (Plate 15c)
Late Spring and Autumn Period
Unearthed from Tomb No. 1 at Wangshan in Jiangling, Hubei
Province
Length 55.7 cm; width 4.6 cm
Hubei Provincial Museum

This *jian*, which belonged to Gou Jian, King of the state of Yue,
is in perfect condition, largely without corrosion. It still glitters
with a golden sheen, and its cutting edges are still very sharp.
There are eight characters on the *jian* which read 'The *jian* made
by Gou Jian, King of the state of ·Yue, for himself.' The
characters are in the 'bird' script, an ornamental style of writing
then popular in the areas of Xu, Chu, Wu and Yue. The entire
jian is covered with lozenge designs filled with an alloy
containing much tin and copper and a small amount of iron,
different from the metal in which the weapon itself was cast.
The decoration and inscription were cast on the blade at the
same time as the weapon was made, instead of being inserted
afterwards. Otherwise, they would have disappeared long ago.
The technique involved in casting this kind of decoration still
has to be studied. The hilt of the *jian* was originally bound with
silk cord known as *hou*, which has perished.

Arrowheads

Arrowheads are the earliest form of weapon cast in bronze. They
have a sharp point and two, usually swept-back, barbs so that
wounds would be enlarged upon the removal of the barbs from
the enemy's flesh. Although there are differences in size,
thickness and width, all bronze arrowheads were made in more
or less the same form. By the time of the Warring States, there

had appeared arrowheads with hollow barbs, and awl-shaped
or triangular arrowheads. It is not yet perfectly clear why these
changes were made although they must have resulted from the
tactics of war employed at that time, improved organization
of the different branches of the army, and advances in weaponry.
The general trend of development was that barbs became
steadily smaller so that arrowheads could penetrate deeper.
Archaeological finds show that arrowheads could penetrate deep
into the bone. The rear end of the arrowhead, fitting into the
shaft of the arrow, is called *tin*. Arrowheads of the Shang and
Zhou Dynasties have very short *tin*, which became longer in
the Warring States. Some bronze arrowheads have iron *tin*.

Arrowhead with short *tin* and broad barbs
(Plate 16a)
Late Shang Dynasty
Length 7.2–10.8 cm
Shanghai Museum

Plate 16a

Arrowhead without *tin* (Plate 16b)
Warring States Period
Length 5.8 cm
Shanghai Museum

Plate 16b

This arrowhead has a socket in the middle for the shaft. The
barbs are hollow.

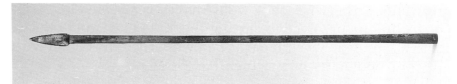

Plate 16c

Three-edged arrowhead with long *tin* (Plate 16c)
Warring States Period
Length 23.9 cm
Shanghai Museum

Small and sharp, this type of arrowhead could penetrate deep
into its victim.

BRONZE RITUAL VESSELS, MUSICAL INSTRUMENTS AND OTHER ARTICLES

Jue with narrow spout (Plate 17)
Erlitou Culture, before the 16th century BC
Unearthed at Erlitou, Yanshi County, Henan Province, in 1973
Height 12 cm; height of legs 3.5 cm; thickness 0.1 cm
Erlitou Work Station of the Institute of Archaeology, Chinese
Academy of Social Sciences

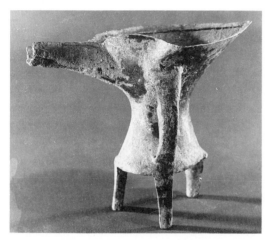

Plate 17

The *jue* (tripod goblet) was a vessel for drinking wine. This
example has a narrow spout, slender waist and flat bottom. The
bottom and waist are almost oval. The handle is semi-circular,
and has remains of a red pottery core on its interior, showing
that the vessel was cast by the piece-mould technique. As the
body fabric is very thin, the mouth-rim has been reinforced with
a bronze band. The spout is short and narrow. There are no
pillar-like protrusions where the spout joins the mouth. The
three legs are unusually short and without decoration, as is
usual. The entire vessel is shaped like a pottery *jue*, almost an
imitation of the pottery *jue* with minor modifications.
Electronic analysis shows that the alloy is a typical tin bronze,
containing 92 per cent copper and 7 per cent tin. This *jue* and
other objects found with it are from the third phase of the Erlitou
remains in Yanshi County, Henan Province. Carbon 14 dating
shows that the Erlitou site, from its first to fourth phase,

flourished between 1920 (± 140) and 1625 (± 130) BC. This
jue may, therefore, be a relic of the Xia Dynasty. It is the earliest
bronze wine vessel so far discovered. As the third and fourth
phases of the Erlitou Culture are somewhat different in their
features from the first and second phases, and closer to the early
Shang culture at Erligang of Zhengzhou, Henan Province, some
scholars are of the opinion that the *jue* belongs to early Shang
culture. However, chronologically it falls within the years of
the Xia Dynasty, and must have been made before the founding
of the Shang Dynasty. There is, as yet, much work to be done
to determine the nature of the Erlitou Culture.

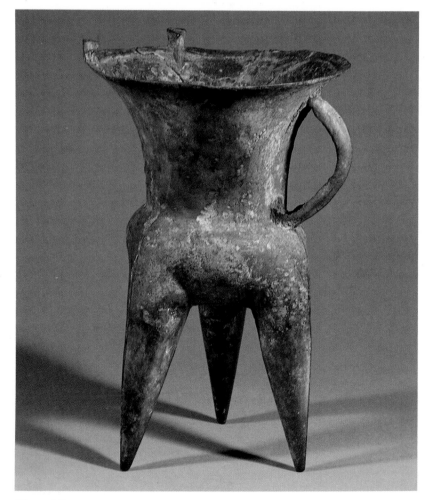

Plate 18

Jia with round studs (Plate 18)
Erlitou Culture
Height 27.2 cm
Shanghai Museum

The *jia* (tripod goblet) was a vessel for drinking wine; it could
also be used for warming wine. This bronze *jia* is very similar
in form to the pottery *jia* unearthed at the Erlitou site, but quite
different from bronze *jia* of the Erligang Culture of the Shang
Dynasty in Zhengzhou, showing that it had not wholly departed
from the stage of imitating pottery vessels. As regards its casting
technique, although this *jia* was cast with a pottery mould, its
thickness is uneven and the molten bronze failed to flow into
one of its pillars, which was recast after the mould had been
removed. Its casting technique was still at a primitive stage by
comparison with that of bronzes of the early Shang Dynasty.
Although no bronze *jia* has as yet been found at Erlitou, analysis
of all this vessel's features shows that it could only belong to
the Erlitou Period. At the base of the front neck of the *jia* is
a row of low-relief round studs. The same kind of round studs
can be found on the bronze *jue* discovered at Erlitou.

Square *ding* with animal masks and nipple studs (Plate 19)
Erligang Period of the Shang Dynasty
Unearthed in Zhengzhou, Henan Province, in 1974
Height 100 cm; weight 82.55 kg
Henan Provincial Museum

Two square *ding* (four-footed food container) with animal masks
and nipple studs were discovered at a construction site on
Duling Street, Zhengzhou, Henan Province, in 1974. These two
are similar in form and design, and were buried side by side.
The present *ding* is the larger of the two, the other being 87
cm in height.
 The circumstances surrounding the burial of these two large
square *ding* are unclear as only a limited area was excavated.
Both *ding* have thickened, platform rims. Their animal masks
are outlined in single lines. Their casting was not done with
a completely sealed-up clay core, which explains why the four

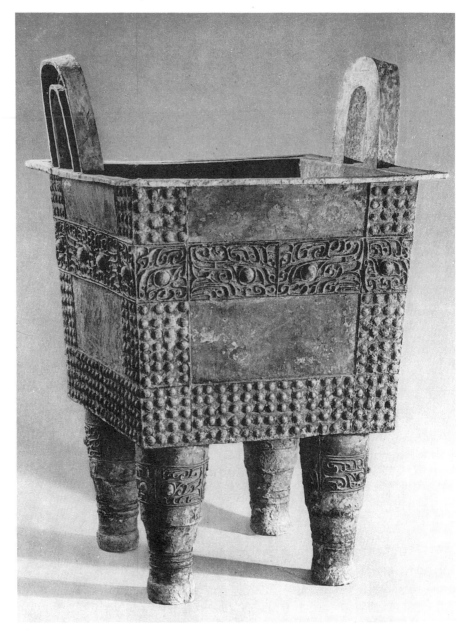

Plate 19

legs are hollow and only the bases of the feet are sealed. These are features peculiar to bronzes of the early Shang Dynasty before the 14th century BC. The casting of bronze *ding* of such size was a truly remarkable achievement in the struggle for pro-

duction. Each side of the body of the *ding* was cast with a whole piece of pottery mould; the joins of the moulds at the four corners are clearly visible. To increase the supporting strength of the bottom of the vessel, the places where the legs join the body are reinforced with extra thickness.

Discovery of the large square *ding* with animal masks and nipple studs sheds light on the bronze technology of the early Shang Dynasty, about which practically nothing was known before 1949. The existence of early Shang Dynasty bronzes was first confirmed by archaeologists working in Zhengzhou in 1952. In the decade or so thereafter, only small bronze objects of the same period were found. The discovery of these large square *ding* has not only revised previous evaluations of the early Shang Dynasty's bronze-casting skills, but has also moved back the history of bronze casting to a much earlier time. This is because their superb casting technique must have been based on long years of cumulative experience. It was a process which, under the conditions of that time, could not have been accomplished within a century or two, but would have required longer. The discovery of the two large square *ding* has automatically pushed back China's history of bronze casting to the Xia Dynasty.

Ding with animal mask decoration (Plate 20)
Erligang Period of the Shang Dynasty
Unearthed at Panlongcheng, Huangpi County, Hubei Province, in 1974
Height 48 cm
Hubei Provincial Museum

The *ding* was a cooking vessel in ancient times. The remains of a walled city of considerable size, enclosing palace foundations, from the early Shang Dynasty, were discovered at Panlongcheng in Hubei Province not long ago. Excavations at a burial ground outside the city in 1974 led to the discovery of slaves buried with the dead and a large number of relics. Most prominent among these unearthed artefacts were bronze objects, which included tools, weapons and ritual vessels, and these have greatly increased our understanding of early Shang bronzes. The Panlongcheng discovery has furnished an important

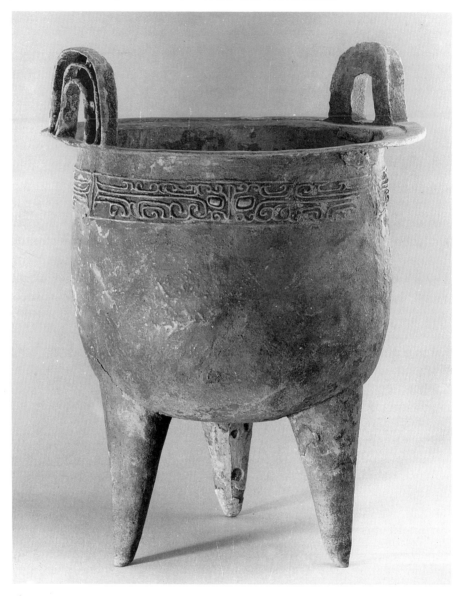

Plate 20

historical fact: as far back as before the 14th century BC, Shang bronze culture had already taken strong root there.

This *ding* with animal mask decoration is one of the larger bronze vessels discovered at Panlongcheng. It has a thin, broad band around its rim and two upright handles which are shaped like curved troughs. Its deep belly is supported by three hollow

tapered legs, so that liquid poured into the *ding* will flow to the bottom of its legs. The animal mask decoration is executed in single lines. All the above are features peculiar to early Shang bronzes. The curved trough-shaped handles and hollow legs show that the technique of sealing the clay core within pottery moulds had not yet been mastered at the time of its casting. There is a clear difference between this *ding* and those of later periods which were cast with the clay cores completely enclosed.

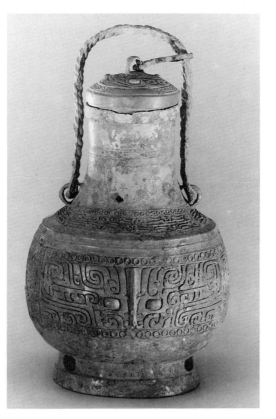

Plate 21

Hu with animal mask decoration (Plate 21)
Erligang Period of the Shang Dynasty
Unearthed at Panlongcheng, Huangpi County, Hubei Province, in 1974
Height 31 cm
Hubei Provincial Museum

Hu is the general name for a type of wine container which was made in many forms, but rare among early Shang bronzes. The bronze *hu* with animal mask decoration unearthed at Panlongcheng shows that this form of bronze vessel was already one in the set of ritual vessels before the 14th century BC. Its mature form indicates that this type of wine container was already popular at the time, but only a few have been discovered. A movable handle is attached to the shoulder of the vessel, and a link joins the lid to the handle. The two movable parts on the vessel show that bronze makers had already mastered the technique of double casting and multiple casting. This was

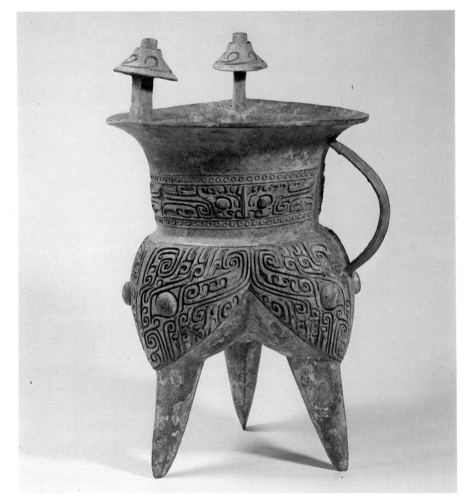

Plate 22

technically a great advance. Mastery of the double-casting technique enabled bronze makers to produce a great variety of bronze articles of exquisite and complicated form.

Jia with animal mask decoration (Plate 22)
Erligang Period of the Shang Dynasty
Height 31.1 cm
Shanghai Museum

In form this unusual bronze *jia* resembles a pottery *li* fitted with two pillars and a handle. Unlike other bronzes of the Shang

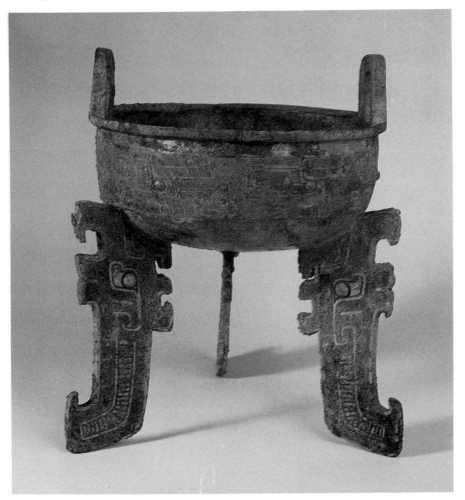

Plate 23

Dynasty unearthed at Panlongcheng, Hubei Province, which generally have relatively simple decoration, this *jia* with animal masks decorating its neck and body appears unusually splendid, yet it follows an early method of casting, with the handle in alignment with one of its legs, and reinforcement of the rim with a band. Its design is relatively mature among bronzes of the same period.

Ding with flat legs of *kui* dragon design (Plate 23)
Middle period of the Yin ruins at Anyang, Henan Province
Height 31.1 cm; diameter of mouth 24.2 cm
Shanghai Museum

This *ding* has large erect handles, and a wide but shallow body supported by three flat legs. Its body is decorated with designs of animals with curled trunks, executed in fine meander patterns and outlined by slightly thicker, incised lines. The animals' eyes are placed at the centre of each design unit. The entire decoration is in smooth, even lines which display fine craftsmanship and are in the characteristic style of the middle period of the Yin ruins at Anyang, the last Shang capital. The three flat legs are made in the shape of *kui* dragons whose curled tails function as supports. The dragons themselves are formed by dense meander patterns with a row of scales in the middle of their bodies. The strong flat legs provide a marked contrast to the simple rounded form of the bowl of the *ding*; such contrasts are a characteristic of Shang Dynasty art.

The Si Mu Wu square *ding* (Plate 24)
Reign of King Wen Ding of the Shang Dynasty
Unearthed at the Yin ruins in Anyang, Henan Province
Height 133 cm; weight 875 kg
Museum of Chinese History

The most massive of the ritual vessels of Shang and Zhou times extant today, the Si Mu Wu square *ding* is a typical example of the highly developed bronze culture of the Shang Dynasty. It has a thick rim and large heavy handles, and the four sides of its body are like four bronze walls. Its handles are decorated

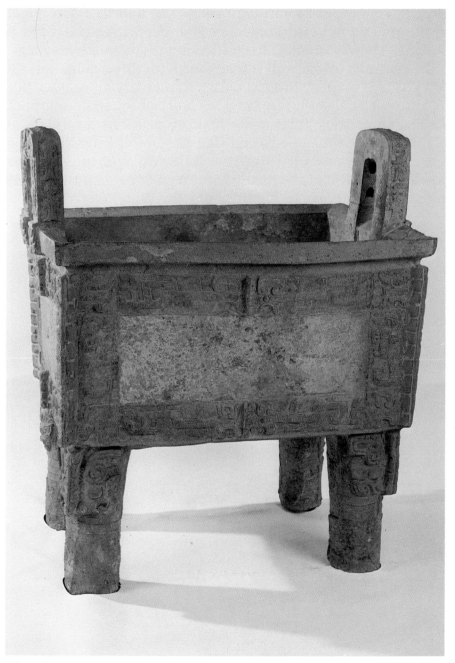

Plate 24

with tigers devouring human heads. The four sides are plain in the middle but surrounded by a border with animal mask designs. The vessel looks magnificent with its four heavy legs.

The vessel's inside wall is inscribed with three characters 'Si Mu Wu'. 'Si' may be interpreted as 'in memory of' or 'sacrifice to'. It has also been interpreted as *'hou'*, or 'queen', a term of address to persons holding the highest positions regardless of sex in ancient times. It is said that the son of King Yu of the Xia Dynasty was called Xia Hou Kai. 'Mu Wu' must be the posthumous title of the Shang King Wen Ding's mother. This *ding* was, then, cast in memory of King Wen Ding's mother.

Plate 25

The He Da square *ding* (Plate 25)
Late period of the Yin ruins at Anyang, Henan Province
Unearthed at Ningxiang, Hunan Province, in 1959
Height 38.5 cm; mouth 23.7 cm by 29.8 cm
Hunan Provincial Museum

This is a medium-sized square *ding* of impressive form. Two large erect handles stand on its thick rim. The upper part of the legs is thicker than the lower, which is characteristic of the late period of the Yin ruins at Anyang, Henan Province, or the late Shang Dynasty. Most square *ding* of the Shang Dynasty are small. There are very few large ones, and medium-sized ones are rare.

What deserves special attention are the four human faces on the four sides of the *ding*. They have well-proportioned features with eyes looking straight forward with a solemn expression. The two curved horns on each side of the forehead, the big ears and the claws flanking the cheeks show that the mask is that of a monster-deity. Very few Shang bronzes are decorated with human-faced beasts, and this *ding* is one of the rare examples.

The two characters, 'He Da', inscribed inside the vessel (see Figure 2, p. 36) are the name of the owner of the *ding*.

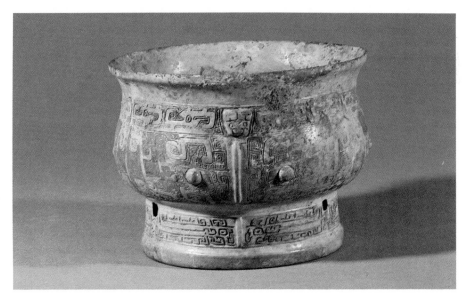

Plate 26

Gui with animal mask decoration (Plate 26)
Middle period of the Yin ruins at Anyang, Henan Province
Height 10.9 cm
Shanghai Museum

The *gui* (ring-footed bowl) is a food vessel for holding cooked rice or millet. With the exception of the eyes, the animal mask designs on the body of the *gui* are executed in gentle and even lines, which create a pleasing contrast with the meander patterns that cover the ground. A frieze of beasts with elephant trunks surrounds the rim, and the foot-ring is decorated with tiger head designs. The composition of these designs still retains some of the style of the early period of the Yin ruins. The three square holes in the foot-ring were for preventing corrosion with accumulation of moisture after long use and enclosure. There are often large crosses or square holes in the tall ring-footed vessels of the early Yin ruins period. Similar openings can also be found in the tall foot-rings of pottery vessels from the same period, which were also for preventing the absorption of moisture. To allow more space for decoration in bronzes of the late period of the Yin ruins, the square holes were made progressively smaller until they had completely disappeared or remained only as symbolic vestiges. The practice, however, never achieved very good results, particularly in damp areas. From the Western Zhou on, animal legs were added to the foot-rings to support the entire vessel.

Jue with a single pillar and animal masks (Plate 27)
Early period of the Yin ruins at Anyang, Henan Province
Unearthed in Feixi, Anhui Province, in 1965
Height 38.4 cm
Anhui Provincial Museum

The *jue* is the most frequently seen drinking vessel. Several tens were uncovered from the tomb of Fu Hao in the Yin ruins, while the number of other types of wine containers from the same tomb was much smaller.[72] This *jue* with tall legs could also

72. See note 16.

have been used for warming wine. Most bronze *jue* have a pair of pillars. A single-pillared example is rare.

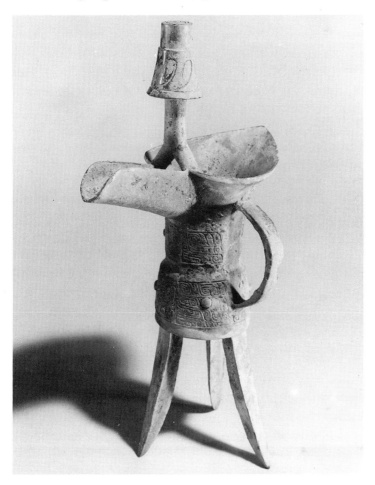

Plate 27

The Huang *gu* (Plate 28)
Middle period of the Yin ruins at Anyang, Henan Province
Height 27.3 cm
Shanghai Museum

The *gu* (trumpet-mouthed beaker) is a drinking vessel. Its neck is decorated with a triangular variation of the animal mask design, also known as the banana leaf design. Two sets of symmetric dragon designs cover its waist. The design of *kui*

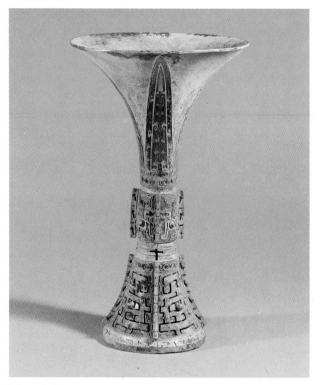

Plate 28

dragons with symmetric curved horns on its foot-ring is pierced, which not only enhances their ornamental effect, but also helps to ventilate the foot-ring and prevent it from rusting. The name of the owner is inscribed on the inside of the foot-ring.

Zun with dragons and tigers (Plate 29)
Early period of the Yin ruins at Anyang, Henan Province
Unearthed near the Minor Grand Canal at Zhuzhai, Funan County, Anhui Province
Height 50.5 cm
Museum of Chinese History

All the other bronzes unearthed at the same spot, including *jia*, *gu* and *jue*, are larger than usual.

The *zun* (jar) is a large wine container. Early *zun* all have shoulders, and on the shoulder of this *zun* are three coiled dragons whose heads protrude beyond the vessel's surface. The

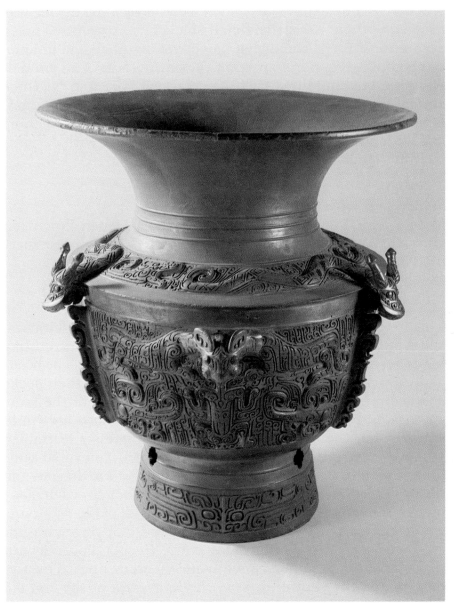

Plate 29

principal decoration on the belly of the vessel is three sets of a group representing a tiger eating a demon. Each of the tigers has one head and two bodies. The purpose of this strange composition was to present the entire image of a fierce tiger seen frontally, which is visually impossible and, therefore,

schematized to a split body. Such a compositional device was adopted without exception for all Shang Dynasty animal mask decorations. It is a somewhat naïve, yet dignified and unique, method of expression to present the entire form of an animal. A similar but simplified style of expression is seen in the three animal mask designs on the lower part of the body of the *zun*. Beneath the mouth of each tiger is a strange figure, crouching and with arms raised. The nude body is covered with designs, and the hands are like claws.

Square *zun* with four rams (Plate 30)
Middle period of the Yin ruins at Anyang, Henan Province
Unearthed at Huangcai, Ningxiang County, Hunan Province, in 1938
Height 58.3 cm
Museum of Chinese History

This is the largest existing square *zun* among Shang bronzes, and is famous for its unique shape. Four large rams with curling horns are cast on the shoulder and belly of the vessel. The heads of the rams are covered with meander patterns, and their necks and bodies with scale patterns. The slender legs of the rams are attached to the foot-ring of the vessel. Sheep are timid animals, but the four rams on the vessel express a restrained yet awe-inspiring dignity. The entire vessel is covered with finely executed designs, banana leaf patterns of *kui* dragons and ribbon-like animal masks on the neck, and four coiled dragons in high relief on the shoulder. The front parts of the four rams are decorated with crested birds, and the foot-ring with *kui* dragon designs. The ground of the entire vessel is covered with meander patterns in fine, smooth and vigorous lines. The four corners and the centre lines on the four sides of the *zun* are decorated with raised vertical ridges in openwork pattern, relieving the monotony of flatter surfaces and increasing the grandeur of the vessel. These flanges also cover up unevenness at the seam joins of the moulds.

 The heads of the rams and dragons were cast first, and then inserted to the moulds before the body of the vessel was cast. This method of double casting has solved many problems

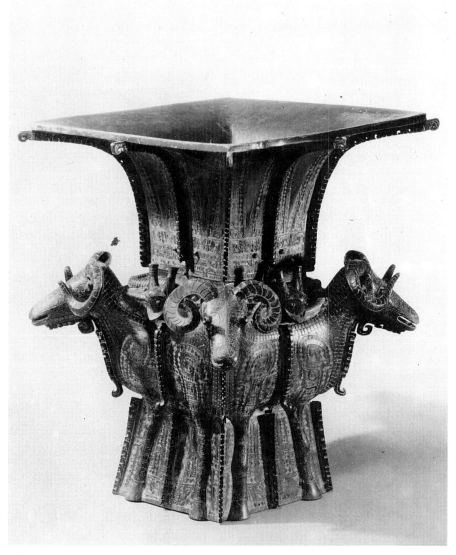

Plate 30

in producing vessels of complicated shapes. The techniques of painting, engraving and bas-relief have been employed in the decoration of the *zun*, to combine two-dimensional patterns with three-dimensional sculptures, and unite the animal and vessel form into one. All this was brought about with superb casting techniques. This *zun* is undoubtedly one of the most outstanding examples of the bronze art of the Shang Dynasty.

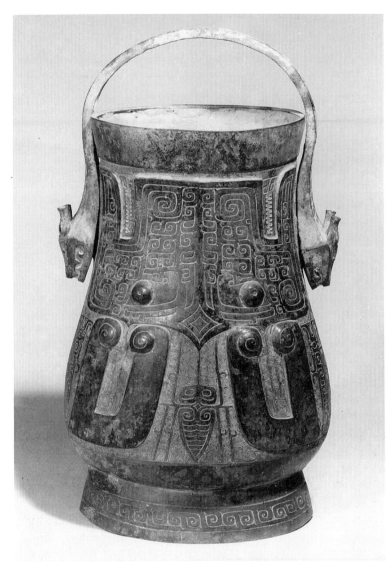

Plate 31

Hu with animal mask decoration (Plate 31)
Middle period of the Yin ruins at Anyang, Henan Province
Unearthed at Taohua Village, Shilou, Shanxi Province, in 1959
Height 42 cm
Shanxi Provincial Museum

This flat, oval *hu* has a wide mouth, and no clear distinction
between its neck and body. This vessel form was popular during

the middle period of the Yin ruins in the Shang Dynasty, and two versions exist: one with a handle and the other without. The version without a handle has two rings attached to each side of the neck, through which rope could be looped to serve as a handle. This *hu* with animal mask decoration has a large broad handle with a dragon head on each of its ends. What deserves attention is the fact that the ends of the handle would cover a considerable part of the vessel's decoration at whatever angle the handle was placed. It is clear that the vessel's body was cast first and that, after its moulds were removed, a second casting was made for the handle. Otherwise, it would have been impossible to position the moulds for casting the decoration obscured by the handle. This vessel is a very good demonstration of the process of casting. A large animal mask, like the head of a bear, covers the entire vessel, and there is a cicada motif on its forehead. The whole mask is placed upside down, which was probably a custom of the time, as reversed patterns are often found on the lids of bronze vessels of the same period.

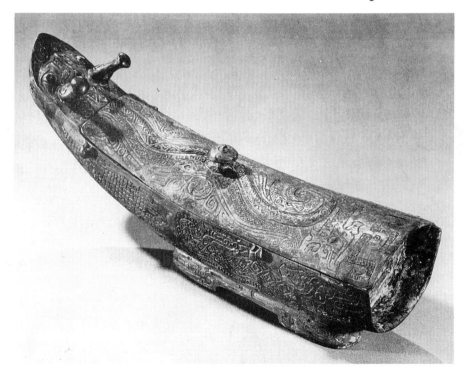

Plate 32

Gong with dragon design (Plate 32)
Middle period of the Yin ruins at Anyang, Henan Province
Unearthed at Taohua Village, Shilou, Shanxi Province
Height 19 cm; length 44 cm
Shanxi Provincial Museum

The *gong* is a wine container with a lid, the front end of which is made in the shape of an animal head. It is sometimes equipped with a ladle, but wine could also be poured out of it through a spout. This *gong* is formed like an ox horn, with its mouth shaped as a dragon head. The lid is decorated with the sinuous body of a dragon, and its rear end is covered with snake patterns. There are lizard and dragon patterns around the vessel's sides. The unusual shape of this vessel shows that it was derived from the natural form of an ox horn. Later *gong* of rhinoceros form and *gong* of *yi* shape were all developed on the basis of the horn-shaped *gong*. The form of this *gong* with dragon design has, to some extent, preserved characteristics of an earlier period.

Since 1949, several groups of Shang bronzes have been unearthed in Shanxi Province, most of them belonging to the early period of the Yin ruins. The Shilou finds were the most concentrated and of a high quality. The county of Shilou is situated in western Shanxi Province, near the Yellow River. The discovery of bronzes in tombs in Shilou was of immense value to our understanding of the distribution of Shang bronze culture in Shanxi Province.

The Fu Hao hawk-shaped *zun* (Plate 33)
Middle period of the Yin ruins
Unearthed from Tomb No. 5 of the Yin ruins at Anyang, Henan Province, in 1976
Height 45.9 cm; weight 16.7 kg
The Institute of Archaeology, Chinese Academy of Social Sciences

An intact tomb of the spouse of a Shang king was discovered among the hillocks north of Xiaotun Village in the Yin ruins at Anyang by the Anyang Work Team of the Institute of Archaeology of the Chinese Academy of Social Sciences.

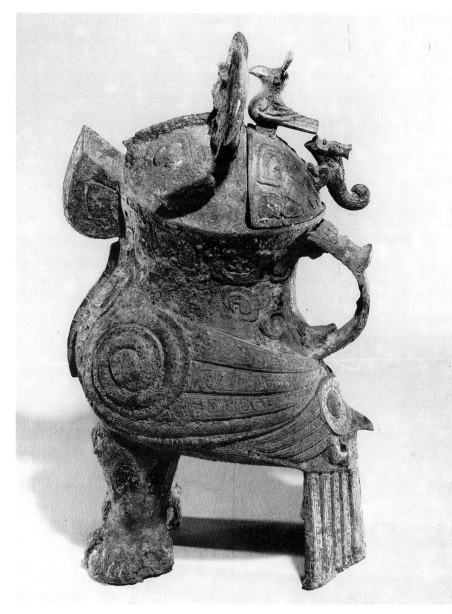

Plate 33

Excavation of the tomb yielded over 1,600 burial objects, including approximately 440 bronzes, 590 jades, and over 600 bone, stone and ivory carvings, as well as nearly 7,000 cowries — the largest collection ever found in a Shang tomb. Half of the bronzes are ritual vessels, many of them unusually large,

reflecting the grandeur of the Shang royal house. As most of the bronzes bear the inscription of Fu Hao, it is deduced that Tomb No. 5 is the tomb of Fu Hao.

This hawk-shaped *zun* is of considerable size, weighing 16.7 kilogrammes. Its vessel form is that of a hawk with hooked beak and *kui* dragon-shaped crest. The hawk has two round eyes and, behind its head, a lid on which stand a small bird and a dragon. There is a two-headed animal motif covering both sides of the hawk's neck, a cicada motif on its back, and an animal mask motif with branched horns on its breast. The hawk's two wings are decorated with designs of coiled snakes, and its tail with an owl motif showing only the head, wings and claws. The hawk's long tail and its two powerful claws form three supports for the vessel. On the back of the hawk is a handle under which is a large animal mask design. More than ten types of differently formed animals can be found in the decoration covering the vessel. This practice of assembling many kinds of strange creatures on one vessel reached its highest point of development in the middle period of the Yin ruins. These highly imaginative compositions are profound and mysterious themes strongly expressing the characteristics of the Shang culture.

Large *nao* bell with animal mask and elephant decoration (Plate 34)
Late period of the Yin ruins at Anyang, Henan Province
Unearthed at Laoliangcang, Ningxiang County, Hunan Province, in 1959
Height 67 cm
Hunan Provincial Museum

The bronze *nao* bell is a percussion instrument. Its mouth opens upwards. It has a hollow stem so that a pin could be inserted into it from a pedestal. *Nao* bells can be either large or small, small examples being arranged in a group of three with progressively higher pitch so that the group covers only three notes. Most large examples have been discovered singly, but those unearthed in Ningxiang are an exception. There are altogether five, with four arranged in a row and one above the others. Each of the five bells is different in decoration. The rim

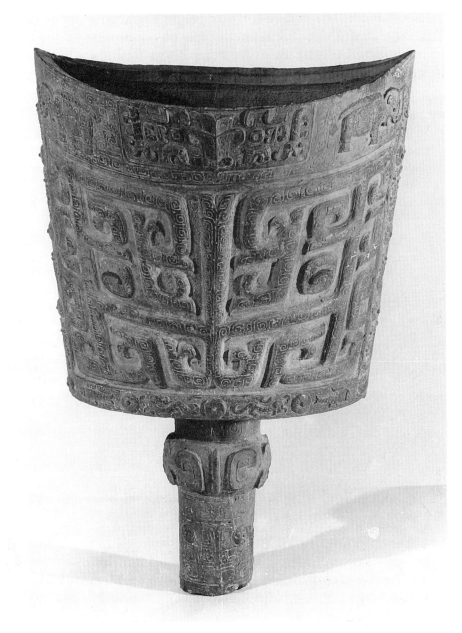

Plate 34

of the largest *nao* bell is decorated with an animal mask in the centre flanked by elephant motifs on each side. The principal decoration on this bell is a variation of the animal mask with flame, dragon and fish motifs surrounding it. This type of *nao*

was popular at the end of the Shang and beginning of the Zhou Dynasty. It was the forerunner of chimes of bronze *zhong* bells that appeared in the mid Western Zhou Period, which were hung with the mouth downward.

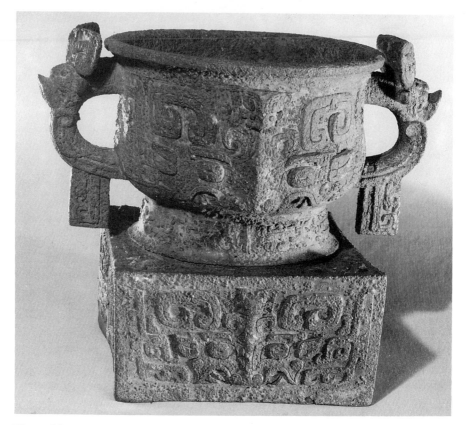

Plate 35

The Li *gui* (Plate 35)
Reign of King Wu of the Western Zhou Dynasty
Unearthed at Linghexi of Lingkou Commune, Lintong County, Shaanxi Province, in 1976
Height 28 cm
Lintong County Cultural Centre

The Li *gui* is placed on a square pedestal. Both the vessel and the pedestal are decorated with large animal masks separated by a band of *kui* dragons on the foot-ring. There are cicada motifs on the borders of the pedestal's sides.

The inside bottom of the *gui* is inscribed with 32 characters in four columns. Although the inscription seems simple, there have been many different interpretations of it. It begins with an account of King Wu's expedition against the Shang on the morning of the *jia zi* day. The Sui star was ahead when the turbulent King Zhou of the Shang was defeated. Eight days later, on the *xin wei* day, King Wu was at Guanqi and rewarded the official Li with bronze from which Li had the present ritual vessel cast to offer sacrifices to the Duke of Dan. The sentence for 'The Sui star was ahead and the turbulent King Zhou of the Shang was defeated' is so terse in the original that it permits many different interpretations. The fact that the Sui star was ahead when King Wu conquered the Shang is recorded in various histories. The book *Huai Nan Zi* says: 'When King Wu launched the expedition against the Shang, he marched eastward toward the Sui star.'[73] A similar record also appears in *The Book of Xun Zi*.[74] The Sui star is Jupiter, whose orbit around the sun is completed in about 12 years. It has been deduced from bronze inscriptions and relevant historical material that King Wu launched his expedition in 1069 BC, the year when the Sui star was visible. The Li *gui* is the only extant relic bearing reference to King Wu's expedition against the Shang. The year of the expedition recorded in the inscription coincides with that in historical records. The discovery of the Li *gui* was one of the most important events in Chinese archaeology in the 1970s.

The Junior Minister Shan *zhi* (Plate 36)
Reign of King Cheng of the Western Zhou Dynasty
Height 13.8 cm
Shanghai Museum

A certain type of circular vase-shaped wine cup is traditionally called *zhi*. This type, however, has a compressed oval body, and some examples have lids. Rare examples are inscribed with the name *guan*.

The present *zhi* is simply decorated with a band of phoenix

73. *Huai Nan zi*, 'Bing lue xun'.
74. *Xun zi*, 'Ru xiao bian'.

Plate 36

around its neck. Its inscription is cast on the inside bottom, relating that King Cheng crushed a rebellion staged by Wu Geng. It states that when Queen Chu defeated the Shang at Chengqi, the Duke of Zhou rewarded Junior Minister Shan with ten strings of cowries. According to historical texts, when King Wu vanquished the Shang, he enfeoffed the Shang King Zhou's son Wu Geng (Lu Fu) at Yin in order to win over the remnant forces of Shang nobles. He also enfeoffed his own younger brothers, Guan Shu, Cai Shu and Hou Shu, there so that they would watch over Wu Geng. When King Wu died, the Duke of Zhou acted as regent. Guan Shu and Cai Shu were dissatisfied and accused the regent of excessive ambition. Wu Geng took this opportunity to conspire with Guan Shu and Cai Shu, and fomented a rebellion which soon spread to the eastern and southern parts of the country, endangering Western Zhou rule. The Duke of Zhou was delegated to launch an eastern expedition to suppress the rebellion, taking three years to win a complete victory. This war was a highly important factor in the consolidation of Zhou dynastic rule. The inscription shows that Junior Minister Shan was a participant in this war and that, when the great army camped at Chengqi, the Duke of Zhou gave him ten strings of cowries as a reward for his service.

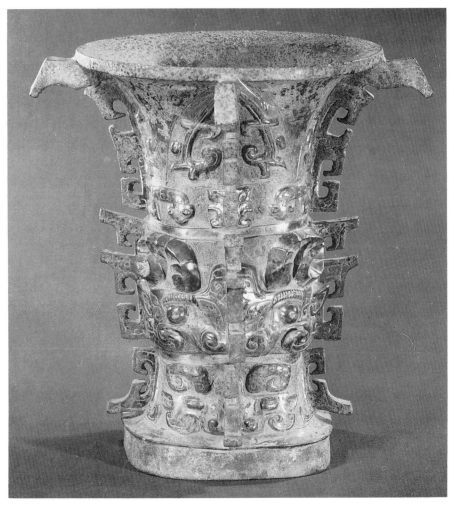

Plate 37

The He *zun* (Plate 37)
Reign of King Cheng of the Western Zhou Dynasty
Unearthed in Baoji, Shaanxi Province, in 1964
Height 38.8 cm
Baoji City Museum

This magnificent ritual *zun* belonged to a slave-owning noble named He. A long inscription on its inside bottom tells of the construction, in the fifth year of King Cheng's reign, of the Zhou capital Luoyi, an important event in the early Zhou Dynasty.
 The gist of the inscription is that when the king began to build

the Zhou capital, he held a grand sacrificial ceremony in memory of King Wu. On the day of *bing wu* in the fourth month, the king in the palace admonished He, the young son of the clan head: 'Your deceased father Gong assisted King Wen who received the mandate of Heaven to rule over the country. Later, King Wu took the Shang capital, the great city of Shang, and offered sacrifices to Heaven, saying, "I will rule over the people".' The king also said: 'Gong performed meritorious service to Heaven. You must sincerely offer sacrifices to him.' After his admonition, the king rewarded He, the young son of the clan head, with 30 strings of cowries. Then, He recorded his glorious audience with the king and the reward he had received on the ritual vessel for offering sacrifices to his father Gong. This was in the fifth year of the king's reign. The king referred to in the inscription was obviously King Cheng.

The inscription mentions King Wen's mandate of Heaven, King Wu's overthrow of the Shang Dynasty, the establishment of the capital Luoyi and the continued construction of Luoyi by King Cheng, which were all important historical events. The person who commissioned the casting of the *zun*, He, was the young son of the clan head and a high-ranking slave-owning noble. His father was King Wen's confidant.

After the overthrow of the Shang Dynasty by King Wu, the country was in a chaotic state. Slave-owning Shang nobles, in particular, still retained considerable influence. They joined forces with the Yi in the east, and the Huai Yi in the south, and seriously threatened the newly established Zhou Dynasty. To cope with this situation, King Wu built the new capital at the locality then known as the centre of the country, from where he could make his influence felt in the eastern and southern parts of the country. This was an important strategic decision, which greatly helped to consolidate the rule of the Zhou Dynasty. From then on, Luoyi (near present-day Luoyang in Henan Province) became the capital of many feudal dynasties in Chinese history.

The inscription on the He *zun* reflects the Western Zhou Dynasty's intention to establish a powerful rule over China at the time when the slave system thrived, and is a very important historical document.

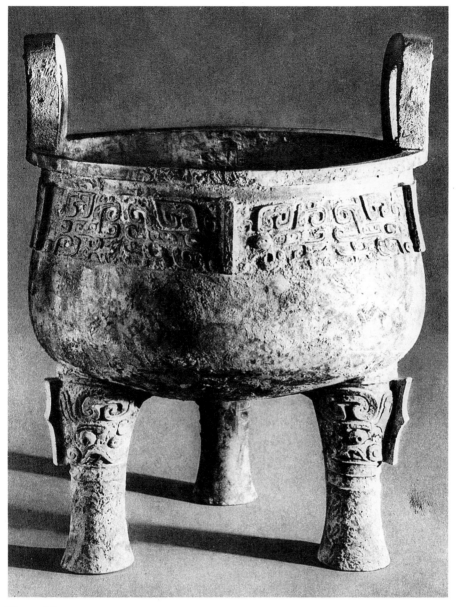

Plate 38

The Jin *ding* (Plate 38)
Reign of King Cheng of the Western Zhou Dynasty
Unearthed in Liulihe, Fangshan, Beijing, in 1975
Height 62 cm; weight 41.5 kg
Beijing Cultural Relics Bureau

A group of Western Zhou tombs was discovered in Beijing for the first time in 1973: at Huangtupo in Liulihe, Fangshan. There were slaves buried with the dead in these tombs, as well as a large number of bronze objects and other cultural relics. Many of the bronze inscriptions had the title 'The Marquis of Yan' in them, proving that the site was the burial ground of nobles of the state of Yan in the early Zhou Dynasty. The discovery of this burial ground was another important event in China's recent archaeological work.

Among the important finds from this burial site was the Jin *ding*, which is heavily formed and weighs 41.5 kilogrammes. The form and decoration of this *ding* are typical of the periods of King Cheng and King Kang. On the inside wall is an inscription of 26 characters, which can be summarized as follows: the Marquis of Yan ordered Jin to deliver gifts to the Grand Guardian at the capital, Zhongzhou. On the day *geng shen*, the Grand Guardian rewarded Jin with cowries and Jin had this *ding* made for the Prince Kui.

The Grand Guardian in the early Zhou Dynasty was Shi, the Duke of Zhao, a famous statesman who was enfeoffed in Yan. The enfeoffment of a feudal lord in Yan was an important event in the history of the early Zhou Dynasty. However, Shi never went to Yan to hold his fief, and the title of Marquis of Yan was assumed by his son. The Marquis of Yan's presentation of gifts to the Duke of Zhao by Jin shows that the state of Yan had very close relationships with the Zhou court. This *ding* is an important cultural relic of early Zhou Dynasty history.

The You Zheng square *ding* (Plate 39)
Early Western Zhou Dynasty
Unearthed at Beidong Village, Gezuo County, Liaoning Province
Height 51.7 cm
Liaoning Provincial Museum

Since 1949, bronze objects of the Shang and Zhou Dynasties have been found several times in Gezuo County along the Daling River in Liaoning Province. A large *yu* of the Marquis of Yan was found in Lingyuan to the north-west of Gezuo. Not

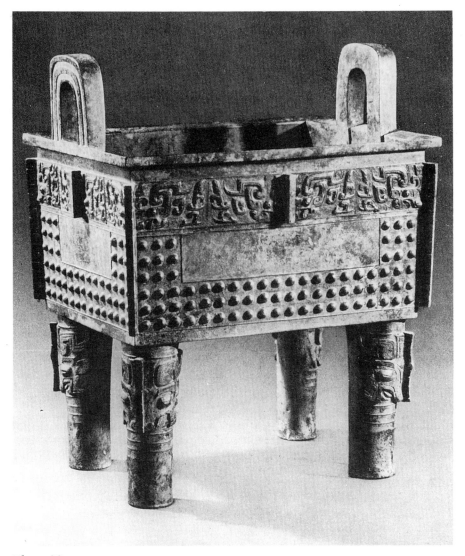

Plate 39

long ago, a group of very fine bronze ritual vessels was unearthed at Beidong Village in Gezuo, of which one is this square *ding*.

The *ding* has a rectangular trough-like body decorated on its exterior with the conventional animal masks and nipple studs. The size of the *ding* is unusual, being smaller than the largest examples but larger than medium-sized ones. Its inscription of 27 characters inside the vessel relates that Huai gave 2,000

cowries in 200 strings to the man holding the official title of You Zheng at a place called Mu. The recipient extolled Huai's generous gift and had this *ding* made to offer sacrifices to his mother Ji. Huai was a member of the Jihou Yayi clan.

The chiefs of the Jihou Yayi clan served as officials in the state of Yan during the early Zhou, and received rewards from the Marquis of Yan. Bronze vessels bearing the name of this clan have been found near the Marco Polo Bridge on the outskirts of Beijing. The discovery of this *ding* with the clan's name on it shows that the heads of the Jihou Yayi clan held influential positions in the state of Yan. Even more important is that their bronze vessels furnish convincing proof that areas of today's Liaoning were already part of the large fief of the Marquis of Yan in the early Zhou Dynasty, and that the territory of the state of Yan extended over a considerable area.

The great Yu *ding* (Plate 40)
Reign of King Kang of the Western Zhou Dynasty
Unearthed at Li Village, Mei County, Shaanxi Province, early in the reign of the Qing Emperor Daoguang (1821-50)
Height 101.9 cm
Museum of Chinese History

The great Yu *ding* is the largest bronze *ding* of the Western Zhou Period so far unearthed. An inscription of 291 characters is cast on the inside wall of the *ding* (see Figure 3, p. 36). It records King Kang's instructions to the high-ranking nobleman Yu and the king's bestowal of wealth on him. The inscription is in two parts.

The main points of the first part are as follows: in the ninth month, at the capital, Zhongzhou, the king gave instructions to Yu. King Kang said: 'Listen Yu! King Wen received the great mandate of Heaven to rule over the country. King Wu succeeded to King Wen's cause, crushed the evil man [referring to King Zhou of the Shang], gained the territory reaching to the four corners of the country and ruled over the people. Officials imposed restrictions on wine and refrained from drinking when meat was cooked for offering sacrifices. That was why Heaven protected the former kings in their rule of the country.' King

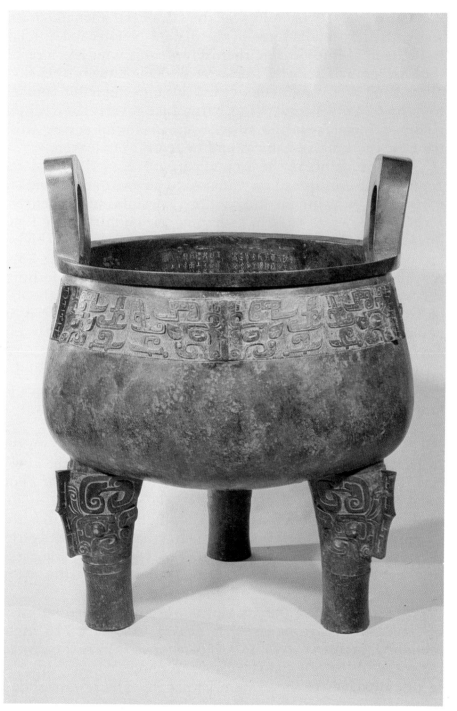

Plate 40

Kang also said: 'I was told that the fall of the Shang Dynasty was caused by feudal lords in the distant regions and officials in the capital intoxicating themselves with wine. As a result the Shang king's army was destroyed.' King Kang further said: 'Take King Wen's righteous virtue as an example for yourself to follow.' Yu was ordered to harmonize reverently with the guiding principle of virtue, to persevere in offering advice, work hard for the king's business and be fearful of Heaven.

The main points of the second part are: King Kang ordered Yu to assist him in military affairs, to be swift and careful in meting out punishment and handling lawsuits, and to help the king from dawn to dusk in governing the country. King Kang himself was to follow the virtue of former kings in receiving the people and territory given to him by Heaven. King Kang rewarded Yu with a *you* of golden ritual wine, hats, clothing, shoes, horses and carriages. The reward also included the flag of Yu's ancestor, the Duke of Nan, so that he could fly it on his hunting chariot. There were also four foremen slaves and 659 ordinary slaves from carriage drivers to peasants; 13 Yi foremen slaves and 1,050 ordinary Yi slaves. To extol the lofty virtue of the king, Yu had this *ding* cast to offer sacrifices to his ancestor, the Duke of Nan. This was in the 23rd year of King Kang's reign.

The first part of the inscription lays particular stress on the mandate of Heaven with the purpose of strengthening the king's rule. This served as a protective talisman to be used by the Zhou royal house against the Shang. On the other hand, in his instructions, King Kang spoke of 'righteous virtue' and 'the guiding principle of virtue', showing that ideologically the Western Zhou slave-owning aristocrats vigorously advocated rule by virtue, for rule by virtue and rule by rites were interdependent.

The second part of the inscription records the large number of slaves in the reward. There was a total of 1,726 men, including foremen slaves, in two categories. The first category consisted of the original slaves of the Zhou Dynasty, and the second of slaves of the eastern Yi people. The reward shows that society at that time was at the height of the period of the slave system.

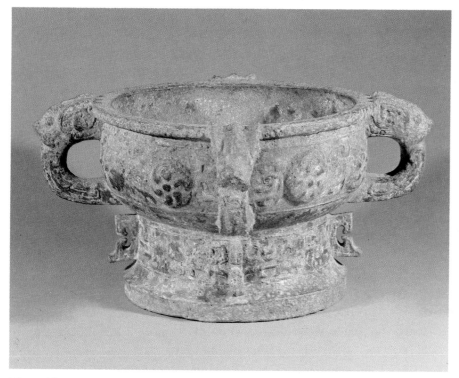

Plate 41

The *gui* of Ze, Marquis of Yi (Plate 41)
Reign of King Kang of the Western Zhou Dynasty
Unearthed at Yandunshan, Danxi County, Jiangsu Province,
in 1954
Height 12.7 cm
Museum of Chinese History

This *gui* has four handles and a high foot-ring. Its body is
decorated with flame and *kui* dragon designs, and the foot-ring
with bird designs. The owner of the *gui* vessel was a noble
named Ze, originally the Marquis of Ze, but later re-enfeoffed
in Yi to become the Marquis of Yi. There are 119 decipherable
characters on the inside of the vessel; the rest of the characters
in the inscription are damaged and illegible. The inscription
records the re-enfeoffment of Ze as the Marquis of Yi by King
Kang of the Zhou Dynasty, and furnishes some historical facts
on the early Zhou Dynasty as well as specific data on the system
of enfeoffment.

The inscription relates how King Kang first examined pictures of King Wu's expedition against the Shang and King Cheng's expedition against Wu Geng, and a map of the eastern regions of the country, and then he re-enfeoffed Ze at Yi in the east to make him the Marquis of Yi. The inscription lists the four awards bestowed on the Marquis of Yi in King Kang's decree of enfeoffment: first, a *you* of sacrificial wine and a *zan* of the Shang Dynasty (the sacrificial wine was for Ze to offer in his ancestral temple on the occasion of the re-enfeoffment, and the *zan* was also a sacrificial vessel); second, a bow and arrows, which were symbols of military power by which the marquis could undertake military campaigns against anyone within his territory; third, land, the principal means of production, including 300 parcels of fertile land at the foot of a mountain and large areas of land in other places (the figure has become indiscernible), as well as 35 towns; and fourth, slaves in large numbers, including 17 surnames from the area of Yi, 1,050 farming slaves supervised by seven foremen slaves, and 600 other slaves who were engaged in farming in Yi. From these awards we can see that the true nature of enfeoffment was in the distribution of power and wealth among slave-owning aristocrats.

To maintain their rule over vast territories, the slave-owning class in the early Zhou Dynasty adopted the system of universal enfeoffment of feudal lords, or regional distribution of land and slaves with the royal house as the centre. This was also known as establishing the state by enfeoffment. Feudal lords had formally only the right to use but not the right to own land, which was a special form of ownership for the slave-owning class. Large-scale enfeoffment was the outcome of the political situation at that time. It facilitated the suppression and appeasement of tribes and clans hostile to the Zhou house, and the establishment of a number of ruling areas of strategic importance on the national scale.

The inscription says that King Kang decided to re-enfeoff Ze at Yi after he had examined pictures depicting King Wu's and King Cheng's expeditions, and a map of the eastern regions. This was because the most serious rebellions in the early Zhou broke out in the eastern regions where there still remained

remnant forces of Shang slave-owners and hostile tribes, such as the Xiong, the Ying and the Bogu. This enfeoffment, therefore, helped to stabilize and consolidate Zhou rule in the east. As the inscription indicates, Ze was probably not the only feudal lord who was enfeoffed by King Kang in the east at the time.

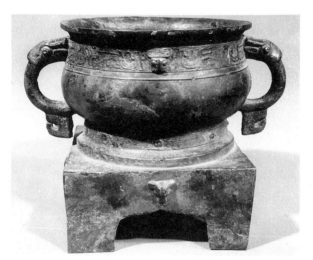

Plate 42

The Count of Guo *gui* (Plate 42)
Reign of King Zhao of the Western Zhou Dynasty
Height 18.4 cm
Lushun Museum

This is a *gui* on a square stand. There is a decorative opening at the lower centre of each side of the stand to prevent moisture from accumulating inside the stand which would have produced corrosion. The simply shaped *gui* has no complicated ornaments. The 16-character inscription inside this vessel records that the Count of Guo accompanied the king in an expedition against the rebellious state of Chu. Bronze was seized, which was used by the count for casting this ritual vessel for his clan's shrine. The state of Chu had originated on Mount Jing, and so Jing became an alternative name for the state of Chu. The royal house of the Western Zhou launched large-scale expeditions against the state of Chu during the reign of King Zhao. According to the *Annals of Zuo Qiuming*, in the fourth

year of the Duke of Xi, 'King Zhao started a campaign against the south and did not return.'[75] Historical records say that King Zhao launched one expedition against the Chu in the 16th year of his reign, and another in the 19th year when the sky over Chu was dark, without light from either sun or moon, and even pheasants and hares showed alarm. Six divisions of the royal guard of the Western Zhou were defeated at Hanshui, and King Zhao lost his life in the battle. The Chu must have been a very powerful state at that time.

The inscription must be a record of the first expedition of the 16th year, as King Zhao did not return from the southern expedition in the 19th year.

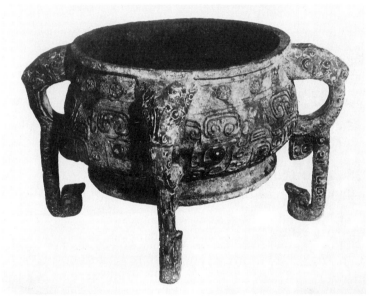

Plate 43

The Ban *gui* (Plate 43)
Reign of King Mu of the Western Zhou Dynasty
Height 22.7 cm
Beijing Cultural Relics Bureau

This vessel was originally preserved in the Qing imperial palace. It was lost when the armies of the Eight Allied Powers occupied

75. *Zuo zhuan*, 'Xi gong, fourth year'.

Beijing in 1900. In 1972, the Beijing Cultural Relics Administrative Department (now the Beijing Cultural Relics Bureau) rediscovered it already broken among bronze fragments. Fortunately, its inscription is largely undamaged, and the vessel has been restored. Its form is unique, with the four handles extending downwards to serve as supports for the vessel.

On the inside of the vessel is an inscription of 182 characters, which relates mainly events of an expedition against the eastern state of Yuanrong. The contents include the following points: first, the Zhou king ordered Count Mao to replace Cheng, the Duke of Guo, his duties being to protect the king and supervise the three vassal states of Fan, Shu and Chao in the east; second, Count Mao was also ordered to lead the generals, foot soldiers and chariots, and the other people of his state in an expedition against the eastern state of Yuanrong; third, the king also ordered the Counts of Wu and Lü to fight on Mao's left and right wings, and to start the campaign together with their clansmen. This war lasted for three years before the eastern states were pacified. In his report of victory to the king, Count Mao said that the Yuanrong people were stupid and knew nothing at all about the mandate of Heaven, and that was why they were destroyed. The last paragraph of the inscription mentions the name of the owner of the vessel, Ban, or Mao Ban. Positions in the clan hierarchy ranging from King Wen to Ban himself are listed in the inscription, showing that Ban was the grandson of Mao Shu Zheng, the 'holy grandson' of King Wen and his queen, and thus from the most prominent of noble families.

Mao Ban's name is mentioned in the 'Biography of King Mu'.[76] It is said that in the last years of King Mu, the lords Mao Ban, Gong Li and Feng Zhou led an expedition against the Quanrong. Mao Ban, therefore, must have been a military commander during the time of King Mu. In the past, the Ban *gui* was dated to the period of King Cheng without sufficient evidence. Today, many scholars believe that it belongs to the period of King Mu. Both the script and the styles of decoration on the vessel also fully accord with the period of King Mu. The

76. *Mu tian zi zhuan.*

expedition against the eastern states in King Mu's time has not been recorded in history. The account given in this inscription may fill in such an omission.

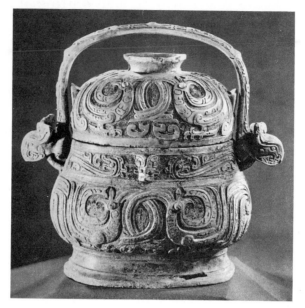

Plate 44

You with phoenix design (Plate 44)
Early Western Zhou Dynasty
Unearthed at Yiqi Commune, Tunxi County, Anhui Province
Height 22.3 cm
Anhui Provincial Museum

This exquisitely decorated *you* is covered with designs of large phoenixes both on its lid and body. The heads of the phoenixes are turned back, with their crest feathers entwined. In addition to the splendid decoration, its casting technique is also perfect. It is an unusually fine example among Western Zhou bronze *you* discovered since 1949.

It is worth noting that the *you* was found in an ancient tomb of a later period in Tunxi, Anhui Province. Buried with it were bronze vessels of the Spring and Autumn, and Warring States Periods, some of which imitate Shang and Western Zhou styles in their forms and decoration, while also having distinct regional characteristics. The geographical position of the tomb shows

that these bronzes are material remains from the ancient Yue people. The fact that this fine bronze vessel of the early Western Zhou Dynasty was buried in a Yue tomb in the transition between the Spring and Autumn, and Warring States Periods proves that the Yue people had a great admiration for the culture of the Central Plain.

Plate 45

The Lü foal-shaped *zun* (Plate 45)
Reign of King Gong of the Western Zhou Dynasty
Unearthed at Li Village, Mei County, Shaanxi Province
Height 32.4 cm; length 34 cm
Museum of Chinese History

This *zun* vessel is realistically modelled in the shape of a foal. On the back of the foal is an opening with a lid, through which wine could be poured in and ladled out. Animal-shaped *zun* are relatively rare, and this example in the form of a foal is unique.

The inscription cast on the chest of the foal says that on the *jia shen* day of the 12th month, the king participated for the first time in the ceremony of 'bitting the horse'. He ordered Shi Ju to summon Lü to an audience, and rewarded him with two foals. Lü kowtowed to the king, thanking him for not having forgotten this humble descendant of the old clan and for bestowing on him such high honour. Lu had the present *zun* made to commemorate his deceased father Da Zhong. There is also a simple inscription on the lid of the *zun*.

The ceremony of 'bitting the horse' was held when the foal had grown into a horse, was separated from its dam, bridled and taught to pull a cart. According to *The Rites of Zhou*, the ceremony was held in spring and sacrifices were offered to the God of Horses. The *Lesser Annuary of the Xia Dynasty* says that it was held in early summer.[77] The inscription testifies that it was held in the 12th month, or in winter. The ancients paid particular attention to raising horses, as they were not only a means of transport, but also the means by which war chariots were driven. The fighting capacity of the army was largely determined by the breeding and training of horses. That was why even the king of the Zhou Dynasty took part in the ceremony of 'bitting the horse'.

The Wei *he* (Plate 46)
Reign of King Gong of the Western Zhou Dynasty
Unearthed at Dong Family Village, Qishan County, Shaanxi Province
Height 29 cm
Shaanxi Provincial Museum

Inside the lid is an inscription of 132 characters. It records Qiu Wei exchanging jades and ceremonial robes for 1,300 *mu* of land. On the *ren yin* day of the third month in the third year of King

77. *Zhou li*, 'Xia guan, xiao ren'; *Xia xiao zheng*.

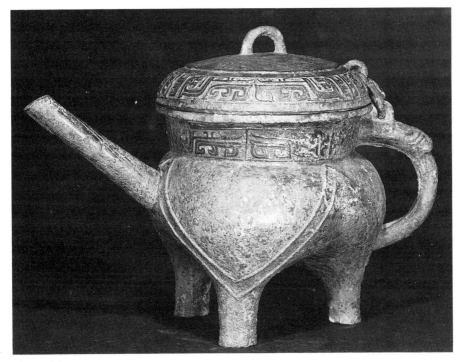

Plate 46

Gong's reign the Zhou king held a ceremony for setting up the flag. The commoner Ju Bo acquired from Qiu Wei a jade sceptre which could be used as a gift when he had an audience with the king, and which was worth 80 strings of cowries. Qiu Wei agreed to the exchange and requested Ju Bo to hand over 1,000 *mu* of land. Ju Bo gave 300 more *mu* of land and obtained from Qiu Wei two red jade tigers, two ceremonial robes and a multi-coloured short apron, all of which were worth 20 strings of cowries. Qiu Wei reported the transaction to the court ministers Bo Yi Fu, Rong Bo, Ding Bo, Liang Bo and Shan Bo, who ordered the Minister of Civil Affairs, Wei Yi, the Minister of War, Shan Lü, and the Minister of Works, Yi Ren Fu, to preside over the transfer of the land. Xian, Fu and Wei's son Yang welcomed them and entertained them at a banquet.

This exchange of goods for land among slave-owning aristocrats of King Gong's time shows that state ownership of land in the Western Zhou Dynasty had begun by then to become less stringent, because such an exchange is in contradiction with

the system of state ownership. Although this transaction had to be approved by ministers in power, the exchange of horses for land recorded in the inscription on a contemporaneous vessel, the Count of Ge *gui* (Plate 48), was not witnessed by official deponents. This was probably because the former involved public land bestowed by the king, while the latter concerned only private land. It is also possible that control over the exchange of land had become increasingly slack.

The Yong *yu* (Plate 47)
Reign of King Gong of the Western Zhou Dynasty
Unearthed at Lantian, Shaanxi Province, in 1969
Height 46 cm
Xi'an Cultural Relics Administrative Committee

The *yu* is a large food container. This example, according to the inscription on it, was used as a container for cooked rice. It is especially large but simply cast, and unusual in being decorated only on one side with an elephant head. The 123-character inscription inside the vessel tells that on the auspicious *ding mao* day, early in the first month of the 12th year of the king's reign, the Duke of Yi had an audience with the king in the palace. When he came out of the palace, he announced the king's decree and said that the land bestowed on Shi Yong was located within the boundaries of Yinyangluo (on the upper reaches of the River Luo in the south-eastern part of present-day Shaanxi Province). The king also gave Yong the land which originally belonged to Shi Su Fu. When the king's decree was announced, Xing Bo, Rong Bo, Yin Shi, Shi Su Fu, Qian Zhong and others were present. The Duke of Yi, therefore, ordered Yu, the Minister of Civil Affairs, to execute the decree and transfer the land bestowed on Yong by the king. Song Ju was the man who defined the boundaries of the land. Shi Yong recorded in the inscription the exact details of the land bestowed on him, and the names of the high-ranking officials who were present as witnesses so that they might prove later that the land legally and irrefutably belonged to him. This was a special way in which the slave-masters of the Western Zhou recorded the properties bestowed on them.

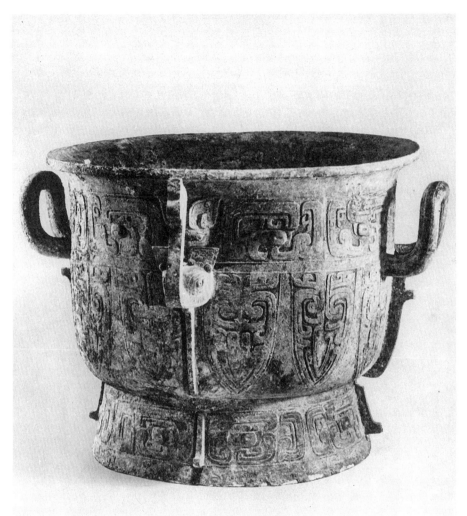

Plate 47

The Count of Ge *gui* (Plate 48)
Reign of King Gong of the Western Zhou Dynasty
Height 31 cm
Shanghai Museum

This *gui* was originally one in a set of four. There are *kui* dragons
and flame designs in a band below its rim, vertical lines on its
body, and similar fluting on the square stand. The fluted

decoration was very popular on bronzes of the mid Western
Zhou Dynasty. Two dragons with curled tails form the two
handles.

Inscriptions are to be found on both the body and the lid.
Some of the characters are damaged with the result that only
82 may be deciphered. Their contents are briefly as follows: on
the auspicious *kui si* day, early in the first month, the Count
of Ge gave four good horses to Peng Sheng in exchange for 3,000

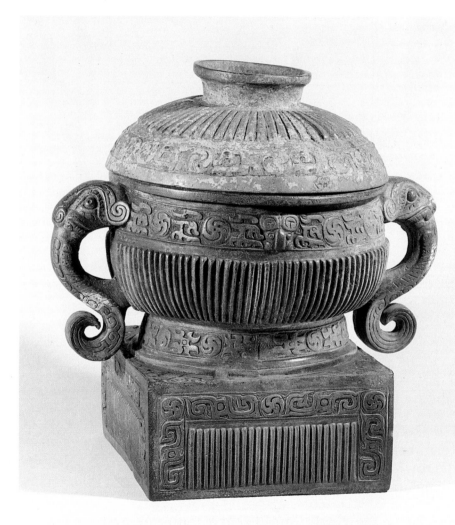

Plate 48

mu of land. The two parties each held half of a written document as proof of their agreement. The Count of Ge surveyed the boundaries of the 3,000 *mu* of land together with his attendants, who were Du Mu, Yuan Gu, Dong Men and two others. The clerk Shi Wu recorded them. The Count of Ge had this precious *gui* cast to mark his acquisition of the land.

This inscription furnishes specific exchange rates between horses and land. Four good horses were equivalent to 3,000 *mu* of land, averaging one horse to 750 *mu* of land. The inscription on the Wei *he* (Plate 46) states that 80 strings of cowries were paid for 1,000 *mu* of land. A string of cowries was equivalent to about 12.5 *mu*, and 3,000 *mu* were worth 240 strings of cowries. Although exchanges did not necessarily follow fixed rates, these figures reflect how exchange was carried out at that time.

The fact that this transaction was not supervised by government officials shows that the buying and selling of land were no longer subject to many restrictions. The land involved was probably private land cleared by the slave-masters.

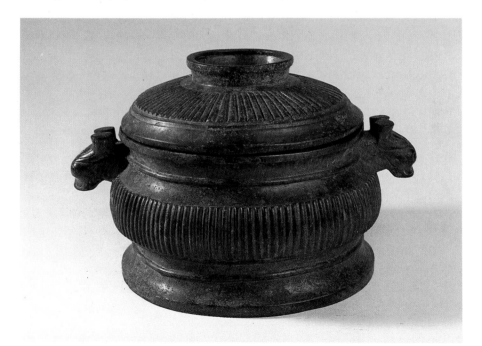

Plate 49

The Grand Master Ju *gui* (Plate 49)
Reign of King Yi of the Western Zhou Dynasty
Reportedly unearthed in Xi'an, Shaanxi Province, in 1941
Height 18.7 cm; diameter of mouth 21.4 cm
Shanghai Museum

This is a low, wide-bodied *gui* vessel. Its lid and body are
decorated with simple straight lines. Its designer managed to
do away with all complicated animal motifs, and used only two
animal heads as handles, giving a feeling of freshness to the
form. An inscription of 70 characters (see Figure 4, p. 37) on
the body and lid of the vessel records that the Zhou king received
Grand Master Ju in the hall of the Shiliang Palace and gave him
a tiger-skin robe. Ju had this vessel made to commemorate the
occasion. The man who accompanied Ju was Shi Chen, and the
one who handed over the tiger-skin robe was Prime Minister
Hu, the owner of the Hu *ding* cast in the first year of King
Gong.[78] Hu had by this time become the prime minister, an
important court official. The inscription is dated 'in the 12th
year', probably of the reign of King Yi (909-885 BC).

The Xun *gui* (Plate 50)
Reign of King Yi of the Western Zhou Dynasty
Unearthed at Beidaogou, Sipo Village, Lantian County, Shaanxi
Province
Height 21 cm; diameter of mouth 24.8 cm
Shaanxi Provincial Museum

This form of vessel first appeared in the period of King Gong
of the Western Zhou Dynasty and remained popular until
the late Western Zhou. The entire vessel is simply decorated
with parallel horizontal grooves. The long inscription inside the
vessel records the Zhou king's decree ordering Xun to succeed
to the official post held by his father and forefathers to supervise
the people in the capital. The Zhou king said in the decree that
when King Wen and King Wu received the mandate of Heaven,
Xun's ancestors helped to lay the foundations of the dynasty.

78. Ruan Yuan, *Jiguzhai zhong ding yiqi kuan shi*, 4:35; Guo Moro, *Liang
Zhou jin wen ci daxi tulu kaoshi*, pl. 83.

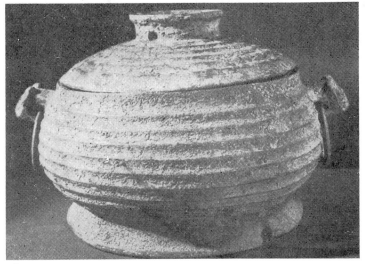

Plate 50

Xun was then ordered to succeed to the post and to control the royal guards and the slaves, who were of the Ximen Yi, Qin Yi and Bo Yi tribes; the Shi Ling Ce Xin and Hua Yi, You(?) Yi and Wu Yi people; and the Cheng Zhou Zou Ya and Xu Qin, Xiang and Fu people. The king rewarded Xun with ritual costumes, weapons, flags and harnesses. Xun gratefully lauded the king's magnanimous appointment and had the *gui* cast in memory of his ancestors Yi Bo and Tong Ji so that it could be passed on to his sons and grandsons through all eternity. This was in the 17th year of the king's reign, at the Sheri Palace. In the morning the king came to the palace where he gave audience to his ministers. It was the Duke of Yi who presented Xun to the king.

There is another *gui* vessel of a later date, on which Xun is called Shi Xun. Xun was a hereditary senior military officer, whose official title was Shi. The Shi office was also entrusted with the task of teaching the crown prince. The royal guards under his control were the Zhou king's palace guards formed of Yi soldiers. The many Yi people mentioned in the inscription were from different tribes performing levy duty as soldiers for their Zhou suzerain. It is recorded in the book *The Rites of Zhou* that the Shi 'was made to exercise control over the Yi people, and to recruit soldiers from among them to stand guard outside

the king's palace'. [79] Shi Ling Ce Xin and Cheng Zhou Zou Ya were junior military officers under Xun's command. The Xu Qin, Xiang and Fu people mentioned in the inscription were slaves.

The Shi Xun *gui* was made in the first year of the Zhou King Yee, whose father was another King Yi.[80] It was in the 17th year of the father's reign that Xun assumed his official post for the first time. The content of the Xun *gui* inscription is more or less the same as that of another vessel known as the Shi You *gui*.[81] Shi You had the vessel made for his father Yi Bo while Xun's vessel was for his grandfather Yi Bo. Xun was, therefore, Shi You's son, and succeeded to his official post after his grandfather and father.

The great Ke *ding* (Plate 51)
Reign of King Xiao of the Western Zhou Dynasty
Unearthed at Famen Temple, Fufeng County, Shaanxi Province
Height 93.1 cm; weight 201.5 kg
Shanghai Museum

The great Ke *ding* is a ritual vessel used by the high-ranking aristocrat Shan Fu Ke to offer sacrifices to his grandfather Shi Hua Fu. This magnificent vessel has three groups of animal mask designs in a band beneath its rim, and ribbon designs on its bulging body. There is an inscription of 290 characters on its inside wall, which can be divided into two parts.

In the first part, Ke praised his grandfather, saying that he was a man modest at heart, peaceful in temperament and possessing lofty virtues; that he protected his sovereign, the Zhou King Gong, assisted the court in giving grace to the common people, and brought peace to the far-flung border regions as well as harmony to the heartland. The inscription says that the wise king Xiao, thinking of Ke's grandfather Shi

79. *Zhou li*, 'Di guan, Shi shi'.
80. Xue Shanggong, *Lidai zhong ding yiqi kuan shi*, 14:14; Guo Moro, *Liang Zhou jin wen ci daxi tulu kaoshi*, pl. 132.
81. Ruan Yuan, *Jiguzhai zhong ding yiqi kuan shi*, 6:23; Guo Moro, *Liang Zhou jin wen ci daxi tulu kaoshi*, pl. 76.

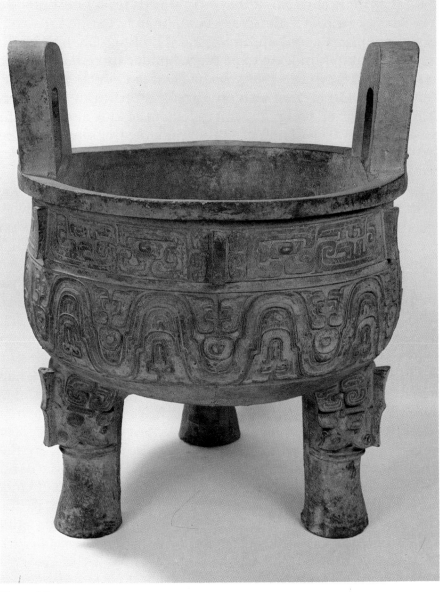

Plate 51

Hua Fu, promoted Ke and made him a minister responsible for transmitting the king's orders.

The main points of the second part are that the Zhou king reaffirmed Ke's appointment and bestowed ritual costumes, land and slaves on him. Included was land in Ye, Pi and Jun,

as well as male and female slaves in those areas. Additionally, he received land in Kang, Yan, Fuyuan and Hanshan, as well as junior officials and an orchestra. The Jing, Chang and Fu people given to him were to be placed under surveillance. Also bestowed on Ke were slaves who had fled to Liang from the Jing family. The Zhou king also ordered Ke to perform his duties diligently day and night, and not to forget the king's commands. Ke then knelt to kowtow in salute, praising the king's exalted virtues, and had this *ding* cast in memory of his grandfather Shi Hua Fu.

In the past, most scholars dated the great Ke *ding* to the period of King Li of the Zhou Dynasty. A number of bronzes with inscriptions of Qiu Wei were unearthed in Fufeng, Shaanxi Province, in 1975.[82] A study of these inscriptions shows that Qiu Wei was a man who lived during King Gong's time. An official named Zhong Ji, a contemporary of Qiu Wei, is mentioned in one of the inscriptions. The same name also appears in the inscription of the great Ke *ding*. This shows that the great Ke *ding* must belong to the period of King Xiao rather than that of King Li of the Zhou Dynasty.

King Xiao reigned in the mid Western Zhou Dynasty, when the slave system was about to decline. High-ranking, slave-owning aristocrats, dependent on the reflected glories of their ancestors, could still enjoy many kinds of privileges. As specified in the inscription on his *ding*, the land bestowed on Ke by the Zhou king extended from western Shaanxi to the Jing River valley in eastern Gansu. In addition to this large stretch of land, he was also given slaves. This generous award attests to the fact that the slave system at the time had not yet died out.

The inscription on the great Ke *ding* has provided us with data on hereditary official titles and rewards of the Western Zhou Dynasty. Generation after generation, Ke's family enjoyed special privileges and multiplied their wealth. Ke's ability to cast such a splendid ritual vessel to record the king's decree and offer sacrifices to his ancestors shows that his family was undoubtedly one of the most prominent at that time.

82. *A Group of Bronzes from Qijia Village at Fufeng* (Beijing, Wenwu Press, 1963).

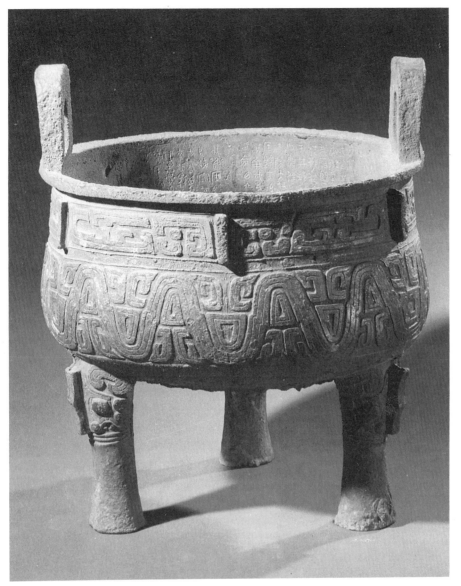

Plate 52

The Yu *ding* (Plate 52)
Reign of King Li of the Western Zhou Dynasty
Unearthed at Ren Village, Qishan County, Shaanxi Province,
in 1942
Height 53 cm
Shaanxi Provincial Museum

The distorted animal mask design below the rim of this *ding* and the ribbon designs on its body are in a typical decorative style of late Western Zhou bronzes. There is an inscription of 205 characters on the inside of the vessel recording a very important war launched by King Li against vassal states in the south, and particularly against the vassal state of E. In brief, the inscription says that the Duke of Mu, Yu's grandfather, had assisted the Zhou king. The Duke of Wu did not forget Yu's grandfather You Da Shu and his father Yi Shu, and so appointed them to rule over the Jing fiefdom. This first part of the inscription tells of the relationship between Yu's family and the Duke of Wu. In the second part Yu laments a great disaster that had struck from heaven. The Marquis Yu Fang of E led the Yi south of the Huai River and the Yi in the east to start a rebellion in those parts of the country, and these rebellious forces had reached the heartland of the Zhou Dynasty. Then, the Zhou king ordered the six western divisions and eight Yin divisions of the royal guards to wipe out the Marquis Yu Fang of E and all the rebels, both old and young, but this expedition against E did not end in victory. The third part of the inscription says that the Duke of Wu sent Yu with 100 chariots, 200 armoured warriors and 1,000 foot soldiers to suppress the Marquis Yu Fang, together with the six western divisions and eight Yin divisions. Yu brought his troops to the state of E, started an attack against the marquis and captured him.

This inscription has furnished the following historical fact: at the time of King Li the minority peoples in the south and east combined in a large-scale revolt, and their forces reached the heartland of the Zhou Dynasty. This has not been recorded in any other historical text.

The Shi Huan *gui* (Plate 53)
Reign of King Li of the Western Zhou Dynasty
Height 27 cm
Shanghai Museum

This *gui* is sturdy and severe in form. It has inscriptions on both its lid and body, recording the victory won by Shi Huan, who

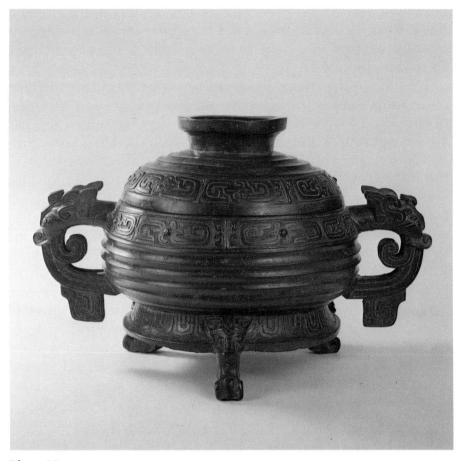

Plate 53

was sent by King Li on a punitive expedition against the Yi of
the Huai River. King Li said to Shi Huan: 'Shi Huan! The Yi
of the Huai River have always been our vassals paying me
tribute. They now have the audacity to force their slaves to stop
work, betraying the royal superintendents and perpetrating high
treason in the east. I now order you to take command of the
officers and men of the states of Qi, Ji, Lai, Li and Zhao, form
them into the left and right armies for a punitive expedition
against the Yi of the Huai River, and at once destroy Ran, Lao,
Ling and Da, the four leaders of the rebels.' Shi Huan worked
extremely hard and earnestly executed his military tasks. His
military exploits merited praise for he had cut off the enemy's

heads and also taken prisoners. The foot soldiers and charioteers under Shi Huan's command did not suffer any losses. Among his captives and loot were men and women, oxen and sheep, as well as bronze.

The Yi of the Huai River valley were minority peoples composed of many tribes who formed a number of vassal states of the Zhou Dynasty. Practising the slave system, they had always delivered tribute and supplied slaves to the Zhou court. In their relationship to the Zhou Dynasty, they were enslaved, but internally they still retained their own form of rule. This was a special characteristic of ethnic enslavement in ancient China. Records of rebellions by the Yi of the Huai River valley and armed suppressions by the Western Zhou court can be found in bronze inscriptions of both King Li's and King Xuan's times.

Because of the strategic position occupied by the Yi of the Huai River valley, their rebellions affected the entire eastern part of the country. King Li, therefore, found it imperative to launch a large-scale suppression. The states of Qi, Ji, Lai, Li and Zhao mentioned in the inscription were all in the Shandong Peninsula. Except for Qi, they were all minor feudal states.

The Guo Ji Zi Bai *pan* (Plate 54)
Reign of King Xuan of the Western Zhou Dynasty
Height 39.5 cm
Museum of Chinese History

This rectangular *pan* (basin) is the largest existing bronze water container of the Shang and Zhou Dynasties. Its form is simple and dignified, and it has vigorous ribbon designs around its sides. An inscription in elegant calligraphy is cast in the centre of the vessel. The 111 characters in the inscription form a rhymed essay or a poem recording Guo Ji Zi Bai's resistance to a Xiongnu (Hun) invasion, at the order of the Zhou king. The first column says that Guo Ji Zi Bai made this *pan* on the auspicious *ding hai* day, early in the first month of the 12th year of King Xuan. The rest of the inscription is in rhyme, and may be summarized as follows: the famous Zi Bai was brave and strong; he performed outstanding service in safeguarding his country's territory, and stopped the Xiongnu east of the River Luo. Having

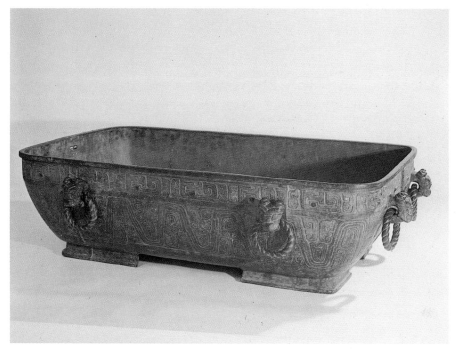

Plate 54

beheaded 500 of the enemy and captured 50, he was in the vanguard of the army. The courageous Zi Bai cut off the enemy's ears and presented them to the king. The king held a banquet at Xuanxie and praised Zi Bai highly. The king gave Zi Bai four horses so that he could better assist the court. Zi Bai also received a great *yue* (battle-axe) to use in fighting against the Man tribes in the south.

The Yanyun mentioned in the inscription was the Western Zhou name for the Xiongnu. When the two characters are pronounced together, they produce the *xiong* sound. The Xiongnu were one of the minority peoples in north-western China, a battle-hardened, plundering alliance of militant nomadic tribes, who often encroached upon the heartland. The inscription says that the Xiongnu were stopped east of the River Luo, which refers to North Luoshui in present-day Shaanxi Province. Xiongnu incursions caused severe damage, which aroused the grave concern of the Zhou court. Great armies were mobilized to resist them. This inscription eulogizes a victory over the Xiongnu.

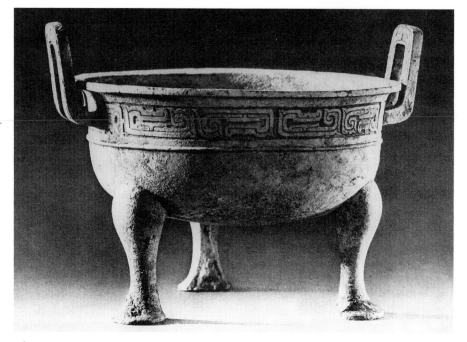

Plate 55

The *ding* of Zhong Zi, Marquis of Zeng (Plate 55)
Early Spring and Autumn Period; the state of Zeng
Unearthed at Jingshan, Hubei Province, in 1966
Set of nine *ding* vessels, the tallest being 28.5 cm, and the
shortest 15.5 cm
Hubei Provincial Museum

The owner of this set of *ding* was the Marquis of Zeng named
You Fu, the head of the state of Zeng in the early Spring and
Autumn Period. These *ding* with shallow bodies, upright
handles, feet made in the form of animal hooves, and decoration
of unrefined ragged curves are typical of the late Western Zhou,
and the early Spring and Autumn Period. Judging from the
calligraphic style of the inscription, the *ding* belongs to the early
Spring and Autumn Period. The nine *ding* in the set are identical
in form but graded in size. An inscription of only one sentence
appears on the first *ding*, stating that it is a ritual vessel cast
by Zhong Zi You Fu, the Marquis of Zeng, for himself.

There were two states of Zeng in history, one in Shandong

and the other in southern Henan. The inscription on another vessel known as the Zi You *ding* of Zeng indicates that Zeng belonged to the Si clan.[83] The state of Zeng during the late Western Zhou Dynasty had considerable influence in the area between the Yangtze and Han Rivers. It is recorded in history that when King You deposed Queen Shen and the crown prince, the Marquis of Shen was angry. In alliance with the Zeng, Western Yi and Quanrong, he attacked and killed King You at the foot of Mount Li. The Marquis of Zeng was, therefore, one of the few feudal lords who participated in eliminating King You.

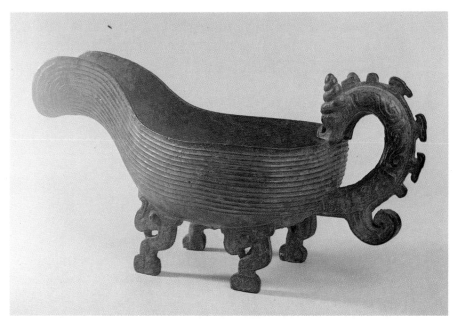

Plate 56

The Marquis of Qi *yi* (Plate 56)
Early Spring and Autumn Period
Height 24.7 cm
Shanghai Museum

This *yi* (ewer) is much larger in size than standard ones. Its body is decorated overall with parallel horizontal lines, and its handle

83. 'Bronzes Recently Acquired by the Shanghai Museum', *Wenwu* 1964:7.

is in the shape of a dragon bending its head into the vessel. In old legends, the dragon was the god of water. The *yi* is a water container, and so its handle is often made ornamentally in the shape of a dragon. The inscription inside the vessel tells that the *yi* was made by the Marquis of Qi for his wife, Meng Ji of the state of Guo. To consolidate their positions and safeguard their immediate interests, feudal lords often formed cliques and alliances. Intermarriage was one of the usual means to achieve those ends. That is why it was said that: 'In order to fight with one heart, it is necessary to make an oath of alliance and to seal it with marriage.'[84] Guo was a small state, while Qi was a powerful state in the east and once the chief of the feudal states. A marriage between members of the Guo and Qi aristocracies was obviously necessitated by political needs.

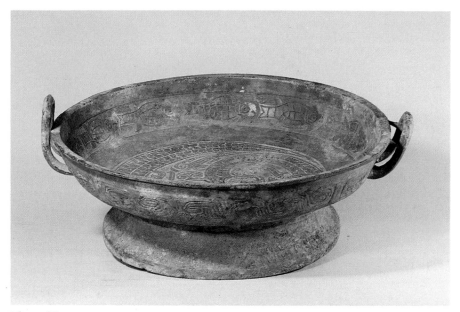

Plate 57

Pan with fish and dragon (Plate 57)
Early Spring and Autumn Period
Height 13.9 cm; diameter 32.8 cm
Shanghai Museum

84. *Zuo zhuan*, 'Cheng gong, 13th year'.

The *pan* and the *yi* form a set of washing utensils. The *yi* was used for scooping up water to wash the hands, and the *pan* for holding the used water. This *pan* is decorated with a coiled dragon at its centre, and 12 fish around its interior wall. The decorative motifs correspond with the function of the vessel.

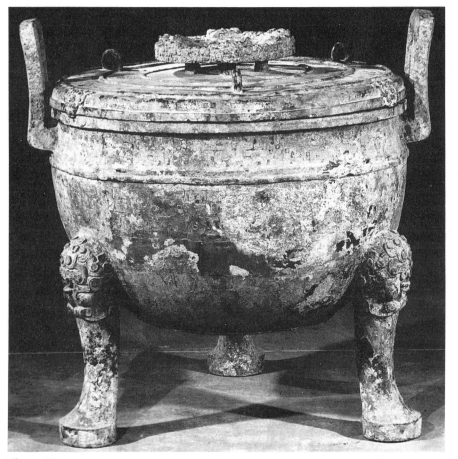

Plate 58

The Marquis of Cai *ding* (Plate 58)
Late Spring and Autumn Period
Unearthed from the tomb of the Marquis of Cai in Shou County,
Anhui Province, in 1955
Height 41.5 cm
Anhui Provincial Museum

More than 500 objects were brought to light when a tomb of the end of the Spring and Autumn Period was excavated in Shou County, Anhui Province, in 1955. Among them were a great number of bronze ritual vessels and musical instruments. The name Fu, the Marquis of Cai, appears in many of the bronze inscriptions, testifying that the tomb was that of the Marquis of Cai. The locality, known as Zhoulai in the Spring and Autumn Period, was part of the territory of the state of Cai. Inscriptions on other vessels from the same tomb show that the states of Cai and Wu had a marital alliance and that the Marquis of Cai, although assisting the Duke of Chu, was also establishing his own state as well as rendering service to the Zhou king. All this indicates that the state of Cai, squeezed between the powerful states of Wu and Chu, was in a difficult position. Fu, the Marquis of Cai, may be identified as Lu, the Marquis Ping of Cai, because the two words Fu and Lu were the same in ancient pronunciation and interchangeable. The Marquis Ping had been re-established in his position by the King of Chu, hence the phrases 'assisting the King of Chu' and 'setting up our own states' in the inscription. However, the tomb could not have been that of the Marquis Ping himself, because the name Fu was chiselled off from an inscription on a bell. Also unearthed from the tomb was a *jian* of Guang, the King of Wu (Plate 62), and so the tomb could not be earlier than his time. It should, therefore, be that of the Marquis Zhao of Cai.

This is a very large *ding* with unusually long legs, similar in form to *ding* of the state of Chu.

Square *hu* with lotus and crane (Plate 59)
Late Spring and Autumn Period
Unearthed in Xinzheng, Henan Province, in 1923
One of a pair: height 118 cm
Museum of Chinese History

This square *hu* is magnificently shaped, with coiled dragons as the principal decorative motif. A pair of splendid large dragons are cast in openwork on the sides to serve as handles; four winged dragons perch on the four corners of the vessel; and two

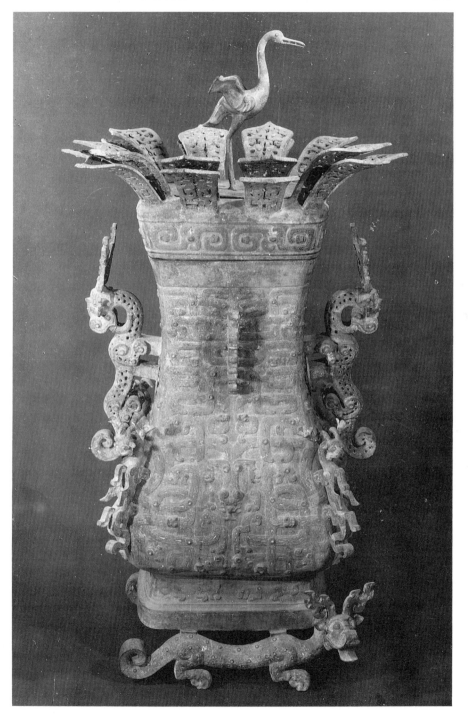

Plate 59

more dragons with protruberant tongues crouch under the foot-ring. All the sculpted creatures on the vessel convey a sense of motion and rhythm. Realistically represented and especially lively is the crane in the midst of lotus petals on top of the lid, with outspread wings and about to take flight. These motifs are in sharp contrast to the basically static and solemn style of decorations on Shang and Zhou bronzes. There were violent social upheavals during the late Spring and Autumn Period, and this *hu* reflects new trends in art during that period.

Hu with bird, beast and dragon decoration (Plate 60)
Late Spring and Autumn Period; the state of Jin
Unearthed in Hunyuan, Shanxi Province, in 1923
One of a pair: height 44.2 cm
Shanghai Museum

The principal decoration is a creature with human face, bird's beak, animal body and bird's tail, entwined with a dragon. Below it are animal masks with strange creatures like the *kui* dragon between their teeth. Between the upper and lower registers are small rhinoceroses, horned beasts, tigers and leopards. In the bottom section are flocks of wild geese. The decorative composition is in the typical style of the state of Jin. A design similar to the principal motif on this *hu* has been found on pottery moulds unearthed from a bronze foundry site of the state of Jin at Houma, Shanxi Province.[85]

Zun of sacrificial ox form (Plate 61)
Late Spring and Autumn Period; the state of Jin
Unearthed in Hunyuan, Shanxi Province, in 1923
Height 33.7 cm
Shanghai Museum

This *zun* is made in the shape of an ox. Liquid could be poured into its hollow body. There are three openings on the back of the ox, the middle one of a pot-like container, the front and rear openings originally having lids which are now missing.

85. See note 9.

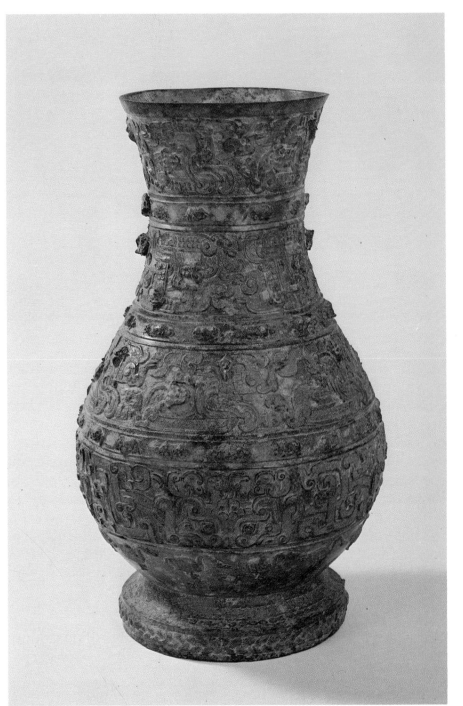

Plate 60

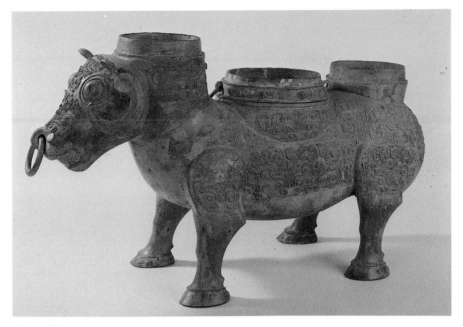

Plate 61

Judging from its structure, this *zun* must have been a wine-warming vessel. Its front and rear openings were for adding and changing water. The *zun* in the form of a sacrificial ox is a very precious type of wine vessel. The present vessel, with its dignified form, is extremely rare. Its decoration is particularly splendid. Designs of coiled *kui* dragons on the ox's neck, and the small tigers and rhinoceroses are exactly the same as those on the *hu* from the same find. The *zun* and the *hu* must be from the same set of wine vessels. A ring attached to the nose of the ox shows that this method of controlling an ox was used as early as the Spring and Autumn Period.

The *jian* of Guang, King of Wu (Plate 62)
Late Spring and Autumn Period
Unearthed from the tomb of the Marquis of Cai in Shou County, Anhui Province, in 1955
Height 35 cm
Anhui Provincial Museum

The *jian* is a large liquid container. It could also have contained

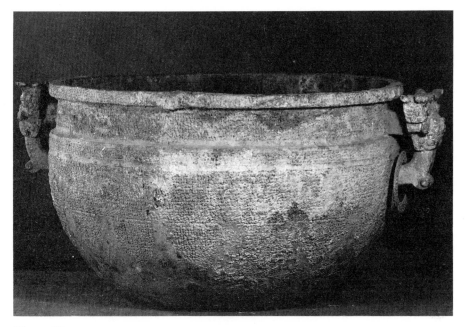

Plate 62

ice for cooling purposes. Below its rim the vessel is covered with a wing-feather pattern of innumerable relief spirals, a most typical variation of animal design in the late Spring and Autumn Period. Two animal heads, each holding a ring, form the handles on each side of the vessel. On the two other sides there were originally two dragon-like creatures which have come off and are lost. On the inside bottom is an inscription of 52 characters in eight columns. The gist of it is that Guang, King of the state of Wu, used bronze, copper and tin to make this *jian* for Shu Ji Si Yu, who was about to be married off to the state of Cai, so that she would enjoy it, be filial to her parents and live a long life. It continues to say that, as Shu Ji was leaving for the state of Cai, she must show genuine respect for the people there so that the close relationship between the two countries would not be forgotten by her offspring.

Guang, the King of Wu, was also known as He Lü. His son was Fu Chai, the next king of Wu. This vessel was cast at a time when the prosperity of the state of Wu was at its zenith. The daughter married off to the state of Cai must have been Fu Chai's sister. The rulers of Wu and Cai all bore the same

surname, Ji. This was, therefore, a rare instance of marriage between people of the same name in ancient times. It was done purely for political expediency to build a buffer zone between the state of Wu and its powerful neighbour to the west, the state of Chu.

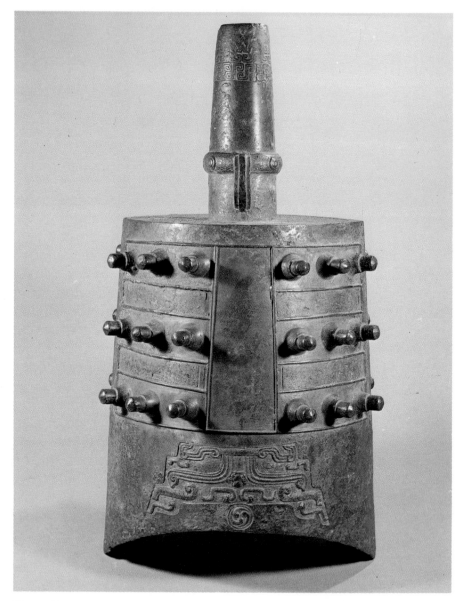

Plate 63

The Lü *zhong* (Plate 63)
Late Spring and Autumn Period; the state of Jin
Unearthed near the Houtu Shrine in Ronghe, Shanxi Province
One of a set: height of largest bell 43.9 cm; height of smallest
bell 24.3 cm
Shanghai Museum

These bells belonged to Lu Qi, and were used for offering
sacrifices to his ancestors as well as for praying for a long life.
Thirteen bells are extant. The same inscription is cast on all
the bells, which says that the ensemble included eight chimes
of bells with four matching chimes of stones. Eight chimes
means that there were eight sets of bells tuned to complete
musical scales. There are 63 bells in the eight sets of bells
unearthed from the tomb of the Marquis of Zeng.[86] However,
the number of bells in each set is not always the same. The
front and sides of each bell should produce two tones three
octaves apart. Eight sets of, for example, 64 bells, therefore, were
able to produce more than 100 notes. This was indeed a peak
of perfection in the development of ancient percussion
instruments, and shows that music was highly developed in
ancient China. Unfortunately, most of the Lü bells are broken
and cannot be tested for sounds. Each of the bells from the tomb
of the Marquis Yi of Zeng produces two audio frequencies.

Gui with animal handles (Plate 64)
Late Spring and Autumn Period
Unearthed from Yiqi Commune, Tunxi, Anhui Province
Height 18.8 cm
Anhui Provincial Museum

A tomb of the ancient Baiyue minority people was discovered
in March 1959 on the western outskirts of Tunxi on the upper
reaches of the Xinan River in Anhui Province. Buried in the
tomb were a considerable number of bronze articles, proto-
celadon stoneware and glazed pottery. Some of the bronzes are
similar in form to those of the Central Plain, but the majority

86. See note 11.

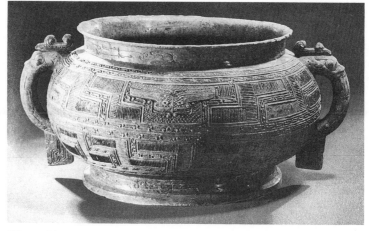

Plate 64

bear geometric patterns or geometric designs of stylized animal masks with a strong regional flavour. More bronzes were uncovered from ancient tombs of the same type in Tunxi during the Cultural Revolution. This *gui* is one of those finds. Its pendent handles are in the shape of animals, retaining some of the characteristics of Shang and Zhou *gui* handles, but the vessel itself has changed completely. Its decoration is of pure geometric pattern evolved from the overlapping, ragged curves on bronzes of the Central Plain of the early Spring and Autumn Period.

Tunxi was inhabited in ancient times by the Baiyue people. The strong regional characteristics of this type of bronze reveal that it was a product of the Baiyue culture. A branch of the Baiyue people inhabiting the Hangzhou Bay area prospered through determined effort, and established the state of Yue in Kuaiji, Zhejiang Province. It fought for supremacy with, and eventually destroyed, the state of Wu. Bronze vessels of similar style have been unearthed in the southern part of Jiangsu Province and near Shanghai.

This *gui* and other bronzes unearthed in Tunxi demonstrate vividly that, in the course of their cultural development, the Baiyue drew upon the bronze culture of the Central Plain and yet created original bronzes with their own ethnic characteristics. They also typify the cultural interflow between various ethnic groups in ancient times.

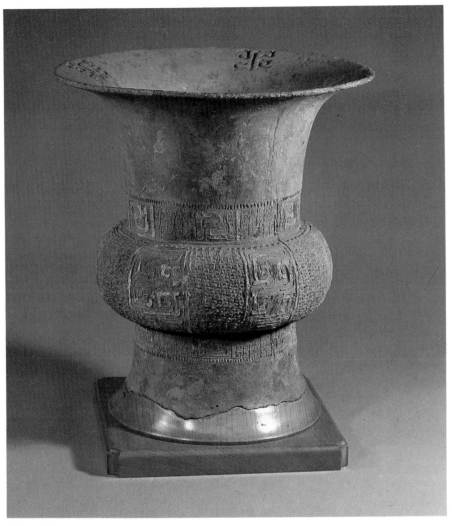

Plate 65

Zun with inlaid coiled dragon design (Plate 65)
Late Spring and Autumn Period
Unearthed at Fenghuang Hill in Songjiang, Shanghai
Height of extant vessel 36.3 cm; diameter of mouth 24.9 cm
Shanghai Museum

This *zun* has a flared mouth, long neck and bulging body. The
lower part of its foot-ring is broken. Its form is very similar to
that of a *zun* unearthed from the tomb of the Marquis of Cai
in Shou County, Anhui Province, and another unearthed in

Tunxi.[87] The decoration around the body of the *zun* is divided into 12 panels inlaid with stylized ragged curves and barb designs alternated with a stylized coiled dragon motif. A band in pearl pattern borders the upper and lower edges of the panels. A chequered pattern and inlaid stylized ragged curves on the lower part of the neck and the upper part of the foot-ring are also divided into 12 panels which alternate with the designs on the body. The upper part of the neck and the lower part of the foot-ring are both decorated with a band of sawtooth design. This *zun* imitates Shang and Zhou *zun* of the same type in form, but with some modifications. The ragged curves are simplified and executed in double lines, but the motif is from bronzes of the Central Plain. Most of the white inlay pieces have come off. The barb designs have more local flavour. Their close arrangement is a variation of coiled dragons, but their appearance has completely changed. This *zun* and bronze vessels of the period of transition between the Spring and Autumn and the Warring States Periods unearthed in Tunxi, Anhui Province, and in Wujin, Jiangsu Province, all display a uniform and distinct regional style. They are all products of the Wu and Yue culture.

The Zi He Zi *fu* (Plate 66)
Early Warring States Period; the state of Qi
Unearthed in Lingshanwei, Jiao County, Shandong Province, in 1857
Height 38.7 cm; capacity 20.46 litres (Discovered together with the Chen Chun *fu* of similar form, and the Zuo Guan *he*.[88] The former has a capacity of 20.58 litres, and the latter a capacity of 20.70 litres.)
Museum of Chinese History

The *fu* was originally a cooking vessel and entirely different from the present measuring vessel in shape. The measuring

87. See note 35 and 'Report on Excavations of Western Zhou Tombs at Tunxi, Anhui', *Kaogu xuebao* 1959:4.
88. A *he* was approximately equivalent to a *dou* as a measure, and a *fu* to a *hu*. The *hu* equalled 10 *dou*.

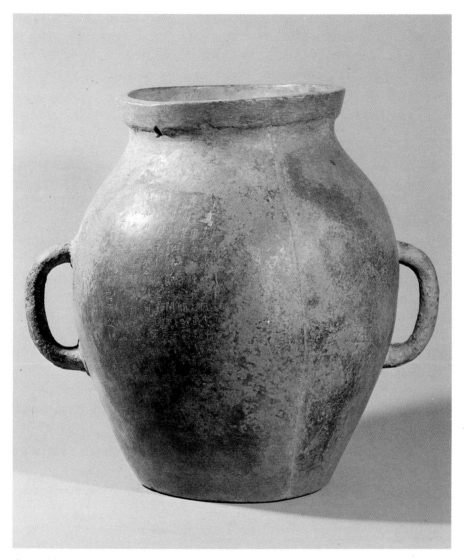

Plate 66

vessel was called *fu* in the Qi dialect. This *fu* has a simple form like a wine jar with two handles. Its inscription is on the exterior of the vessel. Some of the characters cannot be deciphered because of poor casting. Judging from its decipherable characters, the inscription is a decree issued by Zi He Zi to Chen De about the use of standard measures in the Zuo Guan government offices. Its gist is as follows: in the Zuo Guan, the barn *fu* was to be used as the standard official *fu* measure, and similarly as

the basis for the official *he* measure. The practice of Zuo Guan officials of adding a stick or other things to change the volume of these measures was to be stopped. If officials of the Zuo Guan refused to carry out this decree, they would be punished according to the seriousness of the case.

The person, Zi He Zi, mentioned in the inscription was Tian He. As the two characters Tian and Chen were similarly pronounced in ancient orthology he was also known as Chen. This *fu* was cast before Tian He became a feudal lord. According to the inscription, the Zi He Zi *fu* was the barn *fu*. The entire content of the inscription is a decree. This is similar in nature to the *ding* of the state of Jin which had the criminal code cast upon it. The state of Qi had adopted two systems of place-value numeration (quadruple and decimal) in its old measures, which complicated calculations. As a representative of the new landlord class, Chen adopted a new system of measures based on the decimal place-value numeration; that is, 10 *he (dou)* made 1 *fu*, and 10 *fu* became 1 *zhong*.[89] This system simplified calculations, and improved the old system of measures. From the inscription, we can also see that there were no unified measures at the time. The decree, therefore, stipulates that the barn *fu* should be the standard *fu* measure in the Zuo Guan.

Hu with scenes of feasting, music playing and battle (Plate 67)
Early Warring States Period
Unearthed at Baihuatan in Chengdu, Sichuan Province
Height 40.6 cm
Sichuan Provincial Museum

Some striking changes took place in bronze decoration during the late Spring and Autumn and the Warring States Periods. Subject-matter from real life appeared on the bronzes, a significant break from the ideas of fate, mythology and legends that had dominated decoration for the previous 1,000 years or more, and infused new vitality to bronze art. This was also a manifestation of the attack by the landlord class on the old ideology. An example is to found in this *hu*, which is decorated

89. The modern *dou* is equivalent to 10 litres.

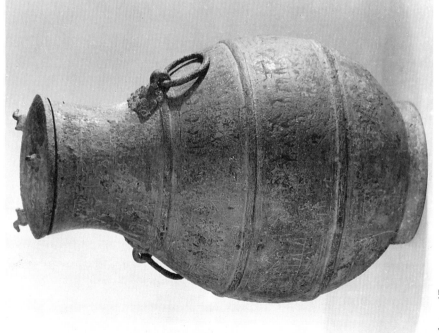

Plate 67

with scenes inlaid in copper. Its upper section has scenes of feasting, archery, mulberry-leaf picking, bird shooting and hunting, and of the life of landlords who enjoyed both power and wealth. Such scenes are described in the books, *Rites* and *The Book of Rites*.[90] At a time when 'rites were unobserved and music degenerated', the feudal lords could adopt without authorization rituals prescribed for the king. Enjoyment of aristocratic life undoubtedly also spread to the new landlord class. However, the political significance of these pictures is different, because they do not represent the political order and ranking system of slave-masters, but only describe some aspects of the life of land-owning aristocrats. The lower section of the decoration depicts foot-soldiers in battle, laying siege to a city and fighting on water. These reflect the class contradictions and wars of annexation in the Warring States Period.

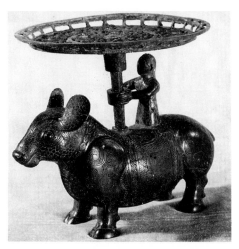

Plate 68

Pan with boy standing on a calf (Plate 68)
Early Warring States Period
Unearthed in Changzhi, Shanxi Province, in 1965
Height 15 cm
Shanxi Provincial Museum

90. *Yili* and *Li ji*, 'Yue ling'.

This openwork plate can be revolved around a rod held in the hands of a small boy. The stand is made in the shape of a calf complete with four hooves but with shortened legs. Bronzes in animal form often have shortened legs to keep their centre of gravity low and maintain stability. The *zun* of sacrificial ox form is another example (Plate 61). There are cowrie patterns on the neck of the calf and rope patterns on its belly, which are typical designs of the states of Han, Zhao and Wei in the Warring States Period. Fine designs cover the entire body of the calf, demonstrating its superb craftsmanship.

Plate 69

Mirror with four tigers (Plate 69)
Early Warring States Period
Reportedly unearthed at Jin Village in Luoyang, Henan Province
Diameter 12.2 cm
Shanghai Museum

The bronze mirror has a smooth surface with four tigers cast in shallow relief on its back. Such tiger images are often seen on bronze objects of the state of Jin. This mirror of considerable thickness must be the product of an early period as bronze mirrors of the Warring States Period are usually thinner.

Bronze mirrors already existed in the Shang Dynasty, but very few have survived. They became popular in everyday life only after the mid Warring States Period. Most extant Warring States bronze mirrors belong to that period.

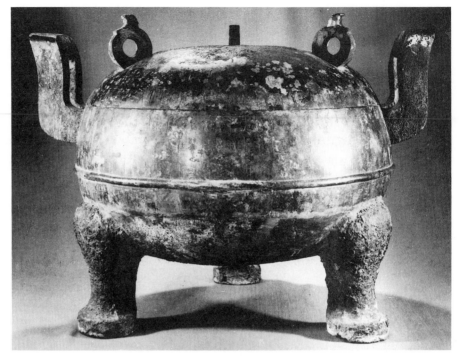

Plate 70

The *ding* of Cuo, Prince of Zhongshan (Plate 70)
Mid Warring states Period
Unearthed from Tomb No. 1 of the Prince of Zhongshan in
Pingshan, Hebei Province
Height 51.5 cm; width across handles 65.8 cm
Hebei Provincial Museum

The 1978 investigation and excavation of the necropolis of the
princes of Zhongshan in the Warring States Period at Pingshan
County, Hebei Province, led to the discovery of large numbers
of cultural relics, which are of great importance both as
historical data and as works of art. The state of Zhongshan, also
known as Xianyu, was established by the Baidi tribe. It was
overthrown in 406 BC. The present vessel belonged to the state
of Zhongshan after its restoration by descendants of the Zhou
royal house, when the ruling family was no longer of Baidi
origin. Inscriptions on the bronzes excavated from these tombs
are all in the script of the Central Plain. Apart from a few articles
with regional or ethnic characteristics, most of these cultural

relics barely differ from those of the Central Plain, but their splendid workmanship is unprecedented. This *ding* of the Prince of Zhongshan has a bronze body with iron legs, and a lid. On the lid and the body is an inscription of 76 columns. With six characters to a column, and including repeated combined characters, there is a total of 469 characters, which makes the inscription the longest on any bronze of the Warring States Period so far discovered.

The main content of this inscription concerns an important historical lesson. The Prince of Zhongshan recounted how Hui, the Prince of Yan, unduly trusted his minister Zi Zhi and gave up his throne to him, which led to civil strife and ended in great disaster to the state of Yan. The inscription praises Sima Zhen, a minister of the Prince of Zhongshan, for his wisdom and the services he had rendered to the prince, and particularly for the expedition he led against the state of Yan, in which several hundred square *li* of land and scores of towns were captured. The prince bestowed upon him honour and privileges, including the exemption of his three succeeding generations from capital punishment. The inscription emphasizes the bitter lesson to be learned from the state of Yan's undue trust in Zi Zhi and, at the same time, points out the service Sima Zhen had rendered to the state of Zhongshan and the tremendous power he enjoyed. This actually implies that the prince was strongly suspicious of Sima Zhen and kept strict vigilance over him, for fear that the incident in the state of Yan should repeat itself in the state of Zhongshan. This was the principal purpose of the inscription. The inscription is full of Confucian ideas of humanity and justice. Similar inscriptions have been found on a *hu* and a bell. The inscription was engraved on the vessel by highly skilful hands, and its characters are in a slender and exquisite style.

Square table with gold and silver inlaid dragons and phoenixes (Plate 71)
Mid Warring States Period
Unearthed from Tomb No. 1 of the Prince of Zhongshan in Pingshan, Hebei Province
Height 37.4 cm; length 48 cm
Hebei Provincial Museum

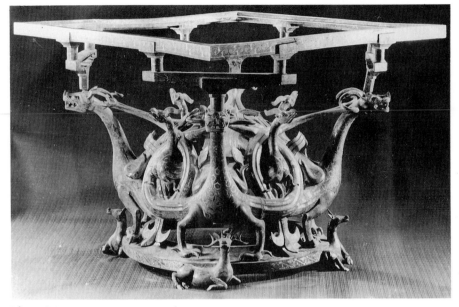

Plate 71

The tombs of the princes of Zhongshan have yielded a large number of cultural relics whose splendid workmanship is unprecedented, opening our eyes to the excellent bronze art of the Warring States Period. This square table is a highly original work of art. The foot-ring of the table rests on four crouching fawns of animated expression. On the foot-ring stand four winged dragons whose split bodies extend to either side, curling upwards to lock on each other's horns. The spread wings of the four dragons are joined together to form an openwork sphere. In the empty space between the split body of each dragon stands a phoenix with outspread wings. These images are unusually beautiful, complex and harmoniously arranged, giving rhythm to the composition and life to the creatures. The imagination and superb technique of the anonymous designer are fully demonstrated. On the four dragon heads are beams which support the edges of the table-top. The table frame is covered with densely arranged gold and silver inlaid patterns of dragon scales, phoenix feathers and fawn spots. These patterns are interspersed with geometric patterns to produce a striking effect of beauty and splendour. The fawns, dragons, phoenixes and

other parts were cast and inlaid separately before being riveted. Some of the parts were made by double casting. This table is undoubtedly a miracle of the handicraft art of the state of Zhongshan in the 4th century BC. The table-top was made of organic material which has since perished.

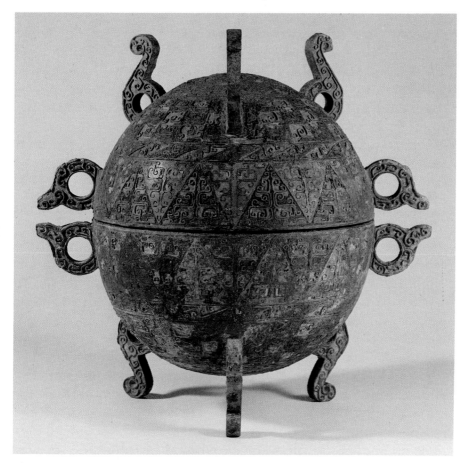

Plate 72

Dui inlaid with triangular cloud designs (Plate 72)
Mid Warring States Period
Height 25.4 cm
Shanghai Museum

The *dui* was a new food container popular during the Warring States Period. Supported on three legs, the vessel and its lid are made in the same size and form. The lid reversed could also

be used as a food container. The entire vessel is beautifully decorated with square and triangular cloud patterns inlaid with thin silver or copper wire. This type of purely geometric design evolved from the animal designs of the early Warring States Period. The last influence of the strongly mythological animal designs on Shang and Zhou bronzes had by now completely disappeared.

Tallies of Qi, Lord of E (Plate 73)
Mid Warring States Period, 323 BC; the state of Chu
Discovered in the Qiu Family Garden, Shou County, Anhui Province, in 1957
Tallies for carts measure 29.1 cm by 7.3 cm; tallies for boats measure 30.2 cm by 7.3 cm
Anhui Provincial Museum

These tallies were issued by King Huai of Chu to Qi, the Lord of E, for transport of goods without paying tax. They belong to two sets. Only two tallies remain in the first set, and three in the second set. Tallies, or *jie*, were issued by the government in different forms and with different content. These are in the shape of bamboo slips. Five such slips, combined in tubular form, would form one complete set. When bronze tallies were cast, several sets inscribed with the same content would have been made. One set would be filed by the government, another given to Qi, and the rest of the sets kept at important checkpoints along land and water routes to be matched for verification. Qi's territory is present-day Echeng in Hubei Province.

The characters on the tallies are inlaid in gold. One set was for water transport, and the other for transport by carts over land. The inscription on the tallies says that they were 'issued in the year Zhao Yang, the grand marshall, defeated the Jin army at Xiangling'. According to historical records, the battle in which the state of Chu defeated the Jin (Wei) army was fought in 323 BC, or the sixth year of the reign of King Huai of Chu. The inscription continues to say that on the *yi hai* day in the summer of that year, King Huai issued a decree at the Pleasure Palace in the Chu capital Ying (north-west of present-day

Plate 73

Jiangling, Hubei Province). Following King Huai's order, the Senior Official of Works ordered his subordinates to make the golden tallies for the finance department of Qi, the Lord of E. The tallies for water transport stipulate that boats used by the Lord of E were to be limited to 150, which would make only one return trip in a year. Boats taking the northern route were to cross the lake, proceed along the Han River, pass Yan and Jiyang and then cross the Han to pass Wang, finally crossing the Xia River to reach Zhi. Those taking the eastern route were to cross the Yangtze, pass Pengni and Songyang, and enter the River Hui to reach Yuanling. Those taking the south-western route were to proceed along the Yangtze, enter the Xiang River, go as far as Beiyang and then enter the Lei River. Those taking the western route were allowed to travel along the Zi, Yuan and Feng rivers, then to proceed along the Yangtze to pass Muguan and reach Chengdu. The inscription says that boats travelling with the golden tallies were exempt from paying tax, but those without the golden tallies must pay tax. Boats carrying animals such as oxen, horses and sheep were to pay taxes directly to the finance department of the King of Chu, rather than at check-points. Carts for transport overland were limited to 50 (each drawn by four horses) and also to only one round trip a year. They were prohibited from transporting bronze, leather and bamboo arrows. If oxen, horses or human carriers were employed instead of carts, the volume transported by 10 beasts or 20 human carriers would be counted as one cartload. If only some of the 50 carts were to be replaced by beasts and human carriers, that part would be deducted from the whole accordingly. Carts were to proceed from E, passing through Yangqiu, Fangcheng, Xianghe, Fanyang, Gaoqiu, Xiacai and Juchao, to reach Chengdu. Tax would be waived at check-points upon presentation of the golden tallies. Without the golden tallies, tax had to be paid.

The inscriptions on these tallies show that trade was well developed in the state of Chu. Even aristocrats and feudal lords profited from trade. The specific regulations laid down in the tally inscriptions were to prevent feudal lords from amassing excessive amounts of wealth, and to ensure increased revenue for the Chu government.

Plate 74

The Shang Yang square *sheng* measure (Plate 74)
Mid Warring States Period, dated to the 18th year of Prince Xiao
of the state of Qin (344 BC)
Length with handle 18.7 cm; average length within inside walls
12.48 cm; average width across inside walls 6.97 cm; average
height 2.32 cm
Shanghai Museum

Shang Yang's square *sheng* measure was the standard measure
for one *sheng* established for the purpose of unifying weights
and measures in the state of Qin when Shang Yang served as
a minister of Qin. Originally a native of Wei but later serving
Prince Xiao of Qin, Shang Yang was a political reformer of the
landlord class in the early Feudal Society of China. The reforms
he introduced were successful in the state of Qin. Although he
was executed during the struggles between old and new political
forces in Qin, his reforms laid the foundations for the
subsequent powerful growth of this state. His reforms, both
political and economic, were comprehensive. Standardization
of weights and measures was only one part of his economic
reforms.

This square *sheng* measure was made with a fair degree of
precision for the standards of that time, its dimensions being

1 *cun* in height, 5.4 *cun* in length and 3 *cun* in width. The inscription engraved on its side states: in the 18th year, a diplomatic mission of senior officials headed by the Prince of Qi came to visit. On the *yi you* day in the 12th month of winter, Minister Yang calculated that 1 *sheng* was to be 16.2 *cun*. In today's mathematical terminology, 1 *sheng* is equal to 16.2 cubic *cun*. There are some slight inaccuracies in the dimensions given above for Shang Yang's square *sheng*, whose volume is 202.15 cubic centimetres. The average length of the Shang Yang *chi* (10 *cun*), based on the measurement of the square *sheng*, is 23.19 centimetres.

The front end of the square *sheng* is carved with two characters, 'Zhongquan', which should be the name of the county where the square *sheng* was issued, 25 kilometres to the south of present-day Pucheng County in Shaanxi Province. Carved on the exterior bottom of the measure is the decree on the standardization of weights and measures for the entire country issued in the 26th year of the First Emperor of Qin, the year in which he unified China (221 BC). This shows that the system of weights and measures adopted by the First Emperor of Qin was the same system devised by Shang Yang 123 years earlier. Another side of the square *sheng* has engraved the character 'Lin', which indicates that the measure had been turned in for checking after promulgation of the decree on the standardization of weights and measures, and was re-issued to Lin, probably Linjin to the east of present-day Dali County in Shaanxi Province.

Bell with tiger design (Plate 75)
Late Warring States Period
Height of extant bell 29.6 cm
Shanghai Museum

This bell of unusual form was cast by the Ba minority people. It has a specially flat body, and its decorative studs are concentrated on a small upper section. It is obviously a variation of the bells of the Central Plain, a product of the merging of Ba culture with the culture of the Central Plain. The ancient Ba people were distributed in the south-eastern part of present-

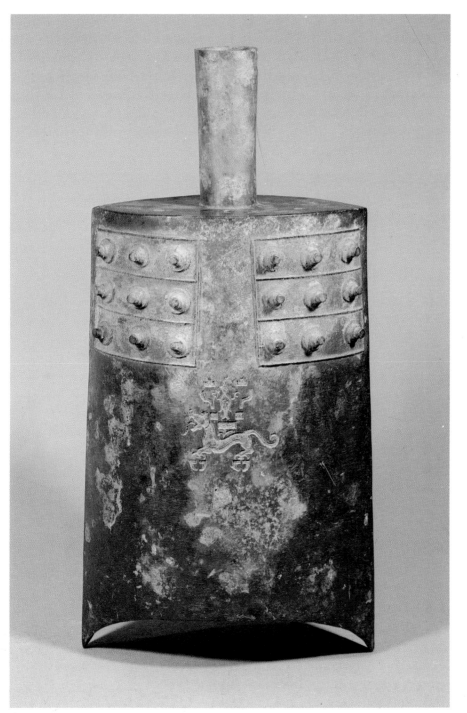

Plate 75

day Sichuan Province around Baxian. Since 1949, several groups of tombs of Ba nobles have been excavated at Dongsunba and other places in Baxian. Most of the bronzes found in these tombs were weapons. It is said that the Ba people were worshippers of the white tiger, which explains why there are often tiger designs on their bronze articles. Above the tiger on this bell are designs of birds of prey, which were also common ornaments of the Ba people.

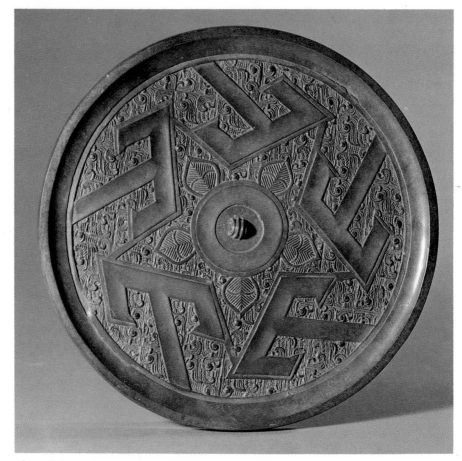

Plate 76

Mirror with five mountain design (Plate 76)
Late Warring States Period
Diameter 16.7 cm
Shanghai Museum

The surface of the mirror is smooth and well polished. On its back are five identical versions of the Chinese character for 'mountain', obliquely oriented against a ground of fine thunder patterns. This type of design is derived from the interlocked thunder pattern of the Warring States Period, transferred on to the mirror in a radiating arrangement. The mirror is very thin and the decoration is finely executed. It is an example of the superb mirror-casting technique of the Warring States Period.

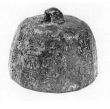

Plate 77

Quan bearing a decree of 221 BC (Plate 77)
26th year of the First Emperor of Qin (221 BC)
Height 3.2 cm; weight 248 g
Shanghai Museum

The *quan* is a weight used on the balance-scale. The ancient Chinese weighing apparatus was worked by suspending the object to be weighed on one end of a beam, and adding *quan* on the other end until the beam was level. The present *quan* weighs 248 grams, approximately equivalent to 1 Qin ounce (250 grams). The decree on the standardization of the country's weights and measures issued in the 26th year of the First Emperor of the Qin Dynasty is carved on the *quan*.

The Changxin Palace lamp (Plate 78)
Early Western Han Dynasty
Unearthed from the tomb of Dou Wan, wife of Liu Sheng, Prince Jing of Zhongshan, in Mancheng, Hebei Province, in 1968
Height 48 cm
Hebei Provincial Museum

The entire lamp is gilded. The palace maid, kneeling on the ground and holding the lamp in her hands, has a child-like face. She looks attentive and very life-like. She is holding the lamp in her left hand; her right sleeve covering the top of the lamp

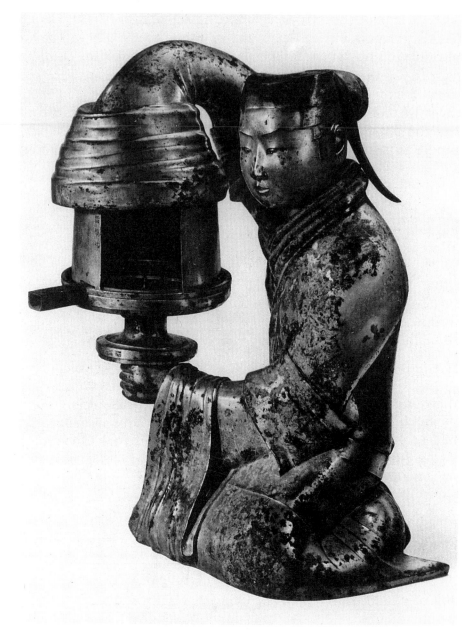

Plate 78

serves as the lamp-shade. The lamp case can be opened and closed to regulate the intensity and direction of the light. The body of the figurine is hollow so that smoke and soot from the lamp may pass throught the right arm to accumulate in the

body. The head and right arm of the palace maid can be detached to facilitate cleaning. On the lamp are carved: 'The house of Yangxin' and 'Changxin Shangyu'. 'The house of Yangxin' was the residence of Liu Jie, who was made the Marquis of Yangxin in the first year of Emperor Wen of the Han Dynasty (AD 179). Later, in AD 151, Liu Jie forfeited his marquisate because of crimes he had committed, and the lamp was confiscated to be placed in the Changxin Palace of the empress dowager Dou, who was Liu Sheng's grandmother. The lamp was probably given to Dou Wan by the empress dowager. It is the most finely crafted bronze lamp of the Han Dynasty so far discovered.

Cowrie container with decoration of Dian tribe sacrificial rites
(Plate 79)
Early Western Han Dynasty
Unearthed at Shizhaishan in Jinning County, Yunnan Province
Height 53 cm
Museum of Chinese History

Between 1955 and 1958 a number of tombs of the Dian tribe in the Jinning area, Yunnan Province, were excavated. The tombs yielded a gold seal given to the king of Dian by the Han emperor and large quantities of other cultural relics. Dian was a small feudal state of the Han empire in Yunnan inhabited by local ethnic groups. A small proportion of the unearthed objects are cultural relics from the Central Plains, but the bulk of them are products of the merging of the culture of the Central Plain with local ethnic culture. This shows that the Dian people had close political, economic and cultural ties with the Central Plain. Buried in the tombs were many bronze cowrie containers holding large quantities of cowries, symbols of wealth at that time.

On the lid of this cowrie container is a scene of sacrifice and celebration cast in the round. Sitting erect in the centre of a building is the Dian chieftain, larger than the other figures and presiding over the sacrificial rites. Two rows of men stand respectfully facing him. Arranged around them are many small bronze drums, which were then symbols of wealth for the Dian slave-owning nobles. In front of the building is a pillar with a

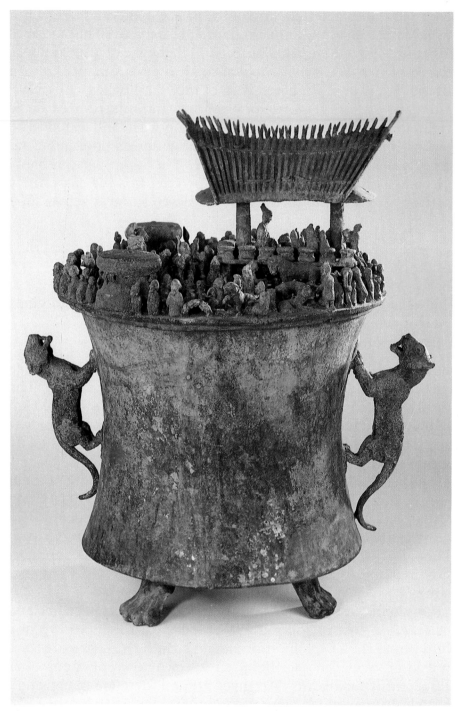

Plate 79

naked sacrificial slave waiting to be slaughtered. Beside the pillar is a column on which are entwined many snakes, the objects of worship to which the sacrifices are to be offered. At the front are two large bronze drums as tall as a man. These represent the rank and power of their owner. There are many other slaves sitting on the ground, recognisable because their legs are fettered. To the right of the building are people slaughtering oxen and sheep near a large *ding* vessel in which the animals are to be cooked. The slave tied to the pillar is guarded by several mounted warriors. A man to the left of the building is beating a drum and striking a bell. He is probably the performer of sacrificial music. Behind is a tamed tiger crouching near the column, and a trainer ordering it to perform. There is also a horse nearby. This part of the scene resembles a modern circus performance. Other figures include slaves weaving cloth, or engaged in other productive labour, as well as Dian spectators and a dance troupe. These sculptures vividly depict the bustling activities of a sacrificial ceremony of the Dian people over 2,000 years ago. Bronze sculptures on other cowrie containers unearthed in Jinning are equally life-like, displaying the superb bronze-casting skills of the ancient Dian people.

Bronze drum with coin design (Plate 80)
Late Western Han Dynasty
Unearthed in Cenxi, Guangxi Province, in 1954
Height 57.2 cm; diameter 90 cm
Guangxi Provincial Museum

The bronze drum was a favourite musical instrument among minority peoples of the south-western region in ancient China. It was used at gatherings and ceremonies in hill villages, and sometimes also as a military drum to signal the advance or retreat of an army. Containers for storing treasures were also made in the shape of a bronze drum. Occasionally, a bronze drum was used as a burial container for bones of the dead. The higher the owner's rank, the larger would be the bronze drum, the largest reaching 181 centimetres in diameter. Bronze drums were, therefore, also symbols of power for the chieftains and

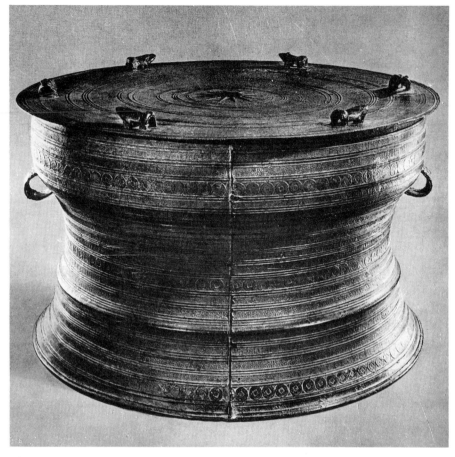

Plate 80

rulers of minority groups in ancient times. The use of bronze drums has a very long history in Yunnan, Sichuan, Guizhou, Guangxi and Guangdong Provinces. This tradition has been handed down to the present day.

This bronze drum is decorated on its top and around its sides with neatly arranged motifs of *wuzhu* coins of the type that was in circulation during the reigns of Emperor Xuan and Emperor Yuan of the Western Han Dynasty. Cenxi was in the jurisdiction of Cangwu Prefecture in the Han Dynasty. The use of the *wuzhu* coin as decoration on the bronze drum is not accidental; it proves that there has been close contact between the people of the Central Plain and the south-west minority peoples since ancient times.

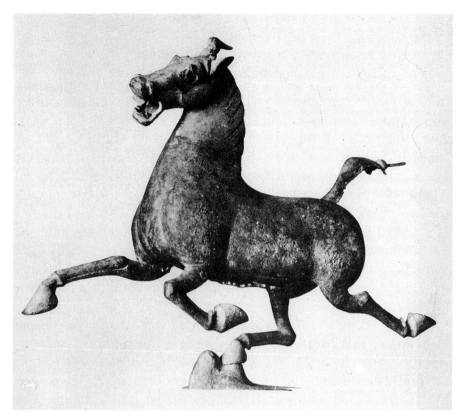

Plate 81

Galloping horse (Plate 81)
Late Eastern Han Dynasty
Unearthed at Leitai in Wuwei County, Gansu Province, in 1969
Height 34.5 cm
Gansu Provincial Museum

This unusually modelled steed looks as if it is galloping at lightning speed. Its swiftness is conveyed by the placement of one of its hooves on the back of a bird in flight. According to legends, King Mu of the Zhou Dynasty had eight fast horses with names such as Skipping the Earth or Overtaking Feathers, meaning that the horses were so swift that they could run without touching the earth with their hooves, and could surpass the speed of a flying bird. This bronze horse is possibly a representation of one such steed. It is the most beautiful of all extant Han Dynasty bronze horses.

BRONZE COINS

Coins in the shape of farm tools (Plate 82)
Spring and Autumn Period and Warring States Period

In the Shang and Zhou Dynasties, bronze shovels of more or
less standardized form and similar weight were used for barter.
They served as coinage and were valued by their weight. As
trade developed further in the late Spring and Autumn Period,
when bronze coins were cast especially for trade in those areas
where bronze shovels has been used as the medium of exchange,
they took the shovel form that had long been in use. This type
of coinage belongs mainly to the Spring and Autumn Period.
Early examples are larger, with forms closer to functional
shovels to the extent of having a socket for the attachment of
a handle, only thinner. The coin form became gradually smaller
in the later period.

Another type of coin was developed from the two-pronged
fork. Also belonging to the Spring and Autumn Period, this type
resembles the *lei* and has a symbolic socket. Its size also became
gradually smaller in the later period. By the time of the Warring
States, its socket had been flattened, and its prongs had become
blunt. Most coins of this type belong to the mid and late Warring
States Period, and were particularly numerous in the late
Warring States Period.

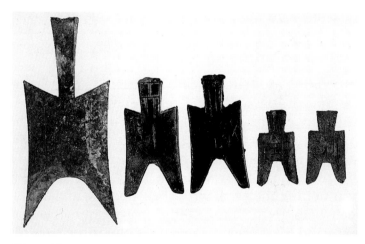

Plate 82

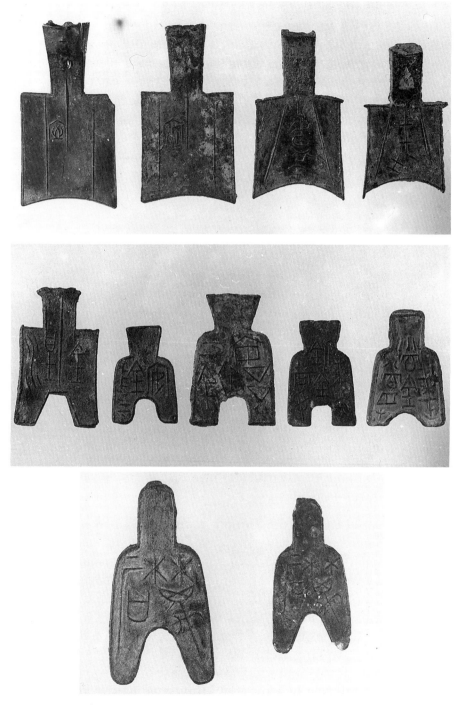

Plate 82

The majority of these coins have the name of a city or a number cast on them; some bear denominations, such as the one-*jin* coin of Jinyang and the two-*jin* coin of Anyi. The area of circulation for coins in the shape of farm tools extended to the states of Yan and Zhao north of the Great Wall, the Guanzhong Plain of Qin in the west, the state of Chu in the south, the state of Qi in the east, and east of the Liao River in the north-east.

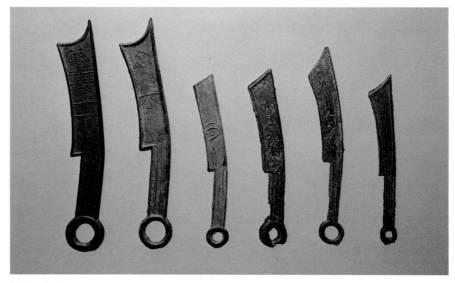

Plate 83

Coins in the shape of knives (Plate 83)
Warring States Period

This type of coin was developed from a kind of knife known as the *xiao* used in everyday life, but as coinage it has no cutting edge. The casting of bronze coinage in the form of a *xiao* knife must have developed from the practice of using knives for barter in more remote times. Knife coins were in circulation during the Warring States Period. They are of two types. One is larger, such as the Qi, Jiemo and Anyang knife coins of the state of Qi; Jiemo and Anyang were the names of two cities. The other is smaller, with the character 'Ming' cast on it. Some also bear the names of places, but are still known as 'Ming' knife coins, these circulating mainly in the states of Yan and Zhao.

Plate 84a

Plate 84b

Coins in the shape of cowries (Plates 84a and b)
Warring States Period

Bronze coins developed from cowries are popularly known as
'ant and nostril coins' because the denomination cast on them
resembles an ant, and the hole looks like a nostril. Cowries were
highly valued in ancient times; they were not only regarded as
valuables, but were also used as ornaments and for barter.
Inscriptions on bronze vessels often record the bestowal of
strings of cowries by a Zhou King on his subjects. Cowrie-shaped
coins were in circulation in the state of Chu at the time of the
Warring States. Characters cast on them are often indecipher-
able. These coins were cast in large quantities, and moulds for
casting them have also been found (Plate 84b).

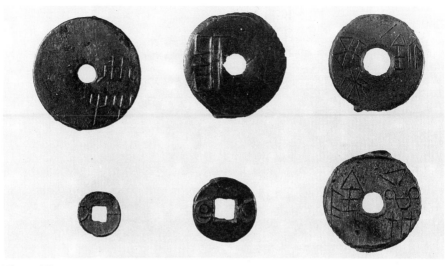

Plate 85

Circular coins (Plate 85)
Warring States Period

Circular coins are the most common form of metal coins throughout the world. Ancient Chinese circular coins have a hole in the centre which enabled them to be strung together. They have place names cast on them, and some bear denominations. They circulated in north China and in the state of Qin on the Guanzhong Plain in the Warring States Period, and also in Shandong and north-east China towards the end of the Warring States.

Part III Nomenclature

FOOD VESSELS

Ding 鼎

The *ding* is a cooking vessel as well as a food container. Few *ding* were used exclusively for cooking because the heat of a fire could have disintegrated the tin in the bronze legs and caused damage. Most elaborately decorated *ding* were for holding cooked meat. However, the *ding* was originally a vessel in which meat was cooked. Blackened marks on the bodies and legs of a few *ding* of the Shang and Zhou dynasties show that they had been placed over a fire for cooking or heating food. The actual cooking vessel was a *huo*, or cauldron. According to *The Rites of Zhou*, 'Ding and *huo* were used together'. A note appended by Zheng Xuan says: 'The *huo* was a vessel for cooking meat and fish. When they were cooked, they were placed in a *ding*.'[91] A *ding* used in everyday life in the Spring and Autumn and the Warring States Periods is mentioned in bronze inscriptions as *ci ding*, or a feeding vessel. *Ding* for holding sacrificial meats were known as deer *ding*, ox *ding* or pig *ding*. This type of *ding* has two handles, a round body and three legs. The rectangular *ding* with four legs was popular in the Shang Dynasty and early Western Zhou Dynasty.

The form of the *ding* varies from period to period and from region to region. The early Shang *ding* has a thin wall, small handles, a deep body and hollowed conical or flattened legs. Most late Shang *ding* have thick upright handles, a straight mouth, deep body and pillar-like legs. Variations include those with a slightly inward curving mouth, a few with flared mouth, narrow waist and shallow body, and some with a shallow body and flattened legs. In the late Shang Dynasty there appeared

91. *Zhou li*, 'Tian guan, Heng ren'.

a special type of *ding* known as the *li ding*. Like a *li*, the body of the *li ding* is formed by three udder-like bags each supported by a foot. It is a combination of the *ding* and the *li*. The early *li ding* has deep dividing lines between the bags. The bags began to degenerate at the end of the Shang and the beginning of the Zhou until there were only shallow lines between them. The *li ding* is also known as the partitioned *ding*. The style of early Western Zhou *ding* is similar to that at the end of the Shang. The popular style features large upright handles, obtuse triangular mouth-rim, and a deep sagging body. Most popular in the late Western Zhou and early Spring and Autumn Period was a *ding* with a cauldron-like body and legs like animal hooves. There were also *ding* with a shallow body, narrow waist and hoofed legs. A small number were made in unusual forms, such as the *yi ding* which has a spout. From the late Spring and Autumn Period onwards, there were more changes in form, such as the long-legged *ding*, known as *qiao*, of the southern states, or the short-legged and shallow-bodied *ding* with lid, of the states of Han, Zhao and Wei. In addition, there were flat-bottomed *ding* and oval-bodied *ding*. These variations in form were caused not only by regional factors, but also by temporal factors. Most *ding* of this later period have handles and lids, whereas very few examples before the early Spring and Autumn Period have bronze lids. As there is great variety in *ding*, the different forms are designated by variant names in inscriptions.

Li 鬲

The *li* served the same purpose as the *ding*, and is in the same category of vessel. It has a large mouth and a bag-like body as if formed by three udders with three short, conical legs. The purpose of this curious design was to expose the largest possible surface of the vessel to the heat so that food in it could be cooked quickly. The Shang Dynasty *li* has a full baggy body, upright handles on the rim and a slightly narrower neck. As the legs joined to the three bags are short, the three bags forming the body are customarily called hollow legs. At the end of the Shang and the beginning of the Zhou, the bag body began to deteriorate, and the vessel became shorter than the partitioned

li, so that its original purpose of exposing the largest possible surface of the vessel to the heat was lost. The main trend in the development of the *li* in the late Western Zhou and the early Spring and Autumn Period was for it to become even squatter, with the addition of a thick rim but, in most cases, without handles. This change in form indicates that *li* were no longer used for cooking. However, a small number of *li* were still made in the old style with the body shaped like three bags. By the late Spring and Autumn Period, the *li* had basically disappeared from ritual vessel types. *Li* are inscribed with that name, but also with the name *ding*, as well as with modifiers added to the *li* character. Only a small number of *li* belong to the Shang Dynasty, or the early and middle periods of the Western Zhou, but many more are of the late Western Zhou Dynasty. Bronze *li* of the Warring States Period are frequently discovered. In tombs of the Spring and Autumn and of the Warring States Periods, bronze *li* were grouped in even numbers of two, four or six to counterbalance *ding* in odd numbers of five or seven. Eight *li* were placed beside nine *ding* in some tombs. Some of these *li* must have served as vessels accompanying the *ding* The bronze *li* had almost totally disappeared by the late Warring States Period, both as a ritual vessel and as a vessel for daily use.

Yan 甗

The *yan* is a steamer. The lower part, in which water was boiled to generate steam, is called the *li*, while the upper part, separated from the lower part by a grid which held the food to be steamed, is called the *zeng*. In the Shang and Western Zhou the upper and lower parts of the *yan* were cast as one. The Shang *yan* has a *zeng* taller than the *li*, upright handles and a straight rim without lip. The late Shang and early Western Zhou steamer has a shorter everted mouth with lip and handles on the lip. A type of square *yan* appeared in the late Western Zhou Dynasty. Most of the steamers of the Spring and Autumn Period have detachable upper and lower parts. The *yan* was not a common ritual vessel, but when it was used it added special importance to the occasion. This can be seen from the sizes of such vessels, as for example, the large *yan* unearthed from the Chu prince's

tomb of the Warring States Period at Lisangudui in Zhujiaji, Anhui Province, which measures more than one metre in height.[92] This must have been a new type of ritual vessel for the state of Chu.

Gui 簋

Shaped like a large bowl, the *gui* is a container for cooked millet, rice, sorghum or other grain. The very few *gui* found among bronzes of the Erligang Period of the Shang Dynasty are still immature in shape. Not many have been found from the early period of the Yin ruins. Available data show that use of the *gui* gradually developed in the middle period of the Yin ruins. The earliest type has no handles, but a large mouth, slightly narrower neck, a smoothly curved body and a foot-ring. An improved type, which appeared later, is equipped with two handles. This type became popular in the late period of the Yin ruins. At the same time, there was also a handleless improved form shaped like a large bowl with a wide mouth. The *gui* with a square stand cast to the foot-ring was a new form of the early Western Zhou Dynasty. This type usually has two handles, but there are also four-handled examples. The stand for the ancient *zun* vessel was known as *jin*, but so far only two *zun* cast with stands have been discovered. This is possibly because many *jin* were made of wood and have not been preserved. Western Zhou *gui* with *jin* cast together show that use of the *jin* was not limited to *zun*. The square stand was in use until the Warring States Period. Placing a *jin* under the *gui* was not the only way to raise its height. Another method was to extend the lobes on the sides of the *gui* below the bottom of the vessel to serve as its supports, so that the *gui's* height would be raised considerably. This type of *gui* with lobe-supports is always with four lobes, a new form that emerged in the Western Zhou Dynasty. Still another method to raise the height of the *gui* was to increase the height of the foot-ring to two or three times that of an ordinary foot-ring. All these various forms are found in

92. 'Report on the Preliminary Investigation of Chu Tombs in Shou County, Anhui', *Kaogu xuebao*, 1 (1936).

gui of the early Western Zhou. The lidded *gui* was the principal form in the mid Western Zhou. The everted lip had disappeared, to be replaced by a lipless, constricted mouth on which was set a close-fitting lid, appearing as one with the vessel itself. This type of *gui* has three animal feet or elephant trunks cast on the foot-ring to raise it and to prevent corrosion-causing moisture from accumulating in the foot-ring. This type of *gui* is also fitted with animal-shaped handles or ring handles. When its lid is turned over, its handle could also serve as a foot-ring. The lidded *gui* with small supports on its foot-ring was the last form in which this type of vessel was made.

Xu 盨

The *xu* is an oblong rice and sorghum container, with a slightly flared mouth. Its lid has appendages in the shape of rectangles or small animals which permit it to serve as a separate container when reversed. The vessel is equipped with handles and a foot-ring, and a small number of this type have animal-feet supports. The *xu* closely resembles a *gui* in square or rectangular form. Some inscriptions on *xu* actually refer to them as *gui*. One inscription states that twelve *xu* were cast at one time, which ought to have been in two groups of six. As *gui* were also made in even numbers, we may conclude that the *xu*, popular in the mid and late Western Zhou, was an immediate variation of the *gui*.

Fu 簠

The *fu* is also a container for rice and sorghum, but of rectangular form with smooth, slanting sides, a flat bottom and a foot-ring. The vessel and its lid are similar in form. It was popular in the mid and late Western Zhou Dynasty and the Warring States Period. The early *fu* has a narrow lip around the rim and a low foot-ring, while the *fu* of the later period has a perpendicular rim making the vessel deeper than before, and a higher foot-ring. Some scholars think that the *fu* and the ritual vessel *hu* 瑚 were one and the same type.

Dui 敦

The *dui* food vessel has a round belly and three legs. The vessel body and its lid are similar, combining to form a sphere. It was popular in the late Spring and Autumn, and Warring States Periods. As its lid, when reversed, could also serve as a container, the *dui* could be used as a pair of containers. There are spherical and globular *dui*, as well as other variations.

Yu 盂

The *yu* is a large container for cooked rice. It has an everted mouth, deep handles and a foot-ring. It is usually quite large, and sometimes even huge. Since it was popular for only a short period, few examples have been unearthed. One or two of the Shang and a few of the early Zhou Dynasty are generally of medium size. Most of the large *yu* belong to the mid and late Western Zhou. The *yu* all but disappeared in the Spring and Autumn Period. Inscriptions on the large type sometimes refer to it as *fan yu*, a container for cooked rice. It was possibly used together with the *gui*. A large *yu* has the capacity of more than ten *gui*. Cooked rice was first put in the *yu*, and then distributed to the *gui*.

Dou 豆

The high-stemmed *dou* is a container for such food as meat sauces. The container part of the Western Zhou *dou* is shaped like a hemispherical bowl known as *pan*. Below the bowl is the stem, which could be grasped, connected to the foot-ring. After the Spring and Autumn Period, the bowl of the *dou* became deeper and was fitted with a lid, which could be turned over and stood on its knob. There are also *dou* with extra long handles.

Pu 鋪

The *pu* is a type of *dou*. Its top part is a flat, shallow dish with straight sides. The difference between the *pu* and the *dou* is

that the former does not have a slender stem. A broad and tall foot-ring is cast immediately under the shallow dish. This foot-ring is often pierced with openwork decoration. *Pu* is the name by which this vessel type is recorded in inscriptions on examples of it. Some inscriptions also call it *fu* which is a homonym.

WINE VESSELS

Jue 爵

The *jue* is a drinking vessel. It has a deep body, an open spout for pouring wine at the front, and a pillar at the point where the spout joins the mouth. The rear part of the mouth-rim tapers off to a pointed tail. There is a handle on one side of the vessel, and three pointed legs below. The *jue* is one of the earliest bronze ritual vessels. Its most primitive type from the Erlitou Period bears characteristics of pottery *jue*. With the passage of time, the different parts of the *jue* changed. The flat-bodied *jue* of the early Shang Dynasty is divided into sections. It has a narrow spout and flat bottom. Its triangular feet do not give a sense of stability, and its form is immature. In the early period of the Yin ruins of the Shang Dynasty, a cup-like *jue* with a round or curved bottom began to become popular as well. There were also cup-shaped flat-bottomed *jue*. The cup-shaped body can be of different heights, either straight sided or narrow at the top and wide at the bottom. *Jue* of these various forms were popular in the middle period of the Yin ruins. Spouts on the *jue* of the period of the Yin ruins are notably broader and shorter. The early nail-like object at the point where the spout joins the rim of the vessel had become a pillar and shifted towards the rear. The rear part of the vessel had been lengthened. The three legs had become thicker cones supporting the vessel from different angles. A small number of single-pillared *jue* appeared in the Erligang Period of the Shang and the early and middle periods of the Yin ruins. They are called single-pillared although two pillars were actually joined to span the spout. In addition, a square *jue* appeared in the middle period of the Yin ruins. The bronze *jue* remained popular throughout the time of the Yin

ruins. Its number was suddenly reduced in the early Western Zhou Dynasty, and its form began to show signs of degeneration. Characteristics of its decline are the reduced size of its body and handle loop, which had become so small that only one finger could be inserted through it, or so small that it could no longer be used as a handle. The spout was further shortened, but its tip was simultaneously raised, impairing the harmony of the design. The two pillars were moved even further back, some being slanted inwards. The three legs, formed like thick knives, became vertical supports with flared feet. The three-legged bronze *jue* had generally ceased to be a ritual vessel by the mid Western Zhou Dynasty. In the late Western Zhou there appeared a variation of the *jue*, whose body resembles a cup with a low foot-ring. At its back is a broad and long handle shaped like a bird's tail. An inscription on one example calls it a 'golden *jue*'. In the Spring and Autumn Period, this type of *jue* was decorated in the front part of the body with a bird's head and feathered wings, and the vessel became known as *que* (bird), then also pronounced as *jue*. In this case, its name matched its appearance. Such bird-shaped *jue* are few in number. According to literature, the capacity of the *jue* was supposed to be one *sheng*, but there was actually great variation in the capacities of Shang *jue*. There are large and even huge examples which show that there was no standard capacity for the *jue*.

Jiao 角

The drinking vessel *jiao* looks like a *jue* but without the spout and pillars. Its left and right sides are made like the rear end of the *jue*. Most examples have lids. The *jiao* was popular in the period of transition between Shang and Zhou, but only a small number appear to have been made.

Zhi 觶

Another drinking vessel, the *zhi* is shaped like a cup with a foot-ring. Most *zhi* of the Shang Dynasty have flaring mouths, contracted necks and deep bulging bodies. *Zhi* of the Zhou

Dynasty are similarly formed, but elongated like a flaring-mouthed bottle. Few bronze *zhi* were made after the mid Western Zhou. A few rare examples of the late Spring and Autumn Period were called 鍴 (*zhi*) in their inscriptions, such as the *zhi* of Xu Wang Yi Chu.[93] 鍴 and 觶 are the same in meaning; they were used interchangeably as they were pronounced in the same way. Another type of vessel with a flared mouth, wide neck, deep body and foot-ring has also been traditionally called *zhi*. Most vessels of this type are, however, fitted with lids, and made in different sizes. They form, therefore, a type of their own. There is also a flat oval *zhi*, which is called *guan* (jar) in inscriptions. As 觶 and 鍴 signify round vessels, the flat oval vessel should not be classified as *zhi*.

Gu 觚

This drinking vessel has a trumpet mouth, long neck, slender waist and high foot-ring. The *gu* was one of the earliest bronze ritual vessels. Early Shang Dynasty·examples are short and squat. The *gu* became slender in the middle period of the Yin ruins. Most *gu* with trumpet mouths of less exaggerated curvature belong to later times. Excavations have revealed that the *jue* and *gu* formed the most basic set of wine vessels. In ancient writings, the word *gu* meant a square vessel. Inscriptions on *gu* do not specify its name. The name *gu* as used today stems from Song Dynasty practice.

Jia 斝

The *jia* is a large drinking vessel, which was also used for offering sacrifices. Similar to the *jue* in form but larger, it has three legs, a round mouth, two pillars standing in the front part of the mouth, and a large handle, but no spout or tail. Early *jia* have necks and bodies divided in registers, and flat bottoms. A few *jia* have *li*-like bodies and hollow feet. In addition to the *jia* with registers, a round-bottomed type with the body shaped

93. *Illustrated Catalogue of the Bronzes in the Gugong* (Beijing, 1958), Vol. II, part 2, Plate 401.

like a *ding* and without division into registers became popular at the time of the Yin ruins. Most *jia* at the transition between the Shang and Zhou Dynasties have animal-hoof supports, and low but huge bodies; this was the final phase in the development of the *jia*.

Gong 觵

This drinking vessel, also known as 觥 (*huang*), is the horn vessel mentioned in ancient writings. The earliest *gong* were found in the Yin ruins. Its primitive form resembles a horizontal ox horn with a rectangular foot-rim, its front part shaped like a dragon head, and with a lid. It can be deduced from this that the ox horn must have been one of the earliest drinking vessels. Later, the *gong* gradually evolved to resemble a dipper with a spout and cover, the cover becoming an animal head extending upwards over the spout. It has a handle at the rear, and a foot-ring on its bottom. Some *gong* have small ladles attached to them for pouring wine. *Gong* were also made entirely in the form of an animal. Most such are formed by combining two different animals at front and rear. For example, the front part may be the body of a sheep while the rear part may be an ox head. The *gong* remained in use until the mid Western Zhou Dynasty. Later, it ceased to be used as a wine vessel, but was formed as a *yi* to be used as a ewer.

He 盉

The drinking vessel *he*, also written as 盉 , is formed like an oval or rectangular jar with a contracted mouth, flat bottom, and a handle. It was popular in the Spring and Autumn, and Warring States Periods. A hemispherical measure of the state of Qi in the Warring States Period was also called *he*, such as, for example, the Zuo Guan *he*.[94]

94. See the entry for Plate 66.

Zun 尊

The wine container *zun* can also be written as 樽 or 鐏. *Zun* is a general name for wine vessels, and all types of wine vessels could, therefore, be called *zun*. The bronze *zun* is a wine container with a flaring mouth, high neck and large body. The *zun* of the early Shang Dynasty has these characteristics plus a wide shoulder and a foot-ring. This form continued until the middle period of the Yin ruins. A *gu*-shaped *zun* became popular in the late period of the Yin ruins and the early Western Zhou Dynasty, but its whole form is thicker and larger than the *gu*, and its body swells slightly. A new form of *zun* with a flaring mouth, contracted neck, drooping body, and foot-ring appeared in the mid Western Zhou, but was not continued. The *zun* was already rare among bronze vessels of the late Western Zhou, but never completely disappeared. Examples have been found in areas of the states of Wu, Yue, Cai and Chu of the Spring and Autumn, and Warring States Periods. There are also *zun* in special forms, designed to resemble an elephant, ox, horse, sheep or bird, and used as wine containers. Since *zun* was the generic name for wine vessels, all these could be called *zun*. However, some were given special names rather than being called *zun*. For example, the inscription on a bird-shaped *zun* calls the vessel 'Play Bird', showing that it was a play thing in daily life. Although the number of animal and bird *zun* is limited, they date from all periods from the Shang to the Warring States.

Hu 壺

The *hu* is a container for wine or water. It has a long neck, bulging deep body and foot-ring. *Hu* is the general name for all long-necked vessels of many varied forms. The *hu* of the Shang Dynasty can be roughly divided into two types: the small-mouthed and long-necked *hu*, and the wide-mouthed and flat ovoid *hu*. The former already existed in the early Shang Dynasty. It has a narrow neck and round body, and some examples are fitted with a horizontal handle on top. The latter

has a drooping body and loops on each side of the neck. Some of this type have lids, and a few have handles. Most of the second type are medium or large in size. They were popular in the middle period of the Yin ruins. Few of this type belong to a later period. When the *you* with a handle became popular in the late period of the Yin ruins, this flat ovoid *hu* gradually disappeared. However, the rectangular *hu* from the mid and late Western Zhou were variants of this type. The rectangular *hu* has a drooping body and is fitted with two large loops on each side of the vessel, as well as a lid of considerable height. The top of the lid is usually in the shape of lotus petals. This type of *hu* was in use until the Warring States Period. In addition, there was a round *hu* with long neck, wide mouth, huge body, and lid in the Western Zhou. It developed into a vessel with an egg-shaped body and short contracted neck in the Spring and Autumn Period. This new form was very popular for a time. Its rectangular version is usually of large or medium size, and was known as the *fang*. The forms of the small *hu* are too numerous to be described here. There were, for example, the tubular and bulging bodied *hu*, the gourd-shaped *hu*, the round *hu* with a slender neck, and the short-necked small-mouthed *hu*, among others.

You 卣

This wine container is shaped like a large oval-bodied *hu* with a lid, horizontal handle and foot-ring. It first appeared among bronze vessels of the late period of the Yin ruins and was very popular for a time. Many *you* are cast with inscriptions, but no specific name is given to this particular type of bronze vessel in the inscriptions. The present name *you* derives from Song Dynasty practice. According to literature, the *you* is a medium-sized *zun*, but its body size actually varies considerably. The original name for this type of vessel has not yet been ascertained. There is no doubt, however, that it was a wine vessel. The bodies of *you* from the Yin ruins are tall and flat. The body's cross-section is oval and became a flat oval in later periods. The largest diameter of the *you* body in the late Shang and early Zhou is at its lower section, which results in a drooping profile.

All *you* have fairly long necks and lids. The handle is fitted to two sides of the shoulder. Some handles of the period between the Shang and the Zhou are fitted longitudinally to front and back on the shoulder. At the same transition period, there was a type of *you* with cylindrical body and handle, but this form did not become popular. There were no longer ritual vessels of the *you* type by the late Western Zhou Period. In addition, handled wine containers in the forms of animals or birds of the period of the Yin ruins are also traditionally called *you*, such as the owl *you*, pig *you* and man-eating tiger *you*. As their specific name is unknown, they remain classified under the name of *you*.

Square *yi* 方彝

Yi is the general name for all ritual bronze vessels, but the square *yi* refers to a square wine container, although its specific name is not known as it is not mentioned in any inscription on this type of vessel. First discovered in the Yin ruins, it is a vessel with four upright sides, some being rectangular in section, with a square foot-rim and a roof-shaped cover. A few are made to look like two *yi* vessels joined together in the form of a rectangular building. These are also known as twinned square *yi*. The form changed somewhat at the end of the Shang and early Western Zhou to become a vessel with a slightly contracted short neck and gently bulging body. Examples of the mid Western Zhou are equipped on each side with handles shaped like elephant trunks. A small square *yi* vessel is divided at its centre into two compartments, with two corresponding holes in its lid through which wine could be ladled out of the vessel. The development of the square *yi* ceased about the mid Western Zhou Dynasty.

Lei 罍

The *lei* is a large wine container. Two types of *lei* have been found in the Yin ruins. One has a large mouth, short neck, wide shoulder, broad body and tall foot-ring; the other is characterized by a small mouth, short neck, wide shoulder,

two loops on the shoulder, tall body, a lid, and another loop on the lower side of the body. This second type may be either round or square bodied, and was used until the mid Western Zhou Dynasty.

Bu 瓿

This is another large wine container. It has a flaring mouth but no contracted neck, a swelling body and foot-ring. Its body is slightly flattened. The *bu* used to be considered a water container, but its frequent occurrence with other wine vessels in excavated sets has resulted in its classification as a wine vessel. The *bu* was used during the early and middle periods of the Yin ruins.

Ling 鎯

This wine vessel has a flaring mouth, narrow neck, wide shoulder and tall body, and is basically similar to the *lei*. The difference is that the *ling* has two tiny dragons on the shoulder instead of two loops, and a false foot-ring at the bottom of the vessel. It is, in fact, a variation of the *lei*. The name *ling* appearing in inscriptions on vessels of this type is a dialect variation in pronunciation of the word *lei*. Few *ling* vessels have been found, and they all belong to the late Western Zhou Dynasty.

Fou 缶

The wine container *fou* has a flaring mouth, broad shoulder, tall body, flat bottom and lid. It is similar to the *ling* in form but without a contracted neck. Most extant examples of this large vessel type were made between the Spring and Autumn, and Warring States Periods.

He 盉

The *he* is a vessel for diluting wine with water to obtain the desired strength and flavour. It has a contracted mouth, a deep

body, a spout in front and a handle in the rear, and three legs below as supports. The *he* of the early Shang Dynasty has a small mouth and a half-enclosed top. Its spout is attached to the front part of the vessel's top. Wide necked and with three hollow legs like the *li*, it has a handle on its rear. Square *he* in this form have been discovered from as late as the Yin ruins. However, the most popular form from the period of the Yin ruins is round bodied like a *hu*, with three pillar legs and a short spout close to the mouth. At the end of the Shang and beginning of the Zhou the hollow-legged *he* had degenerated into a sectional vessel, whose lid is linked to its handle. A type of square *he* similar to the sectional form mentioned above, but with four legs, was popular in the early Zhou. After the mid Western Zhou Period, there appeared a *he* with foot-ring or short legs. This type is named *ying* in its own inscription. *He* in special forms, such as that of a human-faced dragon, have been found in the Yin ruins.

WATER VESSELS

Pan 盤

The *pan* is a water container with straight sides, flat bottom and foot-ring. Most bronze *pan* of the transition period between the Shang and Zhou have no handles. Those from after the mid Western Zhou have animal-shaped handles or movable handles, and supports under the foot-ring in the form of animals or caryatids. The *pan* and the *yi* formed a set for washing purposes in about the mid Western Zhou Period. The bronze *pan* is usually of medium or small size. An exception is the huge Guo Ji Zi Bai *pan* (Plate 54), which may have been used as a large *jian*.

Yi 匜

The *yi* is a water-pouring vessel shaped like a dipper with a spout, three or four legs and a dragon-shaped handle on its rear. After the Spring and Autumn Period, the spout was made in

the shape of an animal head. The *yi* of this period has a flat bottom and foot-rim. The *yi* of the Warring States Period has a latitudinally oval body and a long, narrow spout. Some *yi* of the mid Western Zhou are named *he* in their own inscriptions. The *he* was used for pouring water into wine. From this we can ascertain that the *yi* was originally a wine vessel. Later, the *yi* was used for pouring water to wash hands, the used water being collected below by a *pan*. As fingers were used for eating in ancient times, hand-washing utensils were indispensable.

Jian 鑑

A large vessel for holding water or ice, the *jian* is like a large vat with two or four handles, and is usually flat bottomed. Some *jian* are accompanied by *yi*. According to historical records, the ancients used the *jian* for bathing or as a wash basin. It was in widespread use in the late Spring and Autumn, and Warring States Periods.

MUSICAL INSTRUMENTS

Nao 鐃

The *nao* bell is China's earliest percussion instrument. It has a cup-like resonator with two pointed sides and a flat bottom. There is a handle attached to its bottom, and it is played with the open end pointing upwards. The upper end of the resonator is wider than the lower end. In the Shang Dynasty the usual set of *nao* consisted of three pieces, graded in size. A set of five *nao*, the largest known set of Shang percussion instruments, was unearthed from Tomb No. 5 at the Yin ruins.[95] *The Explanatory Dictionary of Words* defines *nao* as 'a small *zheng*'.[96] All existing *nao* are small percussion instruments.

95. See note 16.
96. *Shuo wen*, 'Jin bu'.

Zheng 鉦

The *zheng* bell is shaped like a *nao*, but is larger and much heavier, with thicker sides. The tallest *zheng* may be as much as 89 centimetres in height. The handle is hollow so that it can be fitted into a stand. All extant *zheng* bells were unearthed singly, except one which was found with a complete set of musical instruments. However, judging from its size and form, this *zheng* did not belong to this set of instruments; it was probably used for tuning other musical instruments. The *zheng* was popular in the late Shang Dynasty and remained in use in the early Zhou. It is also known as the large *nao*.

Zhong 鐘

The *zhong* bell evolved from the *zheng*. The *zhong* of the early Western Zhou Dynasty is shaped like a *zhong*, but with most of its surface covered with studs. The basic form of the *zhong* is a flat resonator with two pointed sides shaped like two tiles joined together, and with a handle on its flat top facilitating its suspension. The names of the different parts of the *zhong* are as follows: *wu* (the top of the bell), *zheng* (the middle section of the bell), *mei* (the 36 studs on the two sides of the bell), *zhuan* (the space between two studs), *gu* (the part of the bell below the *mei* and *zheng*), *sui* (the middle part of the *gu*), *yu* (the curved rim of the bell), and *xian* (the two pointed sides of the bell). The handle on the *wu* is called a *yong*, the top of the *yong* a *heng*, the protruding middle part of the *yong* a *xuan*, and the ring on the *xuan* for suspending the bell a *gan*. The function of the *mei* studs is to mellow the sound of the bell and prevent it from becoming too shrill. It was thought, in the past, that the *mei* studs were for adjusting the tone of the bell, but experiments prove that this is not so. The tone of a *zhong* becomes clearer but less sonorous without studs.

In the late Western Zhou there appeared the *niu* bell which has no *mei* and whose cross-section is oval. The *niu* bell has an even mouth-rim. The *niu* came into being to provide a more decorative bell. Its handle took the form of an entwining dragon and snake, a style very popular at the time between the Spring

and Autumn, and Warring States Periods. When *zhong* of different frequencies are placed together, they become chime bells, or *bian zhong*, and music can be played on them. A set of three chime bells first appeared in the mid Western Zhou Dynasty. The number in a set increased greatly in the late Western Zhou to consist of at least nine bells. The number reached 13 or 14 in the Spring and Autumn, and Warring States Periods. The number of bells in a chime is determined by the scale of the music and the type of music to be played. The chime of the Marquis of Zeng unearthed in Sui County, Hubei Province, consists of 64 bells in eight groups with differing numbers of bells in each group.[97] There was also a large *bo* bell. According to the instructions cast on the bells, and to tests conducted on them with instruments, it was found that each of the chime bells can produce sounds of two different frequencies, one by striking the *sui* part, that is, the centre of the *gu*, the other by striking the spot three-fifths of the distance from the *gu* to the *xian*. The sound produced by the latter is three tones higher than that produced by the former. As a result of a special mode of vibration, flat two-toned chime bells of special form are able to cover three octaves. They are indeed an extraordinary achievement of China's ancient musicians.

Bo 鎛

The *bo* is a large bell to be hung individually. The character can also be written as 鏄 . The name *bo* appears in inscriptions on the Ling *bo* and the *bo* of the Marquis of Zeng, which are two huge bells with oval cross-section and even mouth-rim. The *bo* bell produces only one note when struck, which harmonizes with *zhong* bells and chime stones.

Juduo 句 鐸

The *juduo* is a variation of the *zheng* bell. It has a cylindrical resonator with curved mouth-rim and handle. It can be held

97. See note 11.

in one hand and struck with the other, with the mouth-rim pointing upwards. When *juduo* bells of varying sizes are placed together, they form a set. They were popular in the states of Xu, Chu, Wu and Yue in the Spring and Autumn, and Warring States Periods.

Chunyu 錞于

The *chunyu* is cylindrical, with its upper end larger than the lower end. Formerly it was thought to be a musical instrument used together with the drum by an army on the march. It first emerged in the late Spring and Autumn Period, and was popular until the Han Dynasty. The early *chunyu* has a very small suspension knob. Most Han examples have tiger-shaped knobs. They have been unearthed mainly in the middle and lower reaches of the Yangtze River. The inscription on the *chunyu* of Geng Wu says: 'To be treasured and played eternally by my sons and grandsons.'[98] From this inscription, we can see that the *chunyu* was not necessarily a musical instrument used by the army. Moreover, there are *chunyu* of extremely large size which would be too heavy to be used by an army on the march. A figure striking a *chunyu* appears among the sculptures representing a sacrificial ceremony, on a cowrie container of the Dian people unearthed at Shizhaishan in Jinning, Yunnan Province (Plate 79).

Gu 鼓

The bronze *gu*, or drum, is the least common musical instrument. Still in existence is a Shang bronze drum decorated with demon designs unearthed in earlier times. A Shang bronze drum with animal mask design was discovered in Chongyang, Hubei Province, in 1976.[99] It is a horizontal drum together with a heavy and solid square stand. Its cylinder is covered completely with animal mask designs. Along its edge are cast

98. The *chunyu* of Geng Wu is in the collection of the Shanghai Museum.
99. Wen Fong (ed.), *The Great Bronze Age of China* (New York, 1980), Plate 18.

many nails in imitation of nails on a leather drum. This is the only existing Shang drum with a record of its discovery.

The bronze drums of minority peoples in the south-west are one-sided and vertical. The large ones are beaten while placed on the ground, and small ones while suspended from two loops. Early examples belong to the Spring and Autumn, and Warring States Periods. The tradition of casting bronze drums was continued through the Han, Tang, Song, Yuan and down to the Ming and Qing Dynasties, with some changes in their forms. They were popular in Guangxi, Guizhou, Yunnan, Sichuan and Guangdong Provinces.